YOSHITOSHI
The Splendid Decadent

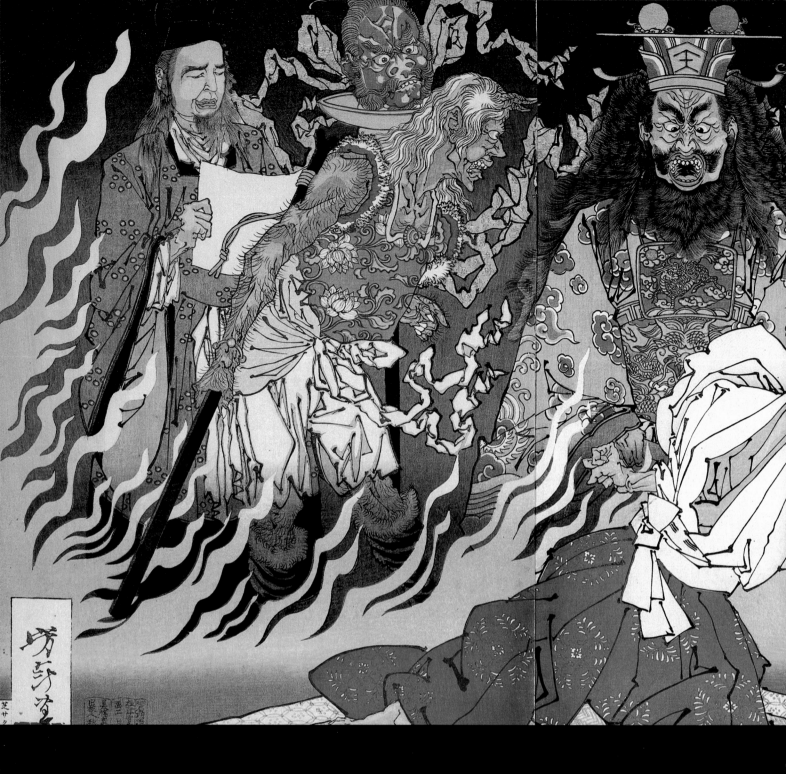

KODANSHA INTERNATIONAL LTD.
Tokyo, New York and San Francisco

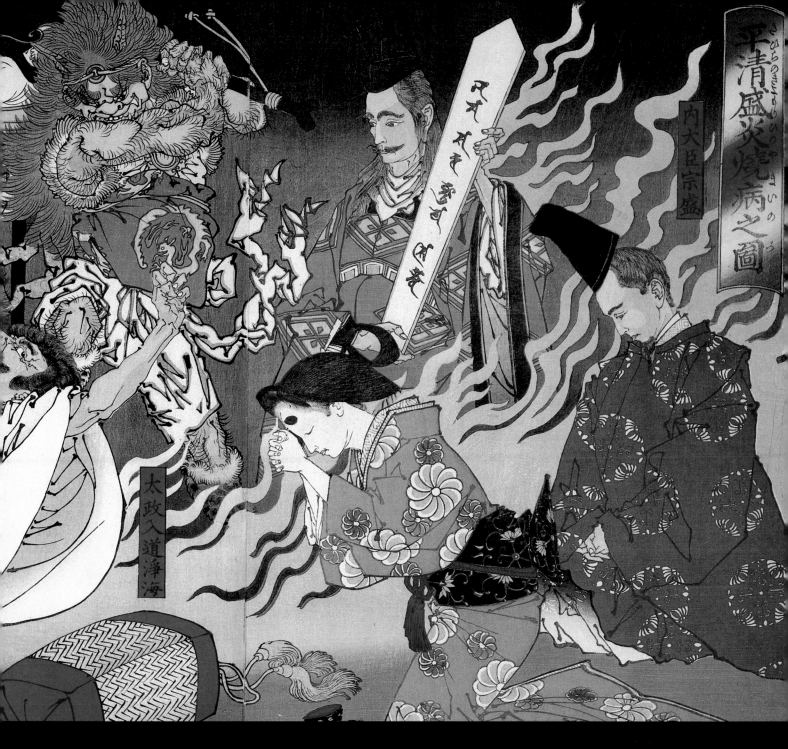

YOSHITOSHI
The Splendid Decadent

Shinichi Segi

translated by
Alfred Birnbaum

NOTE: With the exception of the author's name on the title page, all Japanese names in this book are given in the Japanese fashion, with surname preceding given name.

Illustration on title page: *Taira no Kiyomori Burns with Fever*

For reproduction of prints, grateful acknowledgment is made to Tokyo National Museum (figs. 74, 78–79, 82–84), Ōta Memorial Museum of Art (pl. 57), and Kanagawa Prefectural Museum (pls. 24, 30, 41, 43–44) as well as to Mr. Nishii Masaki for his many kindnesses and other private collectors.

Distributed in the United States by Kodansha International/USA Ltd., through Harper & Row, Publishers, Inc., 10 East 53rd Street, New York, New York 10022. Published by Kodansha International Ltd., 12-21, Otowa 2-chome, Bunkyo-ku, Tokyo 112 and Kodansha International/USA Ltd., with offices at 10 East 53rd Street, New York, New York 10022 and the Hearst Building, 5 Third Street, Suite No. 430, San Francisco, California 94103.

 LCC 84-48700
 ISBN 0-87011-712-2
 ISBN 4-7700-1212-8 (in Japan)
First edition, 1985

CONTENTS

Let us, then, take a look at Yoshitoshi. . . . Do we not observe here the atmosphere of the city in those days, no longer old Edo, but not yet the new Tokyo? Do we

not see the dramatic spirit of that decadent age when
night and day were rolled into one?
 Akutagawa Ryūnosuke

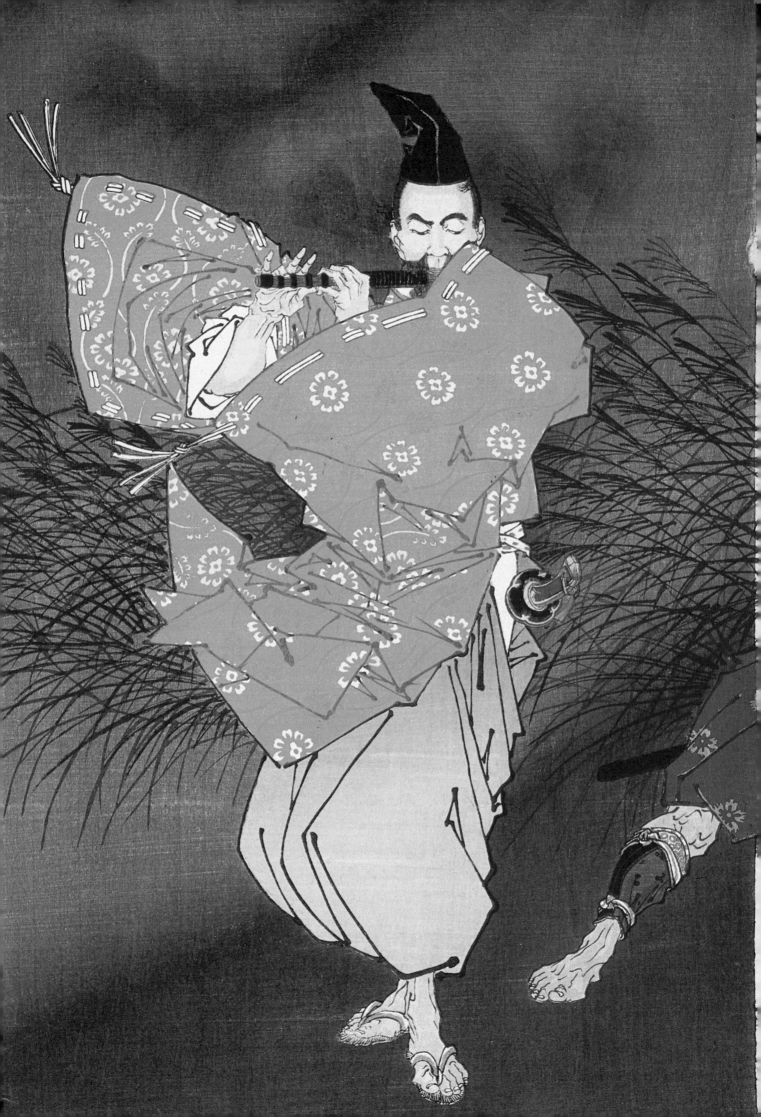

明治十五壬午季秋
繪畫共進會出品圖
藤原保昌月下弄笛
圖應需
大蘇芳年寫

御届明治十六年二月十二日
櫻岸宮永町三丁六〇地
画工 月岡米次郎
日本橋室町三丁目九八地
出版人 秋山武右衛門

PREFACE

In the little more than a century since their introduction to Europe, traditional Japanese Ukiyo-e woodblock prints have truly attained the status of a world art, known and loved everywhere. Cultural exchange has proceeded at such a pace that now Western connoisseurs of these "pictures of the floating world" perhaps outnumber those in Japan. Yet how many are familiar with the name Yoshitoshi?

An undiscovered master at this late date? How comes this sudden revelation? It is not, however, so much a revelation as a reevaluation, for Yoshitoshi (1839–92) was once recognized as the foremost Ukiyo-e artist of his day, though long since fallen by the wayside of prevailing tastes. Generally overlooked among the welter of minor artists crowding the last Ukiyo-e generation of the Meiji era (1868–1912), Yoshitoshi, if remembered at all, was dismissed offhand by later critics as a mere intermediary in the transition from popular Ukiyo-e to the more individualistic *sōsaku hanga*, the so-called modern "original print." Yoshitoshi has thus been long overdue for reinstatement to his rightful position as the last master of true greatness in the 250-year history of Ukiyo-e. In retrospect, it is ironical that Yoshitoshi should have suffered the same fate as his own teacher, Utagawa Kuniyoshi, who had long been unjustifiably overshadowed by such hallowed greats as Hokusai and Hiroshige. Only now, some ninety years after his death, is Yoshitoshi regaining acceptance as a major artist of accomplishment and vision, again following in the footsteps of his master.

Quite possibly the intervening years have been a blessing in disguise, for now we can approach Yoshitoshi with fresh, unbiased eyes. Indeed, part of the problem behind past devaluations was the difficulty of assessing the artist in the then current schemes of art criticism. Yoshitoshi obviously represented too much of tradition in the decades immediately following his death, when Meiji society was most set on cutting ties with old Japan. And, conversely, he failed to meet the aesthete's classicist criteria for "pure Japanese art," free of Western influences and photo-representational innovations. But above all, there was the image of Yoshitoshi as an artist of the macabre. The public no longer sought the sensational blood and gore of his early works, and the dark dreams that haunted his later career were something of an embarrassment in the face of modernist rationality. Those were progressive times—there was no doubt about it—and supernatural fantasy and morbid psychopathology simply had no place. It was all too easy to write off Yoshitoshi's work as the product of a sick mind; after all, it was common knowledge that he had been afflicted with nervous disorders.

Yoshitoshi's art deserved better, and now at last appraisals are starting to treat his genius fairly. As recent trends in art move beyond modernism toward a fuller picture of the human spirit in all its irreducible complexity, people have begun to appreciate the styles of earlier eras and diverse cultural genres as never before. All the more reason to take another look at Yoshitoshi, both for his superb handling of pictorial detail and his penetrating insight into the hidden recesses of the Japanese psyche. Since the late 1960s, increasing numbers of collectors have been seeking out prints by Yoshitoshi, and major exhibitions have been mounted in Japan and abroad. Unfortunately, up until now publications on the artist have been very few, and many of these have been in Japanese.

This book, then, comes at a most opportune time to introduce a wider audience to the art of Yoshitoshi, though, of course, the works themselves speak far more eloquently than any text. The particular pieces reproduced here have been chosen not only to highlight stylistic changes over the course of his career, but to offer a sampling of his finest artistic

achievements. While not by any means the "complete works"—that would require a volume many times this size—it is intended as a comprehensive survey of the best images out of the entire breadth of his individual prints and series. Readers will find themselves in a rich world of imagination and beauty, of romantic decadence and fastidiously observed realism. Always compelling, always a command performance incorporating the latest ideas in textural rendering, spatial recession, dynamic composition, and oblique lighting to the optimum enhancement of the traditions of his art, his images have an emphatic up-to-date, living immediacy. Especially in his later works, masterpieces of subtle coloring and understated contrapuntal tensions that hint at Yoshitoshi's deep understanding of the intuitive aesthetics of the Noh theater, we marvel at his power of psychological suggestion and narrative conciseness. There is a resonant quality to these works, an ineffable profundity brimming beneath the surface, a sure tautness and finish that exactly matches the most avant-garde tenets of contemporary performing arts.

Whether presenting us with subjects of the occult, violence, eroticism, or feverish nightmares, Yoshitoshi's art continues to excite and engage with its mystery, sensuality, and sheer complexity. An artist ahead of his time if there ever was one, he stimulates our sensibilities today precisely because there is so much to read in him, so many stories at so many levels of visualization. Here was a master of breadth and detail; a consummate draftsman, experimenter, and eclectic; a genius of erudition and popular appeal. There simply was no one quite like him.

If this book but whets reader interest in Yoshitoshi, it will have done a great service—both to this long-forgotten giant of Ukiyo-e and to the reader's imagination as well.

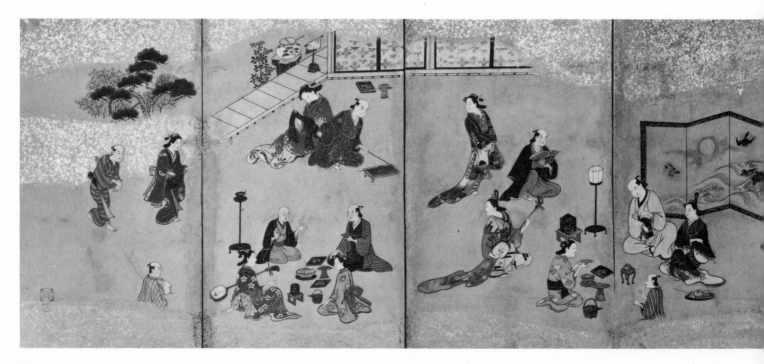

The Utagawa School

For well over two centuries Ukiyo-e had reigned virtually unchallenged as the most popular pictorial art form in Japan, but by the time Yoshitoshi was born in 1839, the "greats" were either gone or not long for this world: Utamaro had died nine years prior, and even the long-lived Hokusai was nearing the end of his prolific career. Yoshitoshi's late arrival on the scene secured him a place in posterity as the last virtuoso to leave his mark before the history of Ukiyo-e drew to a close.

Yoshitoshi's teacher Utagawa Kuniyoshi, a third-generation master of the Utagawa school, was already fifty-two when Yoshitoshi's apprenticeship began in 1850, and eleven years later he too would be gone. Yoshitoshi himself would be a mere twenty-eight when the Meiji Restoration ushered in the modern era in 1868.

These were complicated times, nor was the artist's own story free of its own twists and turns. Since no succinct picture of the man and his art readily emerges, we have to dig. Western readers in particular need some background in the developments that register in the history of the Utagawa school, developments that ultimately lead up to Yoshitoshi.

What follows, then, is an introductory overview of the major figures and achievements of the Utagawa school, with particular reference to how they helped shape the world in which Yoshitoshi lived and worked. Our coverage cannot pretend to exhaust the subject, but without this bare minimum Yoshitoshi would escape us.

TOYOHARU: THE FOUNDER

A promising new face came to the fore in Edo Ukiyo-e circles from around 1770. Utagawa Toyoharu (1735–1814) is said to have studied under the Kanō-school painter Toriyama Sekien (1712–88; fig. 1), deriving the element "Toyo" of his professional signature from his master's personal name Toyofusa. If we go by this, it would place him in the same lineage as Kitagawa Utamaro (1754–1806; fig. 2) and minor print artists Koikawa Harumachi (1744–89; fig. 3) and Chōki (active late eighteenth century to early nineteenth century; fig. 4), all reputedly one-time students of Sekien.

Toyoharu's fame climbed steadily throughout the following decade, his popularity as an artist rivaled only by Torii Kiyonaga (1752–1815), Katsukawa Shunshō (active ca. 1780–95), and the above Harumachi. Like any Ukiyo-e master he designed his share of actor prints (*yakusha-e*) and genre prints of beautiful women (*bijin-ga*), but what distinguished him was his singular dedication to *uki-e*, so-called height-

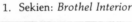

1. Sekien: *Brothel Interior*

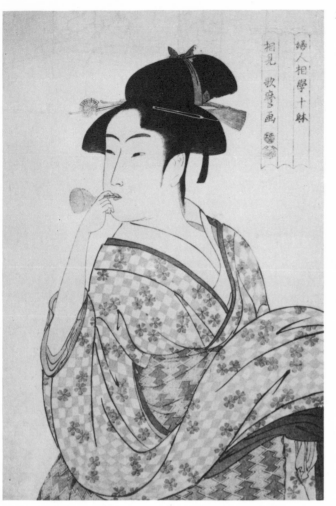

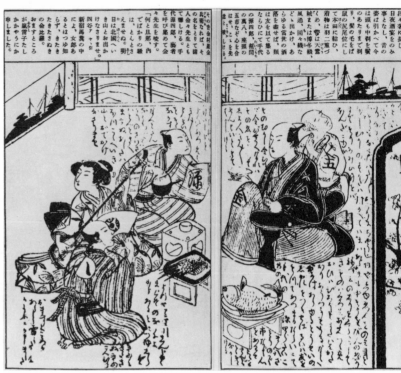

2. Utamaro: *Woman Playing a Poppin*

3. Harumachi: Book illustration from *Kinkin Sensei's Dream of Wealth*

4. Chōki: *The Courtesan Tsukasa Dayū*

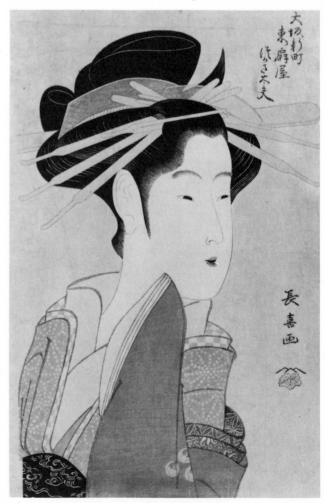

ened images composed to emphasize a sense of depth (fig. 5). Initially inspired by Chinese ink-landscape prints, and later modeled directly upon Dutch engravings, *uki-e* in woodblock prints originated with Okumura Masanobu (1696–1764) in the middle part of the eighteenth century. Although it had been picked up by any number of other artists over the years, the style was still in its infancy. It took Toyoharu to develop it into a refined art after years of meticulous study of Western pictorial techniques.

Today we are so accustomed to the illusionistic space of Western perspective that we may find it hard to appreciate how novel these images were at the time. Our perceptions are reversed; it is now the "flatness" of traditional Japanese representation that beguiles us. Yet we have only to consider the number of artists influenced by the Toyoharu style to realize the remarkable impact *uki-e* had in his day. The mark on his own disciples is clear enough, of course, but in an even broader sense Toyoharu's ventures into expanded spatial composition laid the groundwork for Western-style images and landscapes by such diverse practitioners as the painters–copperplate engravers Shiba Kōkan (1747–1818) and Aōdō Denzen (1748–1822), and world-renowned Ukiyo-e print designers Katsushika Hokusai (1760–1849) and Utagawa Hiroshige (1797–1858).

Almost single-handedly, Toyoharu created precedent for vast exterior views where before teahouse interiors had dominated. He breathed new life into an art that had nearly exhausted the possibilities of such cramped quarters. Only after Toyoharu's achievements in *uki-e* do we see the blossoming of the landscape print, which in turn allowed much greater freedom in the choice of subject matter. His-

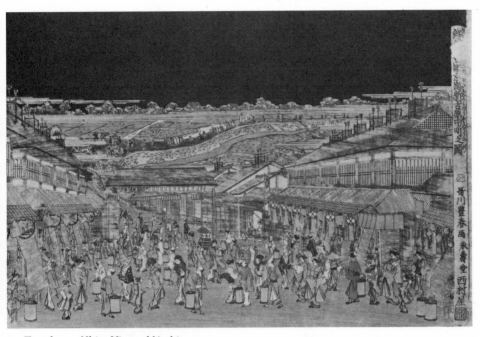

5. Toyoharu: *Uki-e View of Yoshiwara*

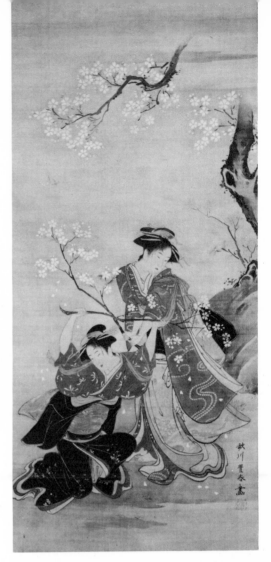

7. Toyoharu: *Cherry Blossom Fight*

6. Toyoharu: *Geisha in Summer Dress with Child*

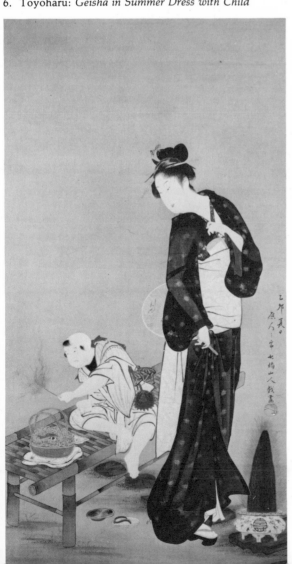

torical themes, pictorializations from literature and legend, scenic places in Edo and the provinces, occasional forays into exotica—famous landmarks and battle scenes abroad modeled on available Western pictures—whole new worlds opened up. In his stance as a roving eye looking for things new and different, Toyoharu thus foreshadowed Shiba Kōkan's curiosity in lands beyond the closed doors of Japan, as well as awakened Hokusai's interest in using the medium to explore many far-reaching channels of expression.

Toyoharu himself must have recognized the potential of this new direction in prints, for he poured the greater part of his energies into a sizable output of *uki-e*. Not that he had no interest in depicting actors or beauties—these subjects, after all, formed the mainstay of the Ukiyo-e tradition. Rather, what few examples survive indicate that he handled these exclusively in paintings, never in prints. This was in keeping with his original training as a painter under Sekien. Most of his extant paintings are highly pigmented yet tasteful portrayals of women, among the finest ever produced by an Ukiyo-e artist (figs. 6–7).

Otherwise he would occasionally receive commissions to paint placards and design programs for the Kabuki theater, jobs formerly monopolized by the Torii school. It seems this privilege came round to Toyoharu in 1785 upon the death of Torii Kiyomitsu (b. 1735), third-generation head of that line, when no immediate heir could be found. These commissions would in time prove a major showplace for the talents of Toyoharu's own disciples. So it was that even before Toyoharu passed away at the age of eighty, the beginnings of a distinct Utagawa school were already to be seen.

8. Sharaku: *Matsumoto Kōshirō IV as Gorobei*

9. Toyokuni: *Kōraiya* (Matsumoto Kōshirō IV as Gorobei)

10. Toyokuni: *Yamatoya* (Bandō Mitsugorō II as Ishii Genzō)

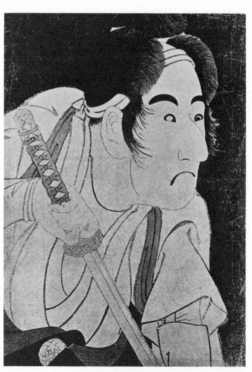

11. Sharaku: *Bandō Mitsugorō II as Ishii Genzō*

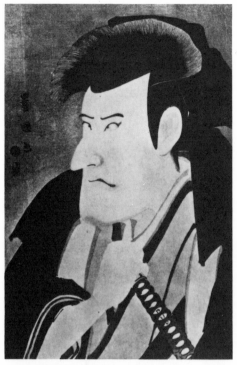

12. Toyokuni: *Ichikawa Komazō III as Shiga no Daishichi*

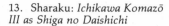

13. Sharaku: *Ichikawa Komazō III as Shiga no Daishichi*

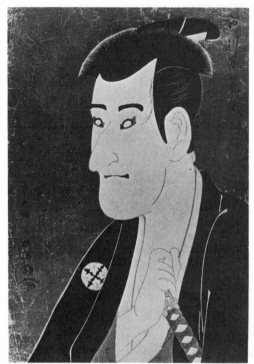

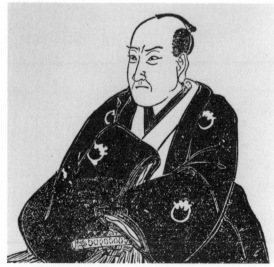

14. Portrait of Toyokuni I

TOYOKUNI AND TOYOHIRO: THE SCHOOL BRANCHES OUT

Toyoharu left no bloodline heirs—two sons and a daughter died before him, and childless at that—but he had managed to gather about him a number of able apprentices. The most outstanding of the group, Toyokuni (1769–1825), showed a leaning toward art from a precocious age, producing his earliest work at Toyoharu's studio in 1785 when barely sixteen.

An appreciative public soon discovered Toyokuni's special genius for actor prints. His series *Views of Actors on Stage* (*Yakusha Butai no Sugata-e*; figs. 9, 10), published over a two-year period from 1794, revealed a vigorous style unlike anything in the Torii school or even the soon-to-be-established Katsukawa school, both better known for their actor prints. Interestingly enough, the series includes several performances also depicted by Tōshūsai Sharaku (active 1794–95; figs. 8, 11). It was Toyokuni, however, who succeeded in winning over theater buffs and went on to a celebrated career; Sharaku, though much admired today, quickly faded into obscurity.

The contrast is instructive: while Sharaku's expressive close-up portraits attest to keener powers of observation, they fail to idealize the actors in the conventional manner or to get across the theatrical flavor of particular roles (fig. 13); Toyokuni's full-length poses met with sweeping recognition precisely because their glamorized presentation captured the whole *mise en scène* as the audience saw it. Toyokuni himself would later create head-and-shoulder portraits as well (fig. 12), but by then his style had become the new standard in *yakusha-e*.

Indeed, there was hardly any competition from the Torii school: the then prominent fourth-generation master, Kiyonaga, was largely occupied with prints of women (fig. 15), and no major figure appeared in the next generation. Even the Katsukawa school of Shunkō (1743–1812) and Shun'ei (1762–1819), stars that had shone so brightly in the field of actor prints for a short while following the death of found-

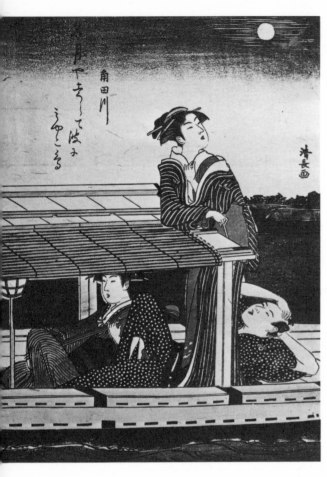

月や今よつて波ぞ
命こそ

角田川

清長画

15. Kiyonaga: *Moon-viewing on the Sumida River*

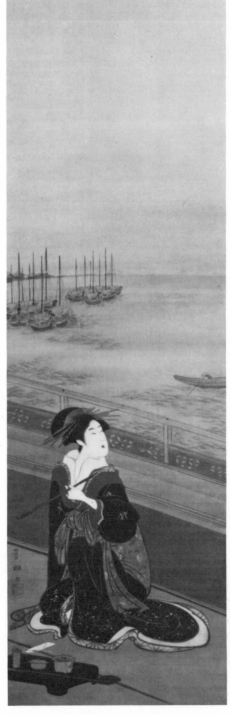

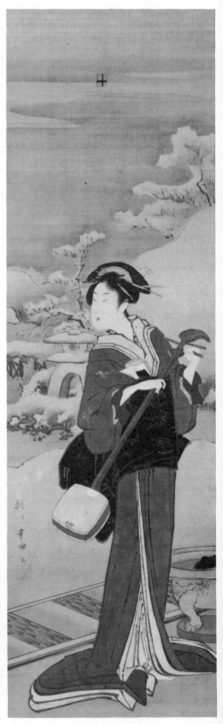

16. Toyokuni: *Courtesan by the Southern Shore*
17. Toyokuni: *Courtesan in a Snowy Garden*

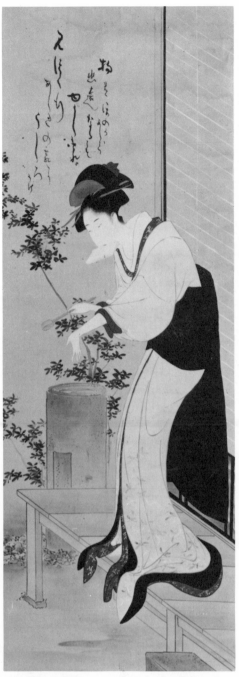

18. Toyohiro: *Beauty Washing Her Hands under the Eaves*

19. Toyohiro: *Beauty with Shamisen*

20. Toyohiro: *Evening Snow at Mimeguri*

ing master Shunshō (1726–92), now too was rapidly declining for want of new talent.

Toyokuni had made impressive strides in conquering the world of the actor print. But at the same time, he also brought his talents to the vision of feminine beauty. From the 1790s on into the first two decades of the nineteenth century, when Utamaro and Kiyonaga were on the wane, his many paintings and multicolored *nishiki-e* prints of women were undoubtedly the best in that genre (figs. 16–17). His paintings in particular are filled with the elegance and rich use of pigments he learned from his teacher, Toyoharu. Later Ukiyo-e circles would come to hold these in high regard as models of excellence.

Still, for all the acclaim he garnered, Toyokuni had a comparatively short active period. After his death in 1825 at fifty-six the Utagawa school boasted no one of Toyokuni's dynamism or stature. The single most noteworthy figure, Toyohiro (d. 1828), had been his junior under Toyoharu. Toyokuni and Toyohiro were not far removed in terms of age, but they could not have been more diametrically opposed in their artistic styles and temperament. Tradition has it that they did not get along very well either.

On examining Toyohiro's oeuvre, we are struck by how few prints there are. His main calling was to painting, and specifically to genre paintings of beauties, for we search in vain for pictures of actors. Here he seems to have taken up Toyoharu's painting style pure and unadulterated. His women have an air of refinement about them, a pristine poetic quality that sometimes borders on fragility (figs. 18–19). By all accounts, Toyohiro was a retiring and contemplative character—unlike Toyokuni, the boisterous theatergoer—and this shows in his works, suggesting that he had higher aspirations for his art than popular Ukiyo-e.

Popular Ukiyo-e catered to the city dweller, so it was only natural that Toyohiro should seek to elevate his aesthetic via landscape images, as no doubt suggested by Toyoharu's *uki-e*. Though few in number, Toyohiro's landscapes are again graced by a certain quiet elegance. The series *Eight Views of Edo* (*Edo Hakkei*) exemplifies this sensibility, and in fact anticipates the world-famous landscapes of Hiroshige (fig. 20).

By the early 1800s the Utagawa school was well established as a major force in Ukiyo-e, based on the complementary strengths of Toyokuni and Toyohiro. Other schools would, of course, persist and even branch off into a number of new subschools—the Chōbunsai line, Hokusai line, and, somewhat later, Kikukawa line, just to name a few—but from this point on the Utagawa becomes by far the dominant school.

THE FACE-OFF BETWEEN TOYOSHIGE AND KUNISADA

If the number of apprentices an artist could take on is any indicator of his success in the world of Ukiyo-e, then surely Toyokuni's position had been remarkable: the names of at least sixteen followers have come down to us today. Take it one step further, and we can easily imagine the intense competition that existed between these apprentices.

So it was that after the death of Toyokuni in 1825, the title of successor was much contested. The most direct lineage belonged to Toyoshige (1777–1835), a relative latecomer to the studio who only began his apprenticeship in 1819, but nonetheless Toyokuni's son-in-law as of 1824. Assuming the

name Toyokuni II, he proved himself adept at depictions of actors (fig. 21) and beautiful women in the style of his master's final years, although he probably never fully realized his potential due to the overshadowing presence of his seniors.

The most potent challenge came from Kunisada (1786–1864), the strongest draftsman of the lot, having studied since 1801 at the age of fifteen. It did not take him long to force Toyoshige out of the picture. The curious thing is, however, that Toyoshige eventually left the household and seems to have abandoned the title Toyokuni II. We are not even certain of his exact death date.

Into the 1830s, Kunisada enjoyed undisputed acclaim as the major figure in the line, outshining all the others. He particularly excelled in the production of actor prints (fig. 23) and paintings of beauties (fig. 24), in which he was the foremost Ukiyo-e master of the day. Inflated with self-confidence, in the summer of 1844 he suddenly started calling himself the second-generation Toyokuni. But Toyokuni II was still alive at this point, and the bravado backfired, subjecting Kunisada to his share of public ridicule. Not one to be confounded by temporary setbacks, though, he quickly turned the tables on his critics by transforming himself into Toyokuni III.

The standard critical view of this Toyokuni III divides his lengthy career roughly into three periods, paralleling his use of the professional signatures Ichiyūsai, Gototei, and Kōchōrō; the middle signature supposedly corresponding to his peak period. The truth, however, is that Kunisada was an astoundingly prolific artist with at least two modes of production under way at any given time: on the one hand, he tossed off increasingly unmanageable quantities of derivative typecast works to meet the demands of his rising popularity, so that, on the other hand, he might still continue to create a small number of consistently superlative prints of actors and beauties as well as genre paintings. The sheer volume of his output—including minor book illustrations and the like—must comprise something in the order of sixty thousand images, hence his general reputation for poor-quality overproduction. Yet in a sense the verdict is unfair, for if we weed out the mass of lesser works and concentrate on that slow but steady stream of carefully executed pieces, we can see him for what he clearly was—one of the great artists of the age.

By 1846 Kunisada had gone into retirement, turning the household over to his pupil and son-in-law Kunimasa III (1823–80), and even bestowed on him the title Kunisada II. He himself nonetheless went on producing some pieces until his death at the age of seventy-eight, just four years before the Meiji Restoration of 1868.

KUNIYOSHI: THE INDEPENDENT SPIRIT

Toward the end of the 1820s, when Toyoshige and Kunisada were battling it out, a third contender was claiming a progressively greater share of the public attention. Kuniyoshi (1797–1861), who was Kunisada's junior by eleven years, had been allowed to enter Toyokuni's studio in 1810 at the age of thirteen in recognition of his unusual artistic abilities. His first work dates from around that very year, and by 1816 or so his output had reached sizable proportions, although recognition was long in coming. Again this was probably the effect of overcrowding among the many apprentices working in the Toyokuni studio style, designing prints of actors and

21. Toyoshige: *Ichikawa Danjūrō VII*

22. Portrait of Kunisada

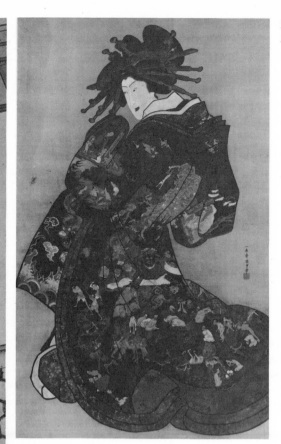

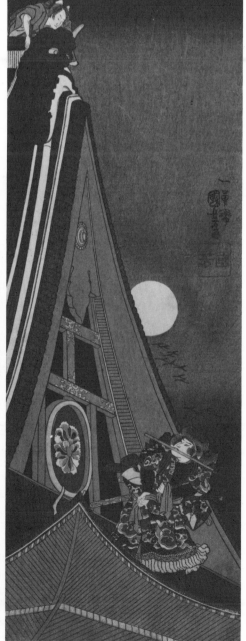

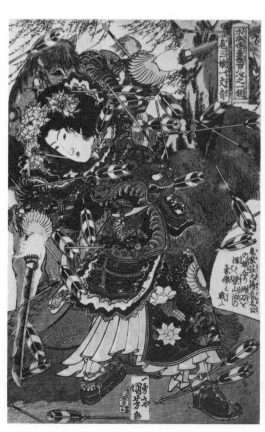

women. No matter how skillful his hand, Kuniyoshi remained in the shadow of his seniors.

It was only by taking a major leap into yet unstaked territories after his mentor's death that sudden fame was his. From 1828 he published a large series of prints entitled *One of a Hundred and Eight Heroes Popularized from the Water Margin Saga* (*Tsūzoku Suikoden Gōketsu Hyakuhachi-nin no ichinin*; fig. 25), a committed attempt to establish an entirely new field in Ukiyo-e—the warrior print (*musha-e*). A trailblazing artist, Kuniyoshi also experimented with incorporating Western stylizations into landscape prints with a sensibility distinctively his own. While not averse to working in the traditional actor and beauty themes of the rest of the Utagawa school, his perceptive departure from the beaten path guaranteed him a unique position in his choice of terrain.

In the 1830s this highly independent talent sought out yet newer areas of expression, extending his vision of the warrior print to encompass the humorous, satirical, and bizarre. These works caught the public eye, and made Kuniyoshi an overnight sensation. "Kunisada for actor prints and Kuniyoshi for warrior prints" became the byword of the day. At times it appeared that Kuniyoshi might eclipse the former in popularity. Granted, Kunisada towered supreme in the years following his 1844 commandeering of the title Toyokuni III. Still, Kuniyoshi's powers were likewise on the upswing, and his own studio now boasted a good number of able pupils.

At this juncture in the history of Ukiyo-e, Kuniyoshi would seem an exceptional figure in the Utagawa school; if anything, his art was inspired by that of Hokusai, wholly removed from the school. And yet, conversely, much of Kuniyoshi's novelty may merely stand relative to the staid conventionalism of the rest of the Utagawa school of that time. We might argue that he was closer to the original innovative spirit of the founding father Toyoharu than any of his peers.

What first appeared a radical departure from the norm in prints of actors and beautiful women, themes which had sustained the Utagawa school through the period of political calm in the early nineteenth century, actually proved the saving grace of the school, providing it with timely viable alternatives. All too soon the Meiji Restoration would shake the foundations of feudal society, and rapid changes focus attention on military exploits and things abnormal—the very stuff of Kuniyoshi's artwork. But perhaps the greatest testimony to the vitality of his personal vision was that from the mid-1840s on: the only new artists able to find a public were those of Kuniyoshi's line.

Fortunately for the Utagawa school and for the whole of Ukiyo-e, Kuniyoshi was known for his extreme generosity as a teacher and took a great many pupils under his wing. By the time he died at sixty-five, a revered master, a veritable flock of fledgling artists had benefited from his tutelage.

HIROSHIGE: AN ANOMALY

There remains one more Ukiyo-e master to consider before we leave our discussion of the Utagawa school. Ordinarily when we speak of the Utagawa school, our immediate associations are with that milieu of artists in the Toyokuni line highlighted by Kuniyoshi. That is understandable, the Toyokuni line being by far the largest branch of the school.

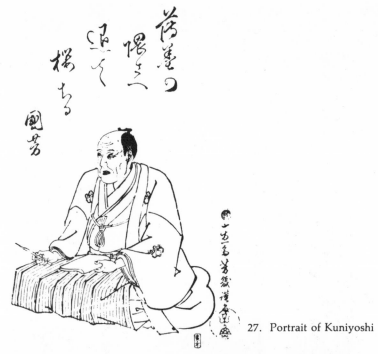

27. Portrait of Kuniyoshi

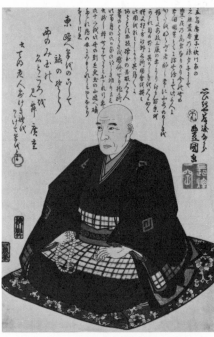

28. Toyokuni: portrait of Hiroshige

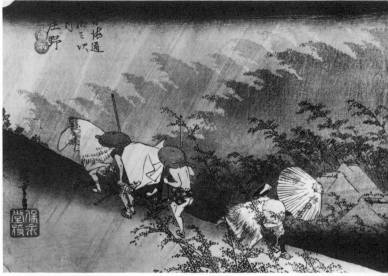

29. Hiroshige: *Shōno*

30. Yoshifuji: "toy image"

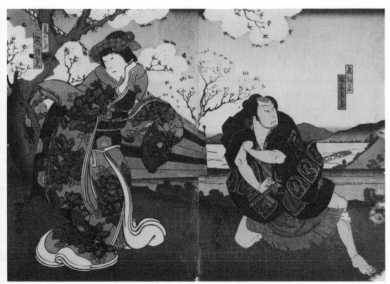

31. Yoshitaki: actor print

We tend to overlook Toyohiro's less outgoing presence back in Toyoharu's studio, and somehow forget to trace his line.

Thus it hardly occurs to anyone that Hiroshige (1797–1858) belongs to the Utagawa school, but the fact is that he studied under Toyohiro. True, there is little about Hiroshige that would remind us of Kunisada and his studio, but a certain commonality can be found in the individualism of his other great contemporary, Kuniyoshi.

Hiroshige's rise to fame came on the heels of his 1833 series of landscape prints *Fifty-three Stations on the Tōkaidō* (*Tōkaidō Gojūsan Tsugi*), which subsequently went through several editions (fig. 29). Following up on Hokusai's *Thirty-six Views of Mt. Fuji* (*Fugaku Sanjūrokkei*), the Tōkaidō series set the wheels of a whole landscape movement in motion, with Hiroshige firmly established as its highly acclaimed leader.

Like Kuniyoshi, Hiroshige also made nominal contributions to the Utagawa-school heritage of prints of actors and beauties, but he was first and foremost a landscape artist. Unlike Kuniyoshi, however, he chose not to accentuate Western perspective but rather blend it with traditional Japanese pictorial style and less formal Chinese-style *nanga* literati painting, achieving a beautifully harmonious naturalism all his own. While he undoubtedly inherited some elements of his style from the pure and graceful landscapes of his teacher, Toyohiro, the endearing charm of Hiroshige's prints probably owes more to the warmth of his own personality.

By a curiously nostalgic reversal of prevailing trends, Hiroshige presented a uniquely wholesome and generally pastoral world view to city dwellers during an era of mounting corruption and widespread disregard for morality. At a time when Kunisada and Kuniyoshi made names for themselves by targeting sophisticated cosmopolitan tastes, here was Hiroshige with series after series of scenic views of the countryside. Yet Hiroshige proved as salable as he was prodigious: so long as he kept coming out with landscapes, his popularity never waned.

FINAL DEVELOPMENTS

From the end of the Edo period (1600–1867) on into the first part of the Meiji era (1868–1912), the Utagawa school comprised three major household divisions—the Kunisada line, the Kuniyoshi line, and the Hiroshige line, each with several dozen more or less active artists and apprentices. It was easily the largest school in Ukiyo-e.

Among the most notable of Kunisada's pupils were Sadahide (1807–73) and Kunichika (1835–1900), while two successive sons-in-law of Hiroshige capitalized on his landscape style under the names Hiroshige II (1826–69) and Hiroshige III (1843–94). But as previously mentioned, it was the Kuniyoshi line that produced the most outstanding artists.

All of Kuniyoshi's followers took after their master in creating excellent warrior prints, added to which each had his own specialty: Yoshifuji (1828–87) his toy images (*omocha-e*; fig. 30), Yoshiiku (1835–1904) genre paintings of beauties, and Yoshitaki (1841–99) actor prints (fig. 31), to mention but a few. Nonetheless, it was Yoshitoshi who displayed the most dazzling talent beginning from the mid-1860s and outstripped all the rest to become the solitary giant of Meiji Ukiyo-e.

The Career of Yoshitoshi

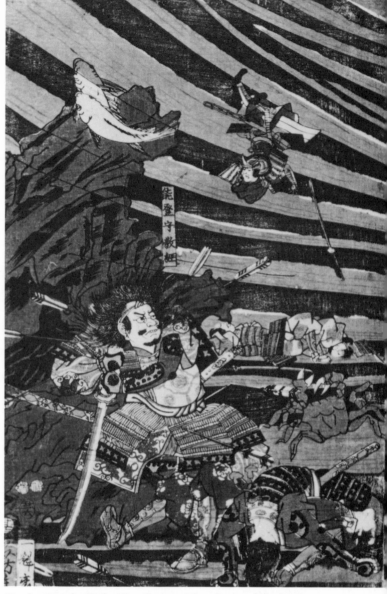

32. *In 1185 the Heike Clan Sank to Their Doom in the Sea*

In the fall of 1850, an eleven-year-old boy of some artistic talent began his apprenticeship under the Ukiyo-e master Utagawa Kuniyoshi, and within three years produced his debut print entitled *In 1185 the Heike Clan Sank to Their Doom in the Sea* (*Bunji Gannen Heike no Ichimon Horobi Kaichū ni Ochiiru Zu*; fig. 32). This subject, originally depicted by Kuniyoshi himself, was a favorite among his disciples, and excellent treatments by Yoshitoshi's seniors Yoshitora and Yoshitsuya also exist.

Yoshitoshi's piece, though largely in the mold of others' work and certainly far from mature, does evidence a characteristically painstaking concern with detail and overall composition: three warriors are placed in a triangular formation across a three-panel background swept by waves stylized into long, concentric arcs of blue and black and dotted by a number of lesser figures, fish, and crabs. No doubt the young Yoshitoshi was aided by his eminent mentor in the realization of this fledgling effort, but it is a powerful first showing all the same. From 1858, a mere five years later, he was able to launch a professional career as an Ukiyo-e print designer in his own right.

Beginning slowly, his early production consisted predominantly of pictorializations from children's stories, occasional illustrations, and cartoons, followed by an increasing number of actor prints (figs. 33–34)—much the same pattern as the early careers of Utamaro and Hokusai. In time he built up a steady clientele for commissions and sales, his artistic expression gradually evolving in a more personal direction toward warrior prints and scenes from historical tales over the next decade into the mid-1860s (figs. 35–38). When his first major series, *Biographies of Modern Heroes* (*Kinsei Kyōgiden*; pl. 1, figs. 39–40) and *One Hundred Ghost Stories of Japan and China* (*Wakan Hyaku Monogatari*; pls. 2–4), started appearing in 1865 together with a sizable volume of warrior prints, he had come into his own stylistically.

Already by that year, Yoshitoshi was ranked the tenth most popular Ukiyo-e artist in the *Edo Almanac* (*Edo Saiseiki*). He was still only twenty-six at the time, but as this appraisal showed, Yoshitoshi was well on the way to artistic stardom.

FAMILY BACKGROUND

Yoshitoshi used many names throughout his career, as was standard practice among Ukiyo-e artists. In his case, though, this nomenclature also says something about his unusually involved personal origins. Most commonly known by the fami-

33. *Edo Prints of Modern Celebrities:*
Fujiwara no Tokihira
34. *Bandō Hikosaburō V as Sadakurō*

29

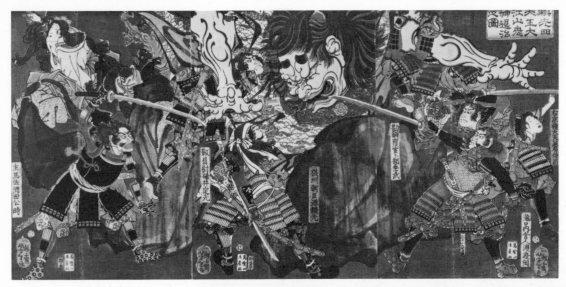

35. *Raikō (Yorimitsu) and His Four Heavenly Generals Vanquish the Ogres of Ōeyama*

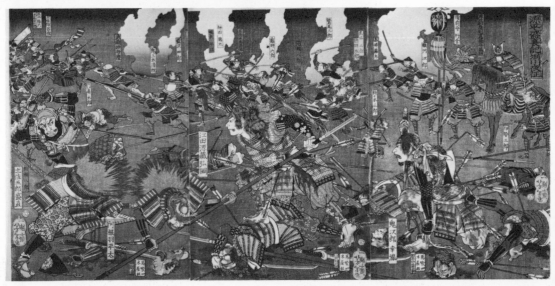

36. *The Night Attack at Horikawa from the Gempei Seisuiki*

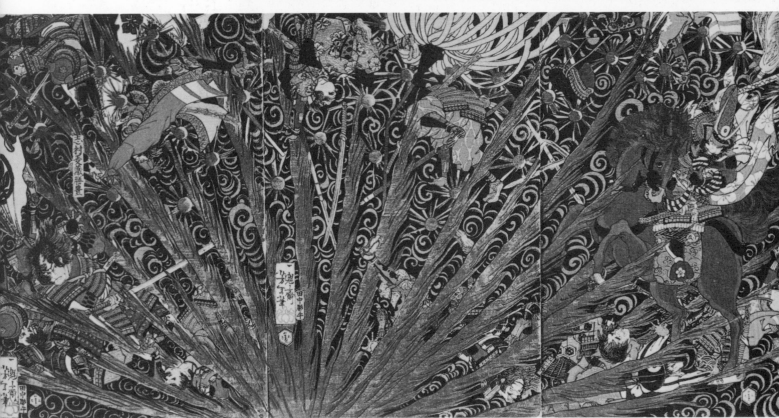

37. *Masakiyo's Difficult Battle from the Taiheiki*

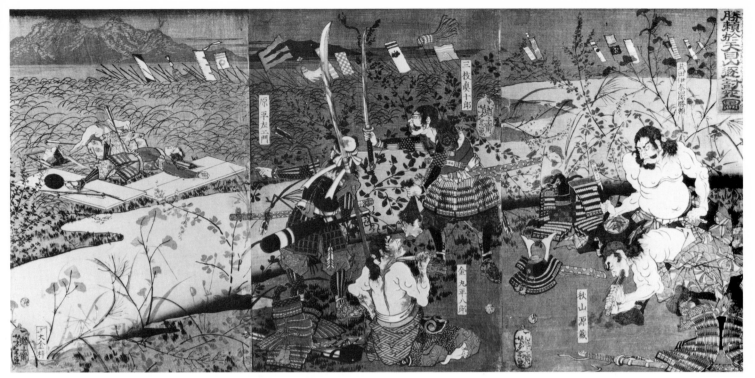

38. *Katsuyori Fights to the Death at Temmoku Mountain*

Figs. 39–40 and pl. 1: from *Biographies of Modern Heroes*

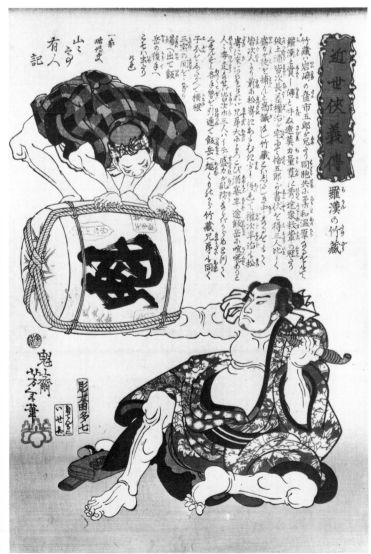

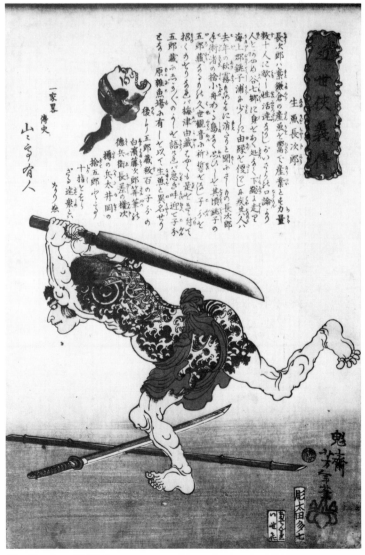

39. *Rakan no Takezō*

40. *Namauo Chōjirō*

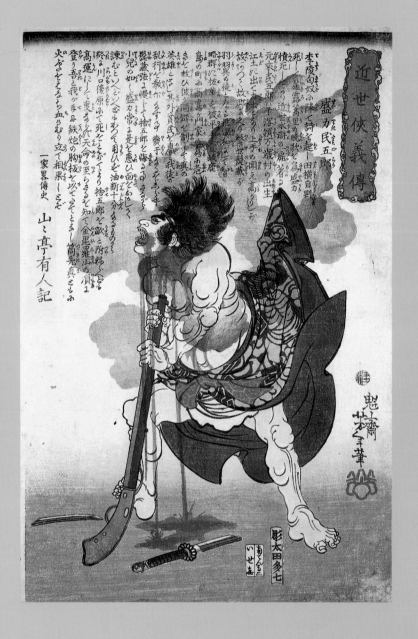

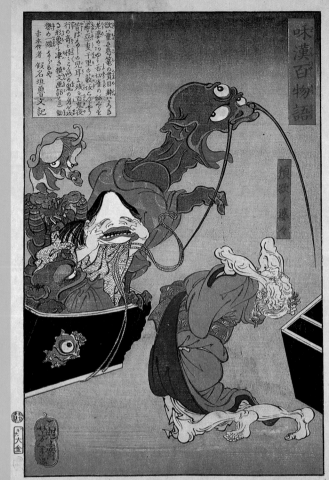

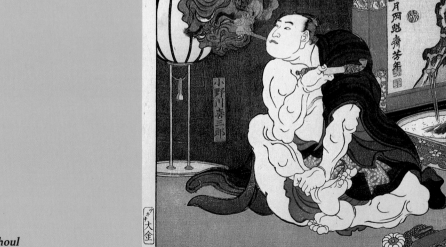

1. *Tamigorō Commits Suicide*

2. *The Greedy Old Woman*
3. *Onogawa Kisaburō Humiliates a Ghoul*
4. *Kung Sunsheng Conjures a Dragon*
Pls. 2-4: from *One Hundred Ghost Stories of Japan and China*

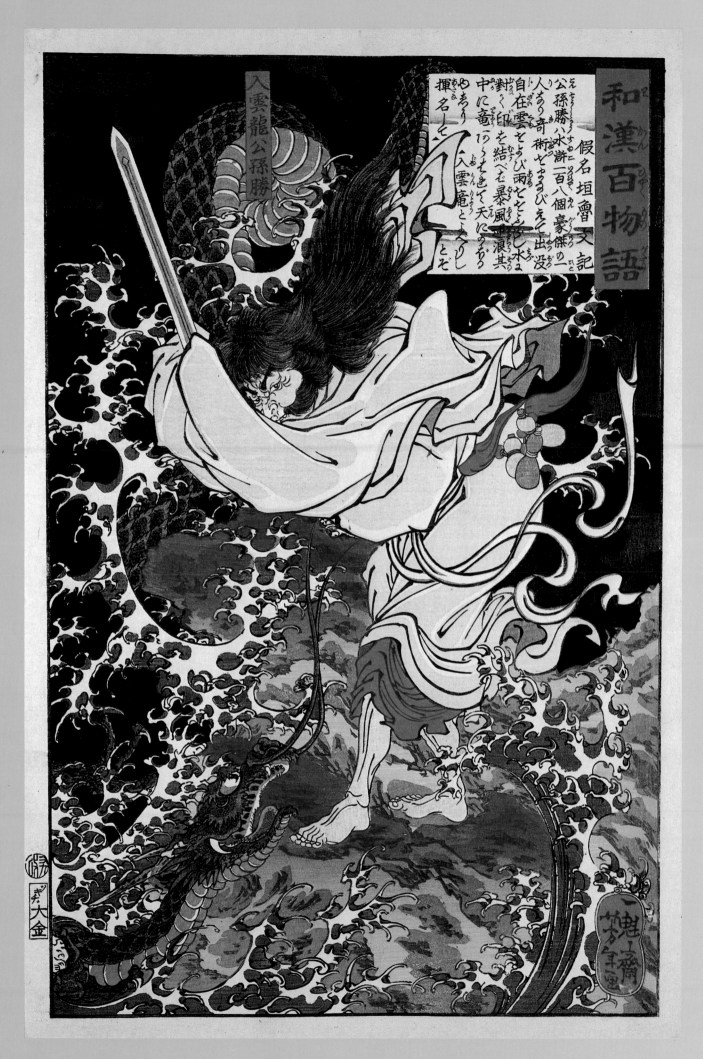

ly name Tsukioka, he only began using it professionally in 1865 and finally registered it officially when the new Meiji government required that print designers list their full name and address on artworks. Before that, Yoshitoshi had gone by the secondary "studio" names Gyokuōrō and Ikkaisai patterned after his teacher Kuniyoshi's own Chōōrō and Ichiyūsai, and continued to use these on occasion thereafter. The very name Yoshitoshi was itself a "gift" from Kuniyoshi, one of many similar artist names of disciples borrowing the "Yoshi" of the master's own name, just as Kuniyoshi had taken the "Kuni" of Toyokuni before him. Yet the name under which he was buried at Sempukuji temple in the Higashi Ōkubo section of Tokyo was Yoshioka Taiso Yoshitoshi.

These and other pieces of information provide clues to his background in the absence of biographical details up to the time he produced his first print at age fourteen. Even so, the intricacies of mutable kinship patterns in the Edo period make it difficult for us to appreciate just where Yoshitoshi himself felt most related. Not only was he raised in more than one household—he was adopted at an early age by a second cousin—but the whole family name changed at one point.

Properly speaking, family names belonged exclusively to samurai clans in the Edo period. Townsfolk of the merchant class typically went by the name of the family business—appellations ending in *ya*, meaning shop. Thus, when Yoshitoshi was born in 1839, the second son of a business household established for three generations under the name of Owariya in the Minami Ōsakachō district of the Shimbashi area of Edo (present-day Tokyo), he too would have had the name Owariya. That is, if he had been known by anything but his given name, Yonejirō; for a personal "childhood" name generally sufficed in the early years before a formal entry was made in the family registry. As it turns out, Yoshitoshi's grandfather had previously bought his way into the samurai-class Yoshioka clan, a fairly common means by which wealthy merchants could gain social mobility, and so had taken the name Yoshioka Hyōbu (1796–1855). This shift in family affiliation entitled all members of his household to the Yoshioka name. Hence Yoshitoshi's father, Owariya Kinzaburō (1815–63) became Yoshioka Hyōbu II.

Yoshitoshi was without a mother from early childhood. Her name is found on no Yoshioka tombstone, suggesting that her disappearance should be ascribed to divorce, not death. Soon his father had brought home another woman to live with them, but she and Yoshitoshi got along poorly, and the boy ran away to the nearby home of his father's cousin. A moderately successful pharmacist in the Maruyachō district of Shimbashi, this second cousin, Kyōya (Yoshioka) Orizaburō, had two children of his own, but had already lost one, a son, in 1842, and was destined to lose the other, a daughter, in 1851. The exact date Yoshitoshi left the house of his birth for this new home is not known, but it presumably occurred sometime during that interval when the daughter was still alive, prompting Orizaburō to adopt him as a possible future match for his daughter and heir to his pharmacy. Eventually, when Yoshitoshi's real father died at the age of forty-eight, he was even officially registered as "Yonejirō, second son of Yoshioka Orizaburō."

Around that time—the fall of 1850 to be precise—when Yoshitoshi first entered Kuniyoshi's studio, he was reportedly accompanied by a shop apprentice, indicating that his new step-father took an active interest in the boy's artistic train-

41. Kaburagi Kiyokata: portrait of Yoshitoshi

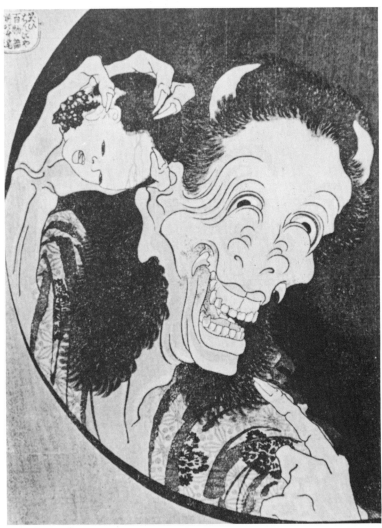

44. Hokusai: *The Tale of the Grinning Hannya*

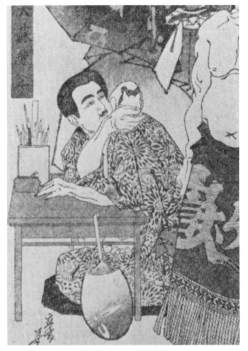

42. Toshinobu: portrait of Yoshitoshi

43. First "Tsukioka" signature (detail of pl. 3)

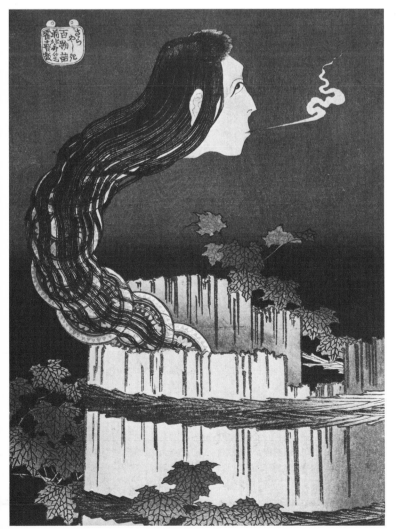

45. Hokusai: *The Tale of the Dish Mansion*

ing. It seems that Orizaburō proved a doting parent, acknowledging Yoshitoshi's natural inclination toward art and encouraging him to pursue a career as an Ukiyo-e print designer, even at the expense of the family business.

From his earliest work, a book of illustrations produced in 1853 or thereabouts, Yoshitoshi signed his family name Yoshioka. But as of 1865, he began to alternate this with Tsukioka (pl. 3, fig. 43), a name he later came to use with even greater frequency. To what family tie did this name relate?

In a corner of the Yoshioka clan plot at Sempukuji temple we encounter a tombstone carved with the names of Tsukioka Sessai and two young daughters. The temple death register identifies this Sessai, the artist name used by the eldest son of the Osaka painter Tsukioka Settei (1710–86), with one Tsukioka Tamezaburō, younger brother of Kyōya Jūgorō. According to this charting of kinship—Jūgorō being the father of Yoshitoshi's step-father Orizaburō—Yoshitoshi had every reason to claim that he was the third generation in the Settei line after the death of second-generation Sessai in 1839, the year of his own birth, and especially after the second of Sessai's daughters passed on in 1865, leaving no other heir.

In fact, even the secondary name Taiso, "Great Rebirth," which Yoshitoshi used to commemorate his recovery from illness at the end of 1853, seems to have been chosen to tie in with the names Taikei, "Great Valley," for Settei and Taiso, "Great Element," for Sessai. Clearly Yoshitoshi wished to identify himself with these two artists, though he never knew either.

All things considered, Yoshitoshi's family tree presents us with a tangle of branches as complex as that of his great predecessor Hokusai. To prune it down to its simplest outline, then, Yoshitoshi was first adopted by his father's cousin, and later opted into the artist lineage of his adoptive grandfather's younger brother. We should note in passing, however, that it is not certain whether Sessai was actually Settei's son who moved up to Edo and became Kyōya Tamezaburō, or whether contrary to the accepted account he was adopted from the Kyōya household and was not Settei's real son, at all.

Much of the confusion surrounding Yoshitoshi's early life stems from the sheer dearth of contemporary records. Yoshitoshi, like most Ukiyo-e artists, kept no journals, was a poor correspondent, and published no memoirs. The single most important source of information on his life is an offhand reminiscence written in 1930 by a former apprentice, Yamanaka Kodō. While hardly complete or necessarily accurate in all details, the larger delineations have proved invaluable in constructing his biography.

INDULGING THE SAVAGE APPETITES OF THE AGE

The most outstanding works of Yoshitoshi's early career, the *Twenty-eight Infamous Murders with Accompanying Verses* (*Eimei Nijūhasshūku*; pls. 5–9, p. 38) of 1866–67 (in collaboration with Yoshiiku; see p. 39) and *One Hundred Selections of Warriors in Battle* (*Kaidai Hyaku Sensō*; pls. 10–14) of 1868–69, seem to revel in a sadistic taste for blood and merciless cruelty. Scene after scene of gruesome brutality unfold—severed heads, gaping wounds, blood-spattered limbs, oozing bowels, dripping sword blades. Was Yoshitoshi simply

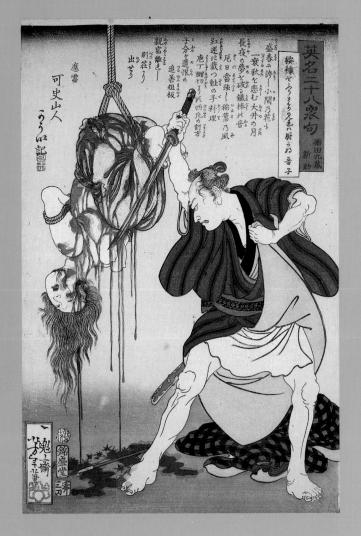

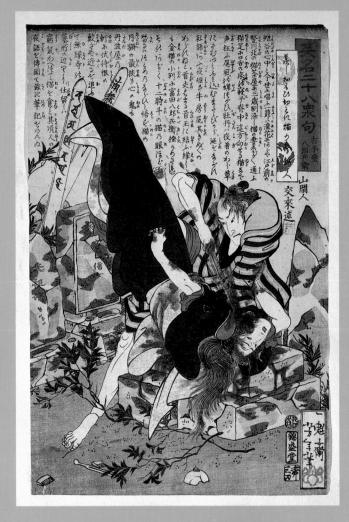

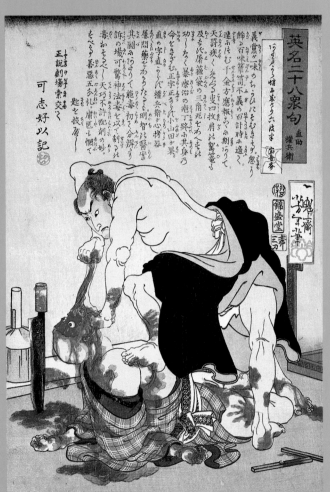

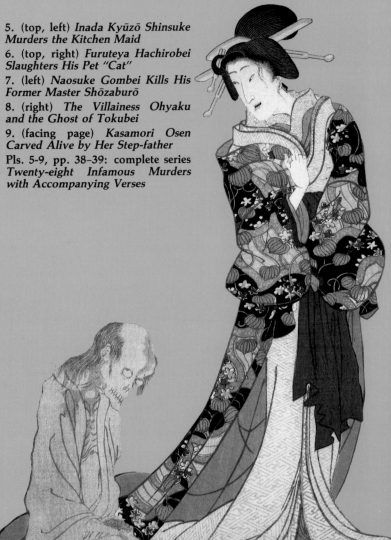

5. (top, left) *Inada Kyūzō Shinsuke Murders the Kitchen Maid*
6. (top, right) *Furuteya Hachirobei Slaughters His Pet "Cat"*
7. (left) *Naosuke Gombei Kills His Former Master Shōzaburō*
8. (right) *The Villainess Ohyaku and the Ghost of Tokubei*
9. (facing page) *Kasamori Osen Carved Alive by Her Step-father*
Pls. 5-9, pp. 38–39: complete series *Twenty-eight Infamous Murders with Accompanying Verses*

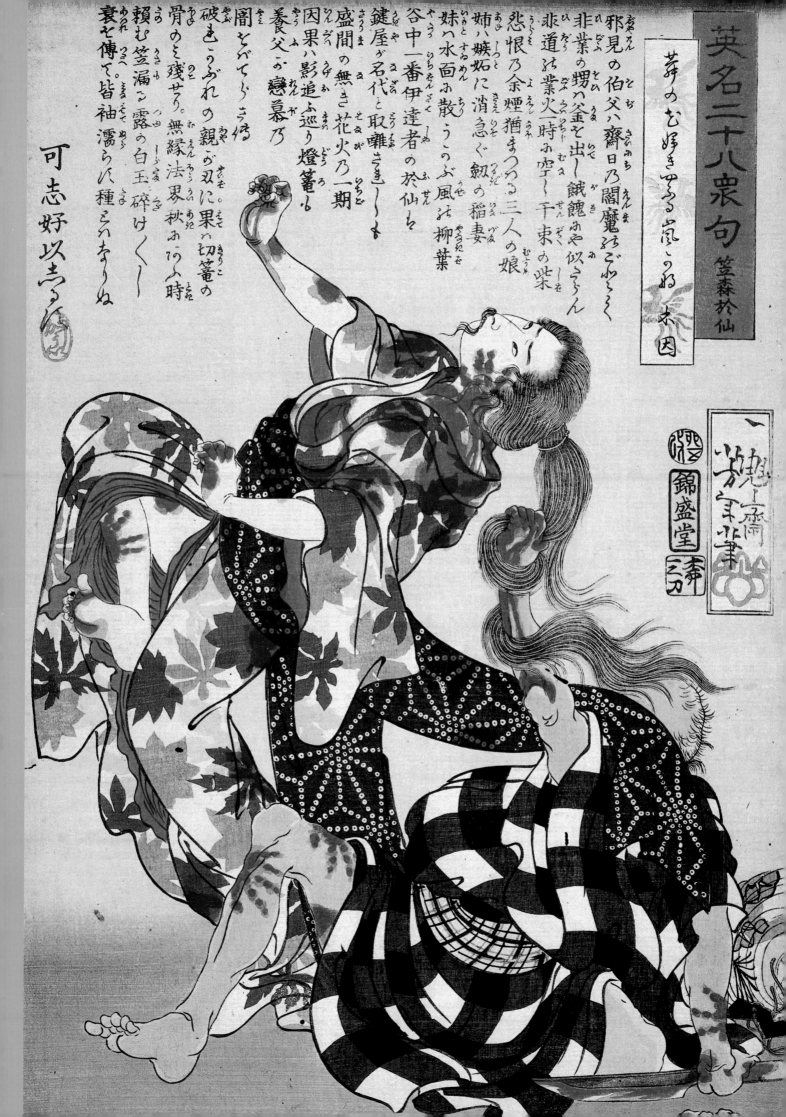

英名二十八衆句　笠森於仙

芽のむ好き坐る嵐いぬ　木因

一魁□□□□
芳年筆
錦盛堂□□

邪見の伯父ハ齋日乃闇魔ちぶふごく
非業の甥ハ釜を出し餓鬼みや似らん
非道ぬ業火一時ふ空ふ干束の柴
悲恨乃余煙猶まつる三人の娘
妹ハ水面ふ散うこのぶ風法柳葉
姉ハ嫉妬に消急ぐ劔の稲妻
谷中一番伊達者の於仙ち
鍵屋が名代と取離さし□し
盛間の無き花火乃一期
因果ハ影追ふ巡り燈篭も
養父ぬ戀慕乃
闇をわてちら□れ
破きこうぶれの親ぶ刃に果ふ切篭の
骨のを残せり。無縁法界秋ふわふ時
頼む笠漏ぬ露の白玉砕けく□
衰を傳で皆袖濡ら□種られまりぬ

可志好以志□□

trying to shock the viewer? Did he himself take a voyeuristic pleasure in this sort of thing, or were these subjects indicative of a special brand of decadence demanded by degenerate times? No matter how skillfully executed—alum and glue were even mixed into the blood pigments to give them a more realistic sheen—we balk at the sheer profusion of raw red gore. The closest Western parallel, Goya's *Disasters of War* (*Los Desastres de la Guerra*), an edition of outrageously morbid etchings on the atrocities of the 1810 Napoleonic invasions of Spain, proves less taxing on our eyes because it is in black and white.

Of course, Yoshitoshi was not alone in portraying unmitigated violence, nor was he the first. As far back as Japan's war-torn middle ages we find grotesque images in Buddhist hell scrolls and paintings of the Six Realms of rebirth. Initially these pictures carried strong moral overtones, warning nonbelievers of the unspeakable sufferings that would become their lot by karmic retribution. Eventually, artists began to depict such horrific subjects not with any didactic aim, but rather merely in pursuit of a certain macabre appeal or galvanizing intensity. Certainly Iwasa Matabei (1578–1650), who helped move Japanese painting away from the medieval in the direction of Ukiyo-e, chose in his *Scroll of Tokiwa in Yamanaka* (*Yamanaka Tokiwa Emaki*) to focus on the grim and ghoulish purely out of personal predilection.

In the Noh theater, pieces called *shuramono*, recounting the fall of a warrior into the ravages of the Realm of the Angry Demigods (*shuradō*) within the Six Realms, had tended as aesthetic visions to be quite solemn affairs. Then came Kabuki with its unpoeticized real-life action and its straightforward presentation of gruesome horror shows—often heightened with startlingly realistic special effects—which proved a powerful box-office draw. The taste of the times had shifted from quietist reflection to sensual thrill-seeking. By the end of the Edo period in mid-nineteenth century, audiences were clamoring for more and more grotesque chills.

In one play, for example, people looked on in captivated disbelief as the character Akechi Mitsuhide, assassin of warlord Oda Nobunaga, emerged from the shadows behind a gourd-vine trellis, spear under his arm, and without so much as a word ran his mother through as she relaxed in her bath. The event never really happened, but fictions of this sort were trumped up left and right to salt stories with a liberal dose of bloodshed. Theaters were filled to capacity with townsfolk who might jeer and catcall, but stayed all the same just to relish this extraordinarily charged atmosphere.

The excitement was contagious and spilled out everywhere—a *fin de siècle* fervor swept Edo society. Yoshitoshi, born right in the heart of the city in 1839, would have been familiar with Kabuki, illustrated storybooks, and color woodblock prints from an early age, and as a result thoroughly imbued with the spirit of the times.

Kabuki dramatist Tsuruya Namboku (1755–1829) and Kawatake Mokuami (1816–93), a later convert to Namboku's style, exerted considerable sway over the theater as a whole, making startling staging and fiendish excesses a must in the competition for public favor. Ukiyo-e soon followed suit, with artists capturing on paper the most blood-curdling scenes directly from the stage. Among the first to specifically focus on such chilling tales was Hokusai in his *One Hundred Ghost Stories* (*Hyaku Monogatari*) of around 1830. Few ac-

46. Yoshitoshi and Yoshiiku: *Twenty-eight Infamous Murders with Accompanying Verses* (complete series with pls. 5–9)

Yoshitoshi (page 38)

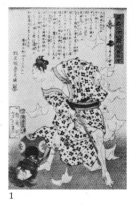
1

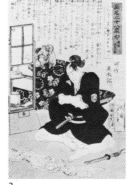
2

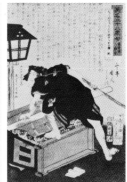
3

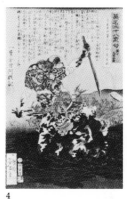
4

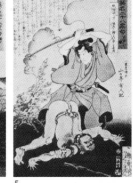
5

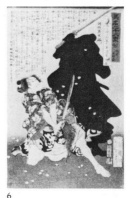
6

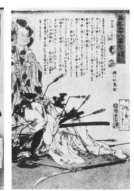
7

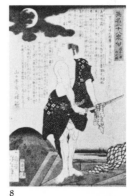
8

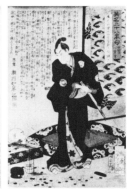
9

Yoshiiku (page 39)

10 11

12 13 14

15 16 17

18 19 20

21 22 23

tual prints of this series were pulled and survive today, but we do have one singularly gruesome image based on *The Tale of the Grinning Hannya* (*Warai Hannya*; fig. 44), which shows a horned *hannya* she-devil holding up the freshly decapitated head of a child, her blood-flecked mouth poised to devour it. Another, *The Tale of the Dish Mansion* (*Sarayashiki*; fig. 45), has the ghostly head of the servant girl Okiku slithering out of the well she haunted, trailing a broken set of dishes. Likewise, one look at Kunisada's actor prints of the same period confirms that stage productions in general aimed at increasingly grotesque effects.

Emerging from this background, Yoshitoshi's works merely took an existing trend of expression to its full conclusion. Or more precisely, as a witness to the times and with the benefit of many exemplary works by earlier artists, he found himself in a unique position to approach this art of blood and horror head-on. Yoshitoshi is known to have held Hokusai's art in high regard, and he naturally modeled many of his prints after those of his teacher Kuniyoshi as well.

Yoshitoshi's *Twenty-eight Murders* especially attest to his keen, sure eye for image and his thorough familiarity with the works of his predecessors. The resemblances are striking. Again, one of Yoshitoshi's *One Hundred Warriors* (pl. 10) holds up an enemy's head in allusion to Hokusai's *Grinning Hannya* (fig. 44), and his hair-raising paintings *An Apparition* (*Yūrei Zu*; pl. 67) and *A Severed Head* (*Sarashikubi Zu*; fig. 155) borrow freely from the works of Keisai Eisen (1790–1848).

Of course, it is Yoshitoshi's originality, his individuality while working in a traditional vein, that makes his renditions so vivid. All the same, we should not discount the distinctive *Zeitgeist* of that era. Yoshitoshi's art was not the product of today's emphasis on personal expression. This is not to belittle Yoshitoshi, for even today it would prove practically impossible to create a work of art so individualistic that it evidenced nothing of the character of the times.

The potential was obviously there, but what brought it to realization was the acute eye of a publisher, fixing on Yoshitoshi as a spokesman of sorts for troubled times. While Yoshitoshi's works were not entirely unprecedented, nor purely the result of spontaneous inspiration, they did possess a power and intensity far beyond the ordinary; it was precisely this that the publisher was astute enough to fathom. The publisher's role did not end there, however. For instance, take those pieces of Yoshitoshi's based on Kabuki plays in which we are presented with a bloody scene divested of any clue as to its theatrical origin, apparently indicating an overt preference on Yoshitoshi's part for cruelty over the element of acting. The decision to do this—to excise reminders of staging and present the scene as an actual event—seems to have originated with the publisher, not Yoshitoshi. Such was the subordinate position of the Ukiyo-e artist.

Yoshitoshi's production of blood-staunched images, an aesthetic reaction to a short-lived epoch, was limited to that disruptive period immediately before and after the Meiji Restoration of 1868. The glut of garish red disappears from his later oeuvre, leaving only a more understated eerie fascination with the occult. Yoshitoshi was not an artist to be transfixed for long by one means of expression; he moved on to fresher artistic forms, drawing ever closer to the innermost reaches of the human psyche.

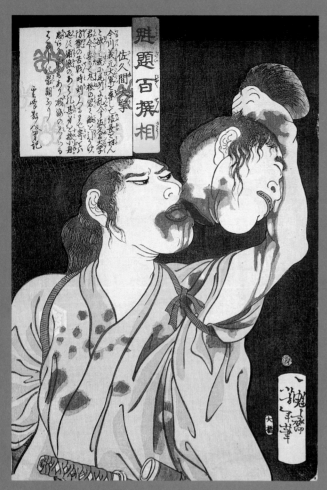

10. *Sakuma Daigaku Drinks His Enemy's Blood*

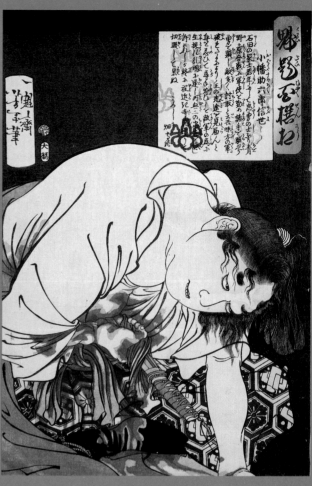

11. *Obata Sukerokurō Nobuyo Commits Harakiri*

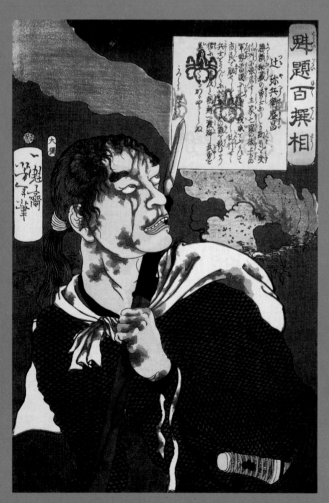

12. *Tsuji Yahyōe Morimasa Fights to the Last*

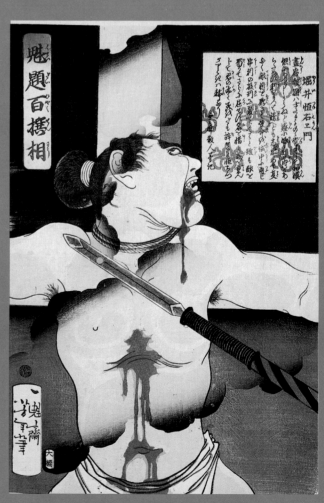

13. *Horii Tsuneemon Speared at the Stake*

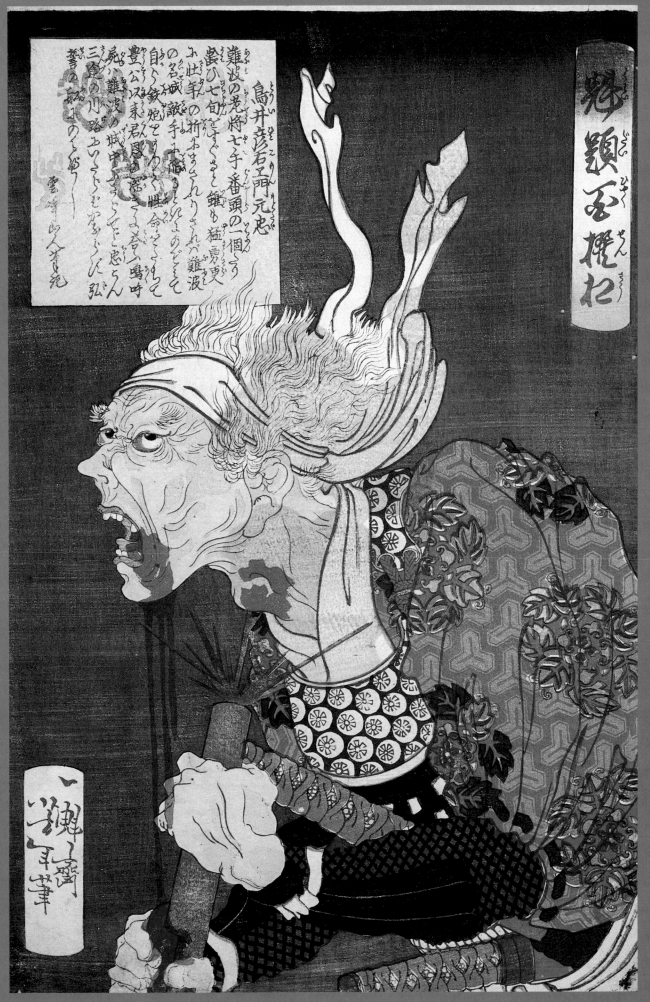

難波の老将七千番頭の一個とう
巖ひ七句ざぐる雖も猛霧更
ぶ壮年の折ふされりされ難波
の名城識手千福いのどこそ
自ら鉄炮とりの乱時
豊公は難波君恩に参忠ん
屍公難波の城中にを鳴時
三食の小路立へてトむをふふん弘
善の躯はのくぼう

鳥井彦右エ門元忠

14. *Torii Hikoemon Mototada Dies with Honor* Pls. 10–14: from *One Hundred Selections of Warriors in Battle*

TRANSITION TO THE MEIJI ERA

At the time of the Meiji Restoration of 1868, when Yoshitoshi was twenty-nine, the whole world of Ukiyo-e was coming on hard times. Most of the major names had died prior to the Meiji era, and some of the few able hands who were left, such as Yoshitora and Hiroshige II, had moved down to the port of Yokohama to ply their trade producing cheap woodblock prints for export.

Under the circumstances, the 1866–67 publication of Yoshitoshi's *Twenty-eight Murders* in collaboration with Yoshiiku proved a major event, springboarding them to instant fame. One account from the following year goes so far as to praise Yoshitoshi along with Yoshiiku and Kunichika as the "three great Ukiyo-e masters of the day." Then when the shogunate fell and full-scale fighting broke out, Yoshitoshi's initiative in eye-witnessing the scene of the 1868 Battle of Ueno boosted his career even further. The horrible blood bath still burning in his mind, he brought a sensational realism to his depictions of battle mutilations in his *One Hundred Warriors* of 1868–69. That year his standing climbed from tenth in 1865 to the fourth most popular artist after Sadahide, Yoshitora, and Yoshiiku.

Yoshitoshi thus made a name for himself in feeling out the pulse of the times and offering exceedingly graphic coverage of current events, but even he could get only so much mileage out of such material. Public interest declined, and so inevitably did his output. He tried a different tack, suddenly returning to the traditional Ukiyo-e theme of beautiful women in 1871 with a series entitled *Raving Beauties at Tokyo Restaurants* (*Tōkyō Ryōri Sukoburu Beppin*; figs. 47–48), but was unable to revive waning sales. Nor did *A Yoshitoshi Miscellany of Figures from Literature* (*Ikkai Zuihitsu*) of 1872–73 fare any better (pls. 15–18, figs. 49–51). From today's vantage point, it is obvious that he poured considerable energy into both series; hence their poor reception must have come as a formidable blow to the artist.

Utterly exhausted, at the end of his wits and funds, Yoshitoshi was reduced to prying up the floorboards of his rented house for fuel. Eventually stress and malnutrition took their toll, and he collapsed into an extended period of illness and unproductiveness. According to some accounts, he suffered a total nervous breakdown.

For the literati, artists, and performers who held over from the old order, the transition to a new way of life was difficult—especially from the year 1872 on, when the new Meiji government issued directives inculcating a sober reverence for Shintoism and nation, enforced fealty to the emperor, and even enlisted the services of professional story-tellers to spread the official word. Gone was the heyday of the Edo townsfolk and their lively culture in the gay quarter.

In little more than a decade after the Meiji Restoration, traditional Japanese pictorial art was plunged into a period of darkness. All the major schools of painting—Kanō, Tosa, Maruyama, and Shijō—experienced hardships and weakened. Ukiyo-e proved no exception to the rule. Only *nanga*, the so-called southern school of painting in Ming and Ch'ing Chinese styles, and Western-style painting boasted continued success. Meanwhile, scores of once-renowned artists desperately sought out other work—designing textile patterns for Yūzen stencil dyeing, for example, or producing cheap pictures for export. Some were on the verge of starvation.

Yoshitoshi was one of the few who was flexible enough

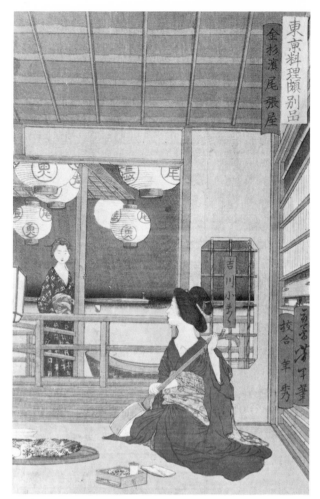

47. *Owariya*

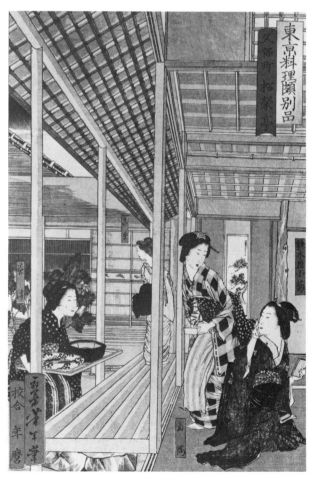

48. *Shōeitei*

42

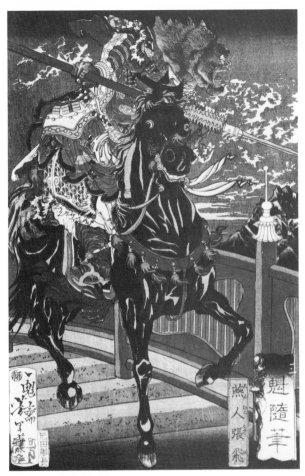

49. *Chang Fei Peiking*

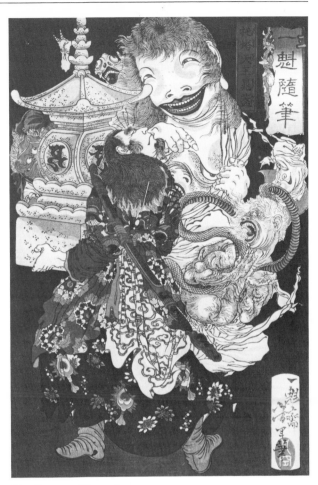

50. *Emperor Chaogai*

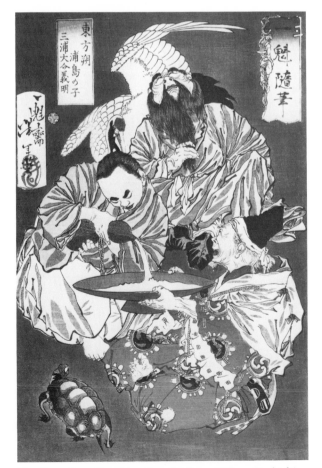

51. *Tung Fang Shu, Urashima Tarō, and Miura Yoshiaki*

to pull through this period, considerably battered but his creative energies intact. Dubbing himself Taiso ("Great Rebirth") after weathering his long spell of sickness, he set himself to work again, this time as a staff artist for the booming new newspaper industry. In 1875 Yoshitoshi was contracted by the *Postal News* (*Yūbin Hōchi Shimbun*) to produce full-color prints as special insert supplements for subscribers, in competition with Yoshiiku's own senior Yoshiiku, who worked for the *Tokyo Daily News* (*Tōkyō Nichinichi Shimbun*). Yoshitoshi's new works soon drew wide acclaim.

The lesson here for Ukiyo-e artists was "adapt or perish." Society's values and standards of taste were changing at an accelerated pace, and so too were the roles traditional arts could play. Ukiyo-e had always been a popular art form, functioning within late Edo-period society to provide images to satisfy the aesthetic urges of the townsfolk. These images generally belonged to one of five genres: beauties, actors, warriors, "bird-and-flower" nature vignettes, and landscapes. While all these genres persisted in one form or another on into the Meiji era, ever greater emphasis was placed on the element of popular appeal. Often this was achieved only at the lowest common denominator of taste—production-grade "pictures," but rarely "art." This trend had already begun by the last years of the Edo period; by the first decade of Meiji the impoverished state of the art was all too apparent.

In Yoshitoshi's case, he had devoted himself almost ex-

43

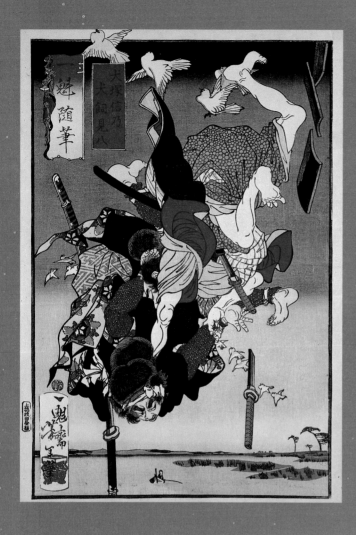

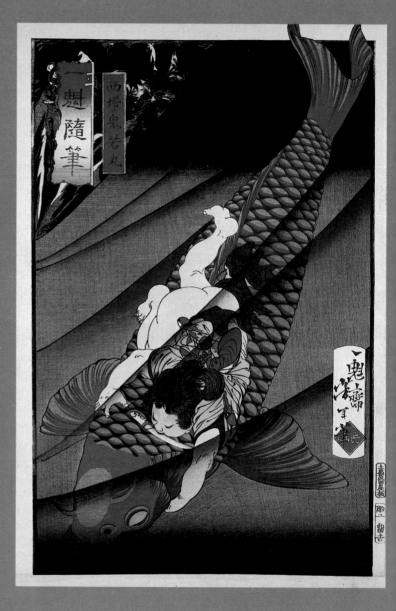

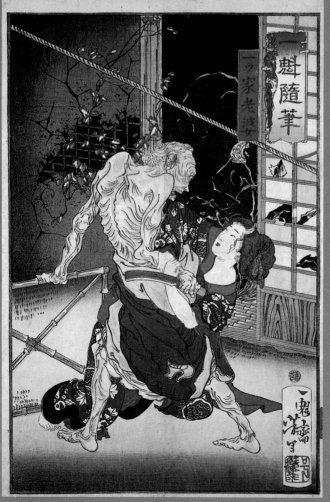

15. *Inuzuka Shino and Inukai Gempachi*
16. *The Hag of Asajigahara*
17. *Oniwaka Seeks Revenge on the Great Carp*
18. *Lady Yodo*

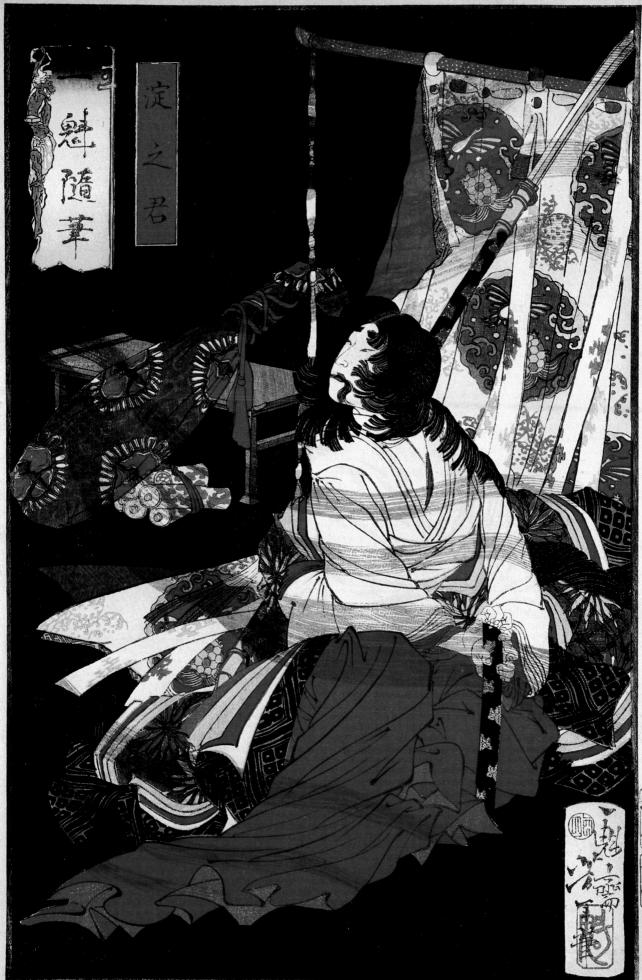

淀之君

魁随筆

45

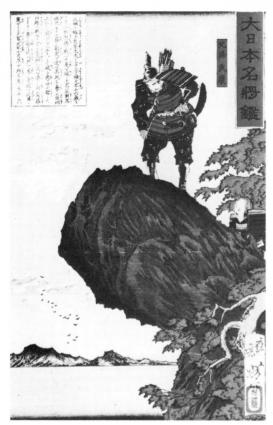

52. *Hōjō Ujiyasu*

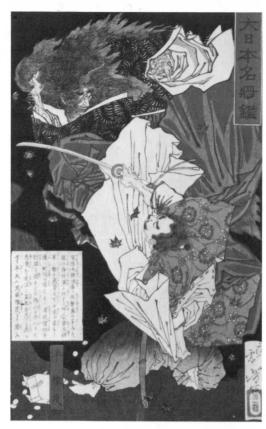

53. *Taira no Koremochi*

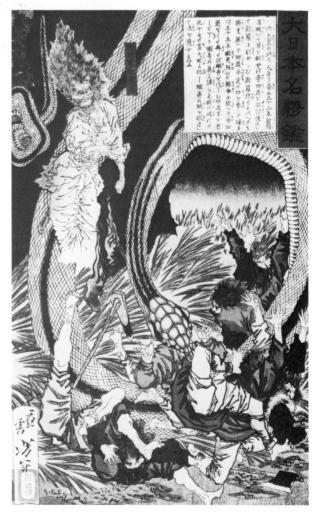

54. *The Ghost of General Tamichi*

clusively to warrior prints until the very outset of the Meiji era, much in line with his original training under Kuniyoshi. Never especially interested in actor prints, what few he did produce veered sharply away from the norm, seeming more a variation upon the warrior theme, or even taking on something of the hallucinatory quality of nightmarish fantasy. The crowning achievements of his early period, the *Twenty-eight Murders*, for instance, are essentially actor prints without a stage. In Yoshitoshi's hands, they become pure depictions of actual historical events. It was this quality, his ability to take material from whatever source or combination of sources and fuse it into scenes of momentous visual immediacy, that captured the imagination of the new era.

He became the public eyes on the fighting of the Meiji Restoration and subsequent Satsuma Rebellion. Truly a trailblazer, he put himself out on the front line of the art world as Japan's first popular illustrator in the modern sense of the word. He was definitely developing his potential, while all around his contemporaries fell by the wayside, held down by their own lack of innovation. Perhaps Kuniyoshi had had an inkling of this potential when he granted Yoshitoshi the secondary name Ikkaisai, "One-Head Studio," for now Yoshitoshi clearly found himself one head out in front of the rest. So by the time the world of Ukiyo-e experienced a revival ten years into the Meiji period, Yoshitoshi was riding this crest of popularity. His *Mirror of Famous Generals of Japan (Dainippon Meishō Kan)* of 1878–82 enjoyed unprecedented sales (pls. 19, figs. 52–54), and Yoshitoshi followed this up, in a burst of prolific activity, with prints in the conventional categories of warriors and historical figures as well as an admixture of fresh works on current topics.

19. *Saohime Perishes in Flames*

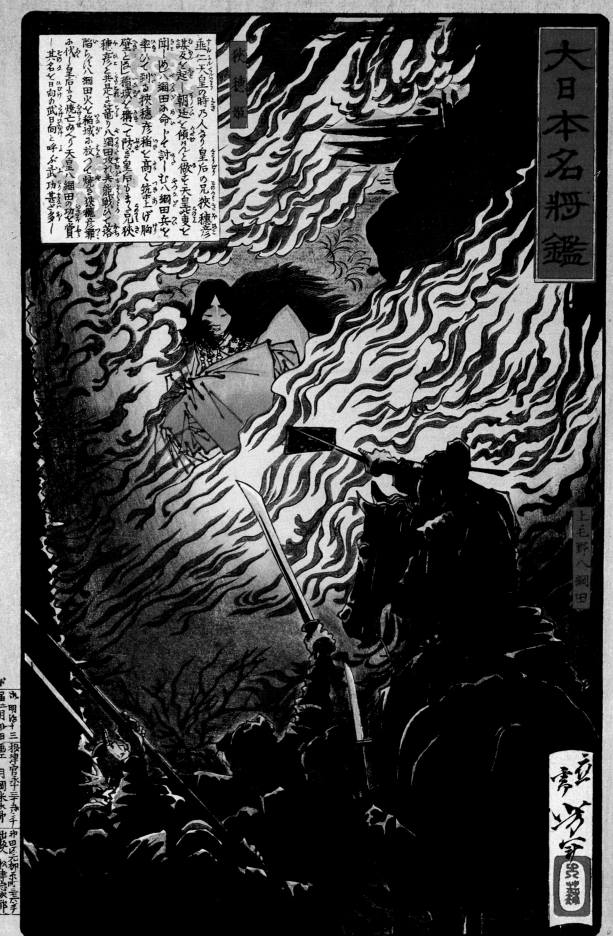

狭穂姫

大日本名將鑑

上毛野八綱田

A CAREER IN NEWSPAPER ILLUSTRATION

The *Postal News* had been in existence for a little over two years since its first issue of June 1872 when the *Tokyo Daily News* began publication, and the pressures of competition quickly escalated. The latter had initiated the practice of including in its issues full-color prints by Yoshiiku (fig. 55), so that as of April 1875 the *Postal News* felt compelled to take on Yoshitoshi as a countermeasure (pl. 21, fig. 56).

Both artists were extremely popular at the time, figuring along with Kunichika as the "three masters of Meiji Ukiyo-e" noted previously. This was despite Yoshitoshi's relative youth, six years Yoshiiku's junior, a fact that irked Yoshiiku no end. Their rivalry was no secret, having begun back in the days of their joint apprenticeship under Kuniyoshi, when Yoshiiku by rights lorded it over the younger Yoshitoshi. In one especially famous episode, when Kuniyoshi died and both students were in attendance at his funeral, Yoshiiku flew into a rage and kicked Yoshitoshi, accusing him of blocking his way. Now working for rival newspapers, the two had picked up where they let off when matching their skills in the coproduction of print designs for the 1866–67 *Twenty-eight Murders* series.

Yoshitoshi's own disciple Yamanaka Kodō writes that in later years, when Yoshiiku was far overshadowed by his younger rival's brilliant success and forced to imitate and even outright copy his prints, Yoshitoshi happened to remark to someone, "At last the shame of days past has been cleared away." All the same, the rift between the two was not so great that it prevented Yoshiiku from going to Yoshitoshi's house to offer condolences upon the occasion of his death.

The turning point in their respective fortunes occurred somewhere in the course of their neck-and-neck newspaper race, for although Yoshiiku had been the first choice when the *Tokyo Daily* looked around for an illustrator, in the end it was Yoshitoshi who came out ahead. With the publication of his numerous reportage illustrations on the fighting in Satsuma in 1877 and his *Mirror of Famous Generals* series of the following year, Yoshitoshi's sales far eclipsed those of his senior.

Their rise and fall in fame can be clearly plotted in retrospect, but as of 1878 Yoshiiku was still in the running, an active contributor and shareholder in the *Tokyo Illustrated Newspaper* (*Tōkyō E-iri Shimbun*; fig. 57). In 1880, this journal would be the most widely read in Japan, with a circulation of 25,000 copies.

Around that same time, Yoshitoshi was for his part doing artwork fairly regularly for the *Illustrated Liberal Newspaper* (*E-iri Jiyū Shimbun*; fig. 58). While this might seem to reestablish the opposition between the two artists on rival papers, the journals themselves cannot be compared in terms of either readership or editorial character.

The *Tokyo Illustrated* was a self-styled populist herald of the "coming new era of enlightenment," an image boldly projected in the front page copper-type emblem of three cherubs busy at a printing press flanked by a globe, telescope, plastercast statue, palette and easel, all surmounted by a Western-style horizontally lettered title. The paper included generous proportions of material of popular appeal as well as a good deal that was uplifting and, at least on the surface, novel as well. By contrast, the *Illustrated Liberal* was a broadsheet for the Liberal Party, newly formed under Meiji parliamentary government.

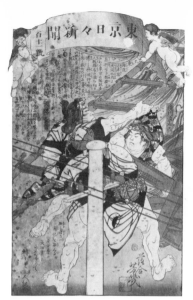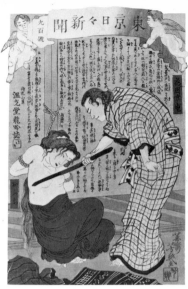

55. Yoshiiku: *Tokyo Daily News* prints

56. *Postal News* prints

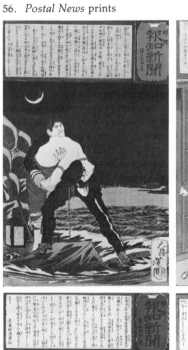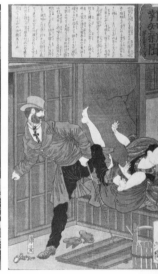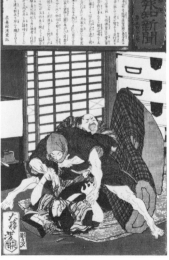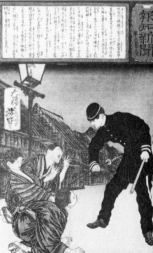

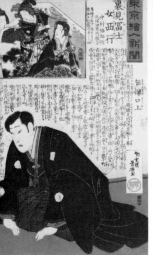

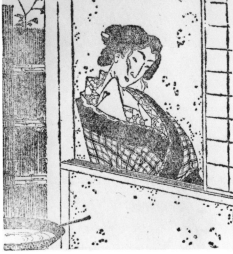

57. Yoshiiku: *Tokyo Illustrated Newspaper* print

59. *Lamp of Liberty* print

58. *Illustrated Liberal Newspaper* print

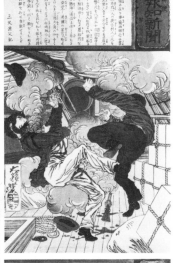

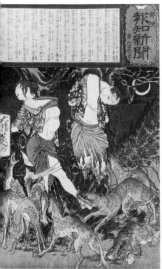

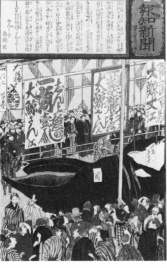

Nonetheless, Yoshitoshi's involvement with the *Illustrated Liberal* should not be construed as a political conversion. Yoshitoshi, who had originally looked askance at Yoshiiku's alignment with the *Tokyo Illustrated*, was approached through an apprentice named Yoshimune with the appeal that only Yoshitoshi's topical illustrations could make the organ of the Liberal Party at all salable. Contract conditions were more than reasonable: a salary of 40 yen a month, a tidy sum in those days, plus transportation to and from the editorial offices in a pedicab bearing the Tsukioka family crest. Later, the stipend was to rise to 100 yen a month, with twenty shares of stock and a *jinrikisha* into the bargain.

Yoshitoshi, of course, did not refuse the offer. Furthermore, aside from his stint with the *Postal News*, he had also done illustrations for the first issues of two other newspapers—the *Masago Shimbun* in 1878 and the *Iroha Shimbun* in 1879—so we know he did not object to newspaper work as such. Rather, his critical attitude toward Yoshiiku must have simply been a sour-grapes reaction to the latter's growing entrepreneurial success. Newspaper work meant more money than could ever be made through print sales alone: there was no way around it.

Around 1878 Yoshitoshi's typical commission for designing a triptych was a mere 3 1/2 yen, or 5 yen sometime later. For the series generally considered the triumph of his last years, *One Hundred Aspects of the Moon* (*Tsuki no Hyakushi*), his fame as an Ukiyo-e master still brought him barely 10 yen a design. Only newspapers could afford to pay him what he felt his art was worth.

Capable of driving a hard bargain when he wanted to, Yoshitoshi stubbornly refused, Yamanaka Kodō writes, to come down to a lesser figure when the subject of his high wages came up at an editorial budget meeting. He was indispensable to the newspaper, and he knew it.

Yet there was more to Yoshitoshi's career in newspaper illustration than can be explained by mere monetary concerns. If we consider the Meiji government's suppressive policies toward journalism in general, the act of drawing illustrations for newspapers must have been motivated by more than a simple business proposition or outright opportunism. Some risk was involved, especially after the introduction of the stringent 1873 Newspaper Act and the 1875 Newspaper Act–Slander Ordinance, then the Ministry of Home Affairs' order of 1880 prohibiting newspapers, magazines, and other printed matter from hindering the welfare of the polity or instigating moral unrest under penalty of seizure or termination. In particular, after the institution in 1881 of a formal system whereby all publications had to be submitted to a review board for approval, Yoshitoshi's involvement with the *Illustrated Liberal*, the newspaper of a political party set up that same year expressly to address criticisms at the government, was tantamount to conspiracy. He must have had reasons other than mere monetary compensation for partaking in such an enterprise.

This becomes clear in light of a remark Yoshitoshi made in 1884. That year an offshoot of the *Illustrated Liberal*, a new journal called the *Lamp of Liberty* (*Jiyūtō*) was established in affiliation with left-wing elements that broke away from the Liberal Party. At this time Yoshitoshi flatly stated, "Fine, just let me do the pictures and I'll make it sell." As it turned out, Yoshitoshi's art did prove the mainstay of the *Lamp* (fig. 59), and the articles appearing therein subsidiary. Indeed, Yoshitoshi's efforts were essential to the paper's success.

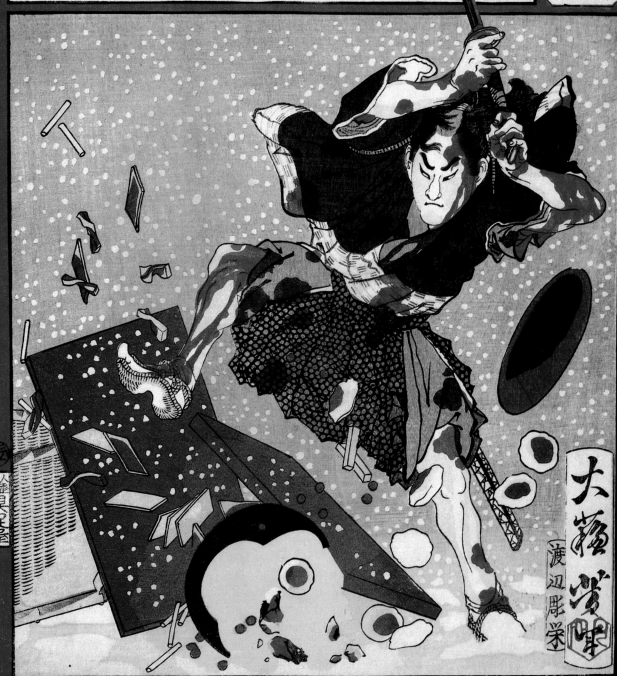

廣瀬數馬

廣瀬氏ハ彦根中将殿の愛臣にして小性役を勤め食禄て小性役を勤め食禄

二百石を領せ其生来温和にして志あつく武術ふ達しうり此

人常の言語ふ凡士族なるもの坐

食らして四民の上に立ハ主恩乃深

浅富巌蒼海ましたると、、ぢうて

凶ぞ禱るにあり祢ば君主一大事ね

時ふのぞみ假染る一歩も跡へ引じ

さいそう為言そうらべ弥生の幽護紅雪

散ハ桜田に無双の血戦死を完ぬ

その忠名を亀鑑に残せり

應需

松林伯圓記

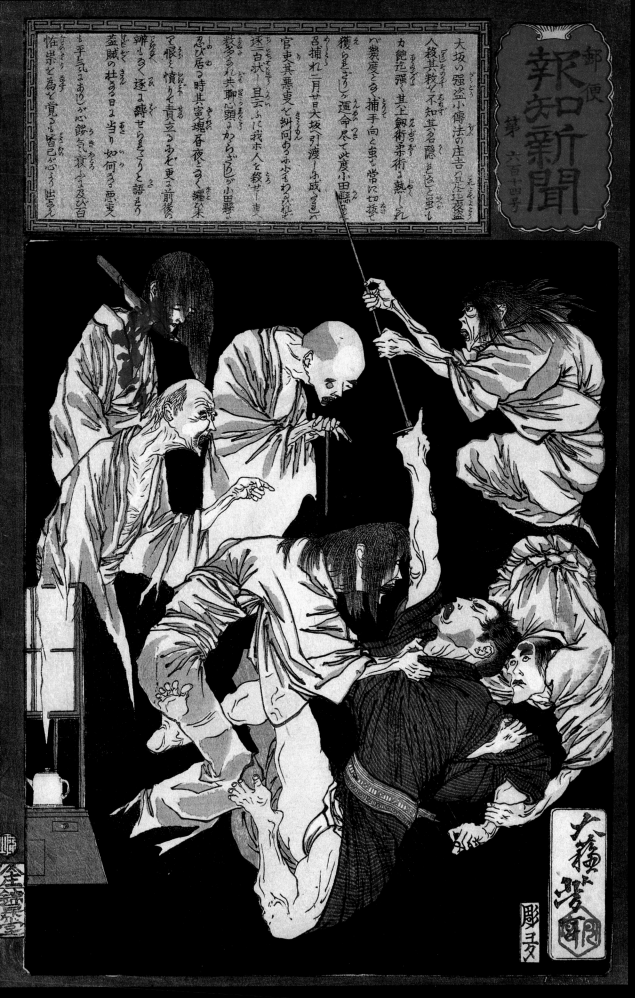

21. *Shōdembō no Shōkichi, the Thief: Postal News newspaper*

Ordinarily we think of Ukiyo-e artists as apolitical. No matter how much of a stir their prints created, the personal philosophy of even the most prominent artists remains sketchy. Their political leanings, needless to say, are almost entirely inapprehensible. Of course, the feudal authority of the Edo-period shogunate hardly encouraged isolated individuals to assume a critical stance. Occasionally artists such as Yoshitoshi's own teacher Kuniyoshi might come out with a piece of sharply honed satire, but even so he could not afford to reject the entire power structure. Thus, granted that Yoshitoshi's apprentice Yoshimune had political ties and so elicited a personal favor on behalf of the *Illustrated Liberal*, the extent to which Yoshitoshi got himself involved in political art was still exceptional, to say the least.

An interesting serial work of 1878, *Beauties of the Seven Nights* (*Mitate Shichi Yōsei*), comes to mind in this connection (pl. 22, figs. 66–71). This grouping of seven prints depicted different imperial ladies-in-waiting for each day of the week. Stylistically and thematically related to pre-Meiji pictures of court life romanticized to echo the classical *Tale of Genji*, the series insinuated that relations existed between these women—some listed specifically by name—and the emperor himself. It was extremely topical, to say the least. In one print in particular (pl. 22), the rather risqué image of Lady Yanagihara Aiko about to extinguish a lamp before retiring to the emperor's chamber would have been sufficiently suggestive by Meiji standards to be read as an accusation of loose morals within the imperial system. This was not one's usual risqué picture, nor did it fail to arouse its share of controversy.

Needless to say, the imperial household was little amused by pictures depicting the figure of the emperor constantly surrounded by a bevy of desirable women, and in 1882 print publishers and heads of associated unions nationwide were called in to receive a stern official warning that "neither the marketing of printed, oil-painted or sculpted images of Their Sacred Imperial Majesties, nor the public sale of like illustrated books etc., would be tolerated" (from an article in the *Tokyo Daily News*). Thereafter, the subject of the emperor promptly vanished from Ukiyo-e prints. Historically, this corresponds exactly to the period when the emperor was making frequent tours of various localities throughout the nation to bolster imperial prestige. Hence Yoshitoshi's willingness to participate in the publication of politically problematic newspapers around this time must indicate something of an antiauthoritarian streak in him.

Whatever Yoshitoshi's reasons for doing newspaper work, by the mid-1880s his position was secure enough that he could afford to devote greater attention to his own creations, and so take on fewer and fewer illustration assignments. His last major involvement with a newspaper was undertaken more out of a sense of obligation to friends than anything else. Between the years of 1886 and 1888 Yoshitoshi contributed illustrations to the *Yamato Shimbun* (fig. 60) for the humorous yarns spun by his long-time friend, comic *rakugo* performer Sanyūtei Enchō (1839–1900), as well as a series of twenty especially fine portrait prints, *Personalities of Recent Times* (*Kinsei Jimbutsu Shi*), for monthly distribution to subscribers (pls. 23–25, figs. 62–65). By then, with the artist's style fully developed and his work in great demand, this presented a rare opportunity for the public to obtain a complete series of his prints as a giveaway. Meanwhile, Yoshitoshi had already gone on to bigger and better things.

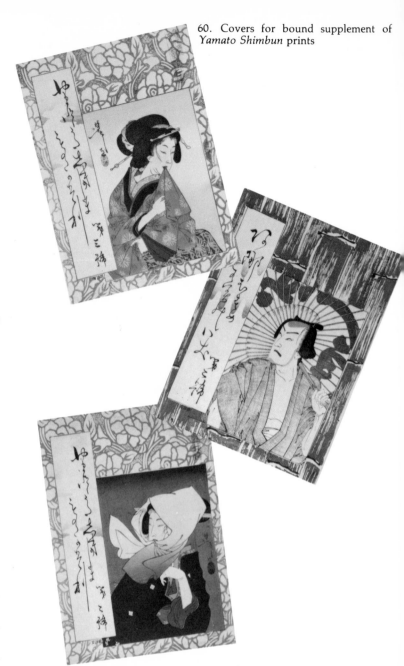

60. Covers for bound supplement of *Yamato Shimbun* prints

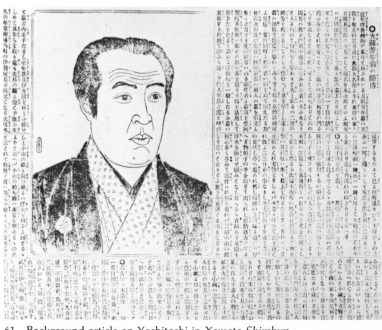

61. Background article on Yoshitoshi in *Yamato Shimbun*

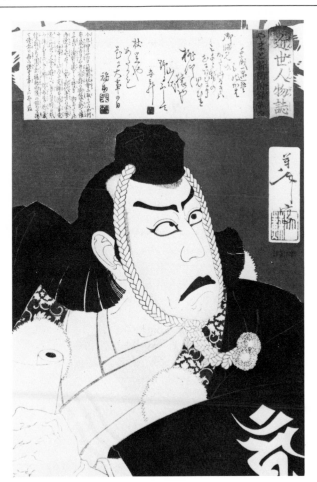

62. *Princess Tokugawa Yō*

63. *Ichikawa Danjūrō IX as Benkei*

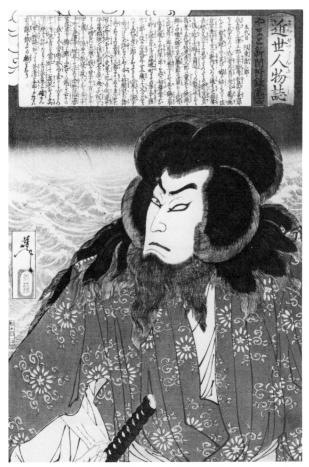

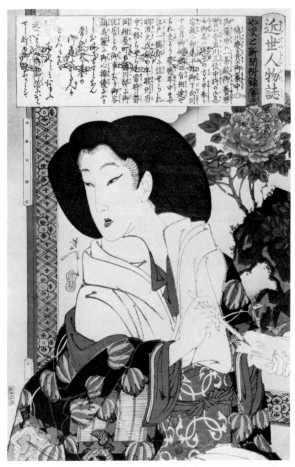

64. *Bandō Hikosaburō V*

65. *Lady Tokugawa Keiki (Yoshinobu)*

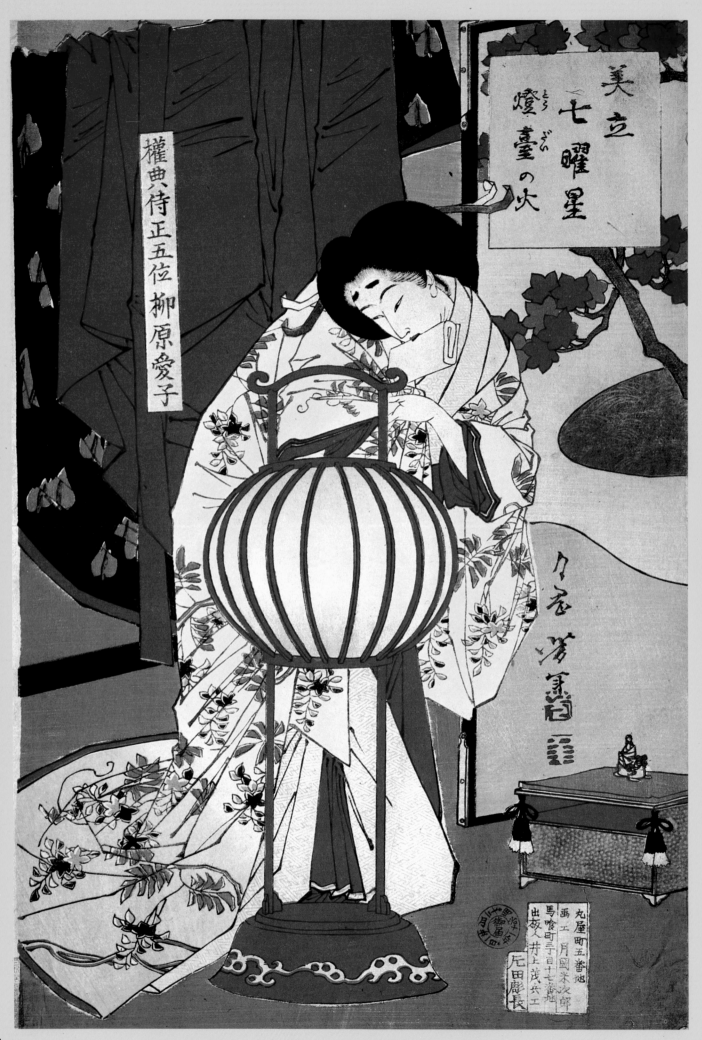

22. *The Lantern Light*

Pl. 22 and figs. 66–71: complete *Beauties of the Seven Nights*

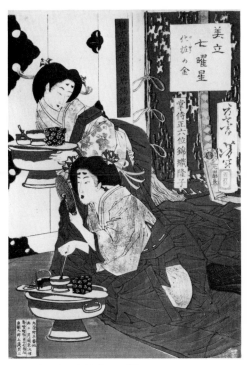

66. *The Metal Makeup Mirror*

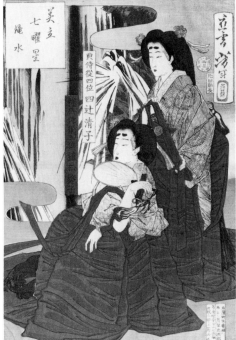

67. *The Waterfall*

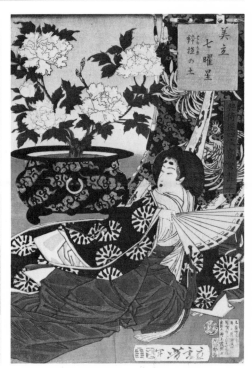

68. *The Potted Plant Soil*

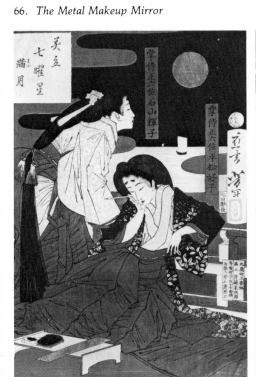

69. *The Full Moon*

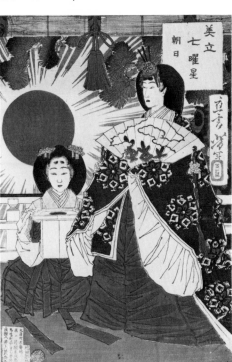

70. *The Morning Sun*

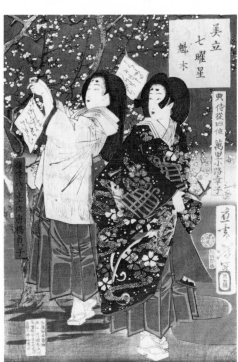

71. *The Decorated Tree*

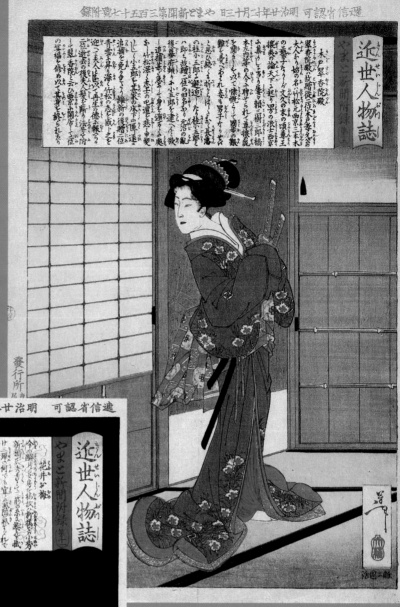

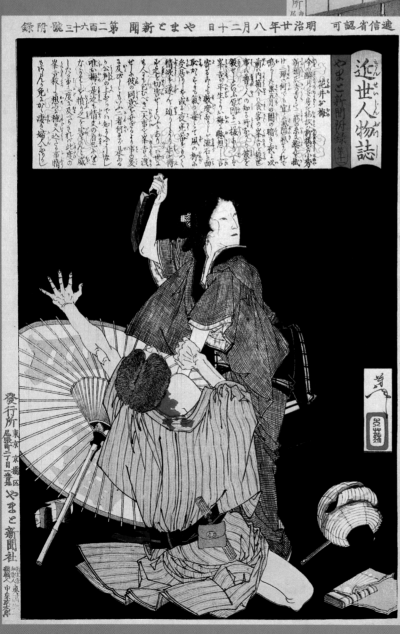

23. *Hanai Oume Kills Kamekichi*
24. *Lady Kido Suikōinden*
25. *Muraoka, Head Lady-in-waiting of the Konoe Clan*

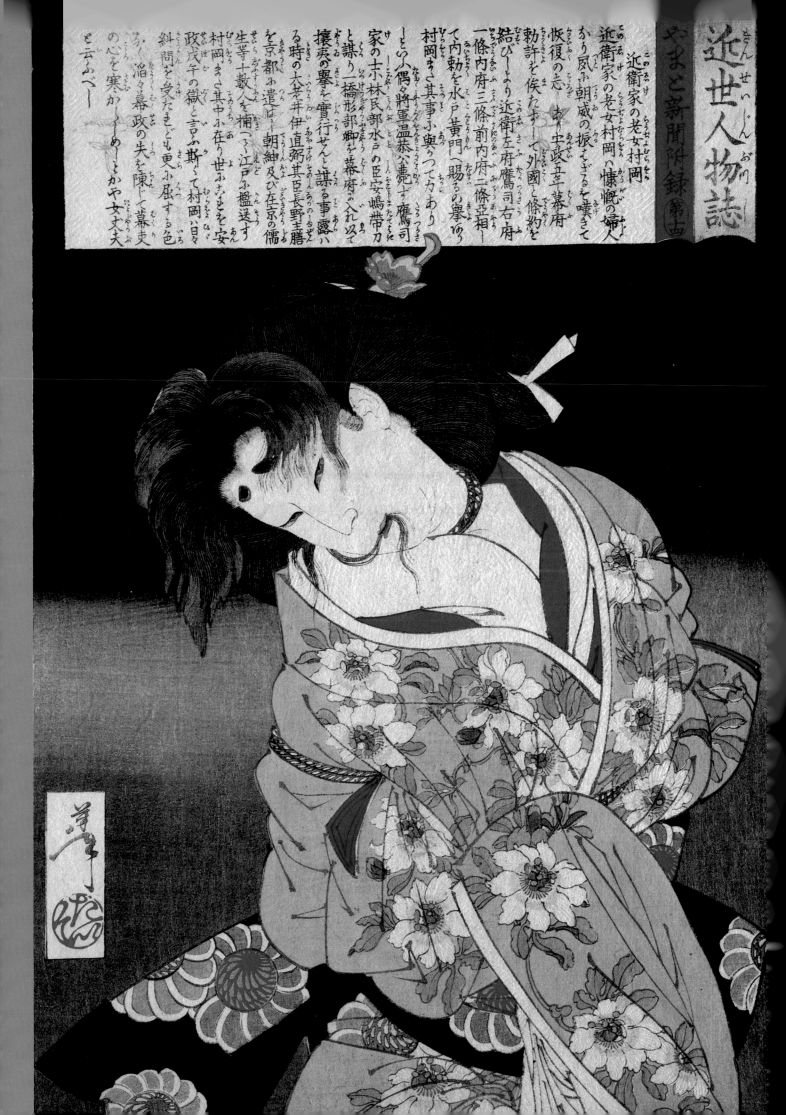

近衛家の老女村岡

この老女村岡は慷慨の婦人
にして近衛家の老女村岡
あり風の朝威の振はざるを嘆きて
恢復の志あり安政五年幕府
勅許を俟たずして外國と條約を
結びしより近衛左府鷹司右府相
一條内府三條前内府二條並相
て内勅を水戸黄門に賜るの擧ゆ
村岡も其事に小與かつて力あり
しと小偶々將軍温恭公薨ず鷹司
家の小林民部水戸の臣安嶋帶刀
と謀り一橋刑部卿を幕府へ入れ以て
攘夷の擧を實行せんと謀る事露は
る時の大老井伊直弼其臣長野主膳
を京都へ遣はし一朝紳及び在京の儒
生等十數人を捕へ江戸へ小檻送す
村岡まで其中小在りしとを安
政戊午の獄と言ふ斯て村岡は日々
絲問を受たれども更ふ屈する色
なく滔々幕政の失を陳じて幕吏
の心を寒からしめけりよかや女丈夫
と云ふべし

Fig. 72 and pls. 26–30: from *One Hundred Aspects of the Moon*

Yoshitoshi began his career in the warrior print genre he inherited from Kuniyoshi, then charged his brush with blood when the perilous passage into the Meiji era wrought widespread havoc, and eventually changed directions again as society settled into a new way of life. Moving into new areas of expression, his artistic manner became lighter, more tastefully orchestrated and pleasing to the eye. For subjects, he turned his attention to recent historical events, pictorializations from legend, and the persons, incidents, and changing styles of contemporary society.

In his newspaper illustrations for the *Postal News* he often had to depict newsworthy but brutalizing scenes taken from the current events of the day, and this had kept him tied to his old pictorial style. But from the time of his *Yamato Shimbun* illustration work, subjects unrelated to the dark side of the news allowed him to ease into what was to become his mature style. There was a sureness and resonant subtlety to these new works, announcing that he had "arrived." It did not go unnoticed, for in the 1885 edition of *Tokyo Vogues in Detail* (*Tōkyō Ryūkō Saikenki*) he was ranked first in the field of Ukiyo-e.

In 1884 Yoshitoshi hit full stride, indicated by the fact that he had over eighty apprentices studying under him. By 1885, he had conceived and begun working on some of his most ambitious and artistically satisfying works: the monumental series *One Hundred Aspects of the Moon* (*Tsuki no Hyakushi*; pls. 26–30, fig. 72), the two diptych series *A Yoshitoshi Storybook* (*Yoshitoshi Manga*; pls. 31–32, fig. 73) and *Newly Selected Edo Color Prints* (*Shinsen Azuma Nishiki-e*; pls. 33–37, figs. 74–85), and the highly novel vertical diptychs that Tokyo painter Kaburagi Kiyokata (1878–1973), third generation in the Yoshitoshi line, praised as "the most polished and absolutely perfect works Yoshitoshi ever did" (pls. 38–42, 49–50, figs. 86–93).

Even the most casual viewer could see these new works were of astonishing artistic refinement. A beautiful "rightness" harmonized all pictorial elements. Yoshitoshi made the pictures look so natural, so free from contrived effects, that they achieved a feather-light buoyancy, a certain graceful quietude—the very opposite of his earlier works. Understandably, then, there have been those who have pointed to this as evidence of a radical shift in his thinking. But marked as the change is, beneath the tranquil surface of *One Hundred Aspects of the Moon* we still sense a strangely charged ether. This undercurrent would intensify as time went on, until ultimately it would issue forth completely unmasked in his series *Selected New Forms of Thirty-six Ghosts* (*Shingata Sanjūrokkaisen*) just before he died (pls. 43–48, fig. 94).

The title of this last series tells all: *shingata*, "new forms," which can also be pronounced *shinkei*, plays on the word for "nerves," hinting at the turbulent underside of the apparent calm at this point. For despite appearances, his nervous illness of the early 1870s had not been laid to rest. At the end of his days it would resurface with a vengeance.

In attempting to discuss this period in Yoshitoshi's career, we must carefully weigh his position as a link to the past with that of his role as an innovator within the Ukiyo-e tradition. For it was his chosen path to walk that fine line between the old and the new. Conservative in the best meaning of the word, he sought to preserve what was good about the heri-

72. Prints from *One Hundred Aspects of the Moon*

1

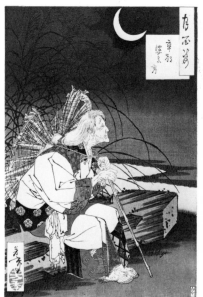

2

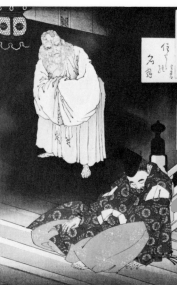

3

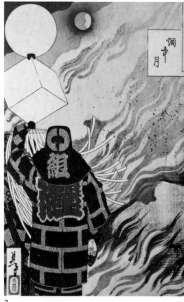

4

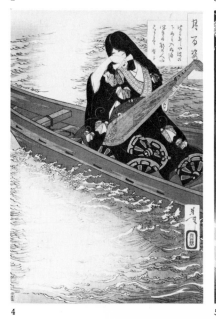

5

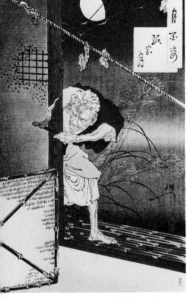

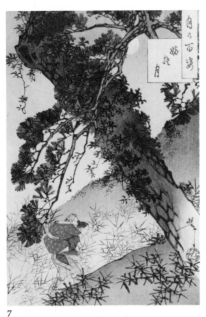

7

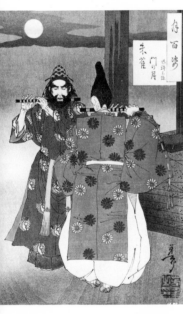

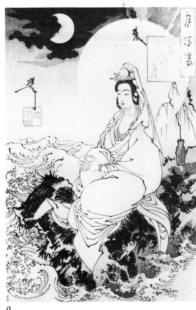

9

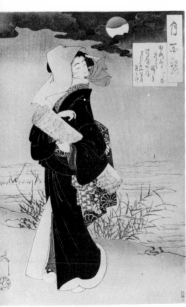

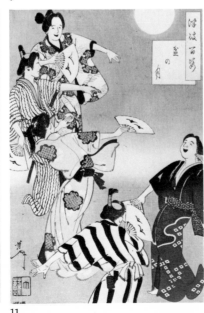

11

tage he had apprenticed into, while at the same time selectively and adaptively augmenting it with some of the better things from other traditions. Progressive where it counted, he labored to conserve his own tradition by keeping it alive.

Nowhere was this delicate balance more precisely attuned than in the works of this, his period of artistic maturity. Obviously still belonging to Ukiyo-e, they strike us immediately as *different* from anything else we have ever seen in the art. By this point in his career, he had honed his skills to razor-sharp perfection.

The other side of the picture is, of course, that he never quite fit in with his contemporaries. Often this came across as a perverse stubbornness. He would give society what it wanted—but only up to a point. And in straying from expectations, he sometimes encountered disapproval from the authorities. His 1885 vertical diptych *The Hag of Adachigahara* (*Ōshū Adachigahara Hitotsuya no Zu*; pl. 49), for instance, was suppressed because of its gruesome subject. Or again in the same year, another vertical diptych, *Genji in the Provinces* (*Inaka Genji*; pl. 50), which was inspired by a Mokuami play, was considered immoral for straightforwardly depicting a man and woman traveling together without making any attempt to disguise their intimacy; this was likewise suppressed. Yoshitoshi obviously stood out just a bit too much from the run of conventional Ukiyo-e artists who were content to merely follow trends. Unlike them, Yoshitoshi strongly believed in the vital, topical potential of Ukiyo-e, even amidst Meiji modernization.

Yoshitoshi dared to be different. If not daring politically, then always aesthetically and morally, as these two prints show. Yoshitoshi was ever pushing himself to the limit, ever walking a fine line, and this was ultimately to prove his undoing. There is no other explanation for his final relapse into delirium, just as he appeared to be at the high point in his career. He was not only respected by all as the ablest proponent of Ukiyo-e, but was managing his affairs with total competence. And yet, somewhere inside him, the pressure was mounting.

In one sense, Yoshitoshi's character bore the indelible stamp of the boisterous Edo culture. He worked hard and played hard, and the rigid conformity demanded under Meiji authoritarianism went against the grain. He was impulsive and outspoken, thinking nothing of making a nuisance of himself in the eyes of officialdom. Incapable of blind obedience, his forbearance could be pushed only so far before it sprang back with resilient perversity. Who else but Yoshitoshi would have thought of taking a critical look at the sex life of the emperor? What other Ukiyo-e artist would have dared?

By this point in his career, Yoshitoshi was producing art of such quality it claimed a place in the history of the times, challenging as it did the prim self-righteousness of Meiji bureaucrats. There is every reason to believe Yoshitoshi was fully aware of both factors, the aesthetic and the moral, in making himself someone to be reckoned with, though in the end it cost him all his reserves of energy. This is not to suggest that the risks he took in his art were calculated to create a "Yoshitoshi legend," nor that he set out to become a martyr to the cause of Ukiyo-e. Nonetheless, we do get a picture of his intense drive to succeed at all costs, the courage it took to maintain an independent stance in the face of ever increasing regimentation under the banner of Westernization.

From around the middle 1880s, when Yoshitoshi entered

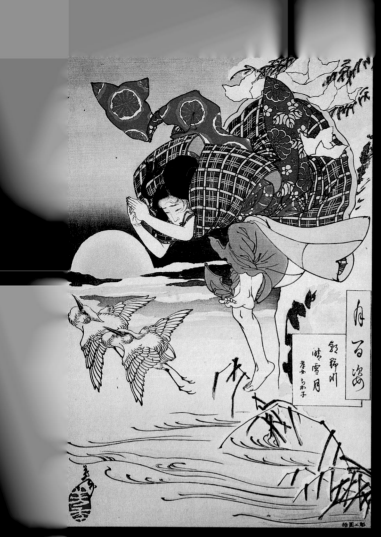

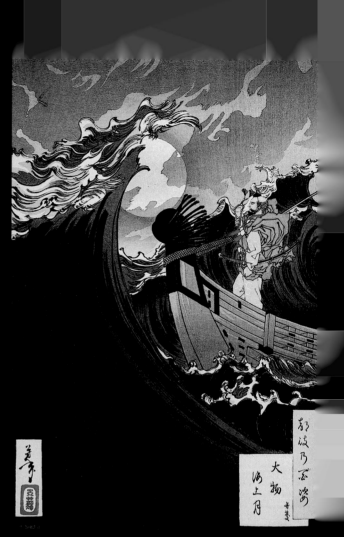

26. *Filial Chikako Dives into the Snowy Asano River*

27. *Benkei Calms Daimotsu Bay by Moonlight*

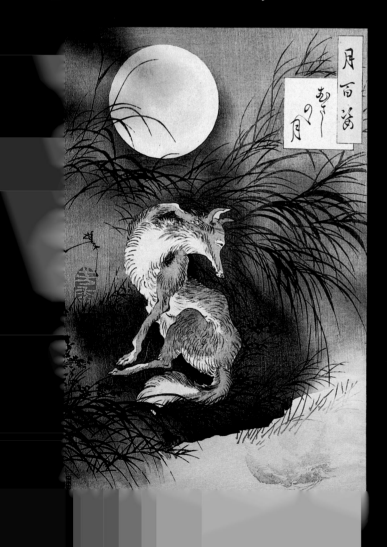

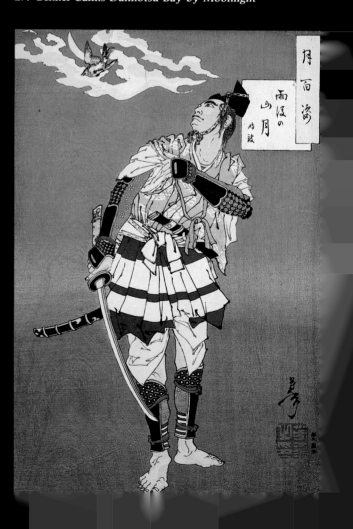

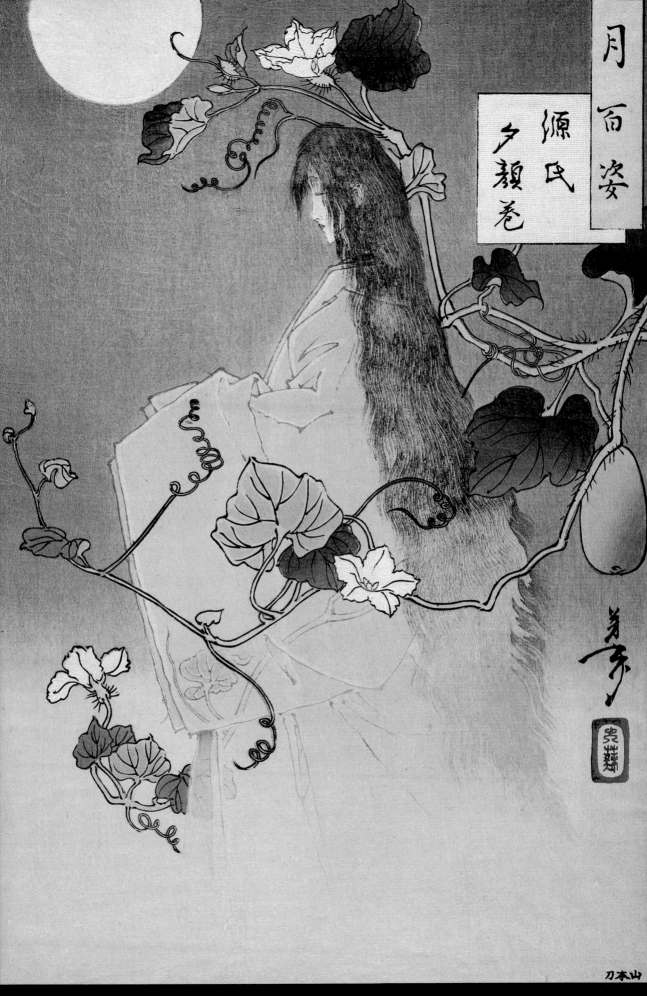

30. *The Ghost of Genji's Lover, Yūgao*

this period of peak production, the effort he devoted to his artwork can only be described as superhuman. Yet, at least until his final collapse, the returns on this burst of energy were equally amazing. The more he drove himself, the more his imagination took flight. Witness the progression from *The Other Murasaki with Genji in the Provinces* (*Nise Murasaki Inaka Genji;* pl. 52) of 1882, to *Fujiwara no Yasumasa Plays the Flute beneath the Moon* (*Fujiwara no Yasumasa Gekka Rōteki Zu;* see foldout) and *Taira no Kiyomori Burns with Fever* (*Taira no Kiyomori Hi no Yamai no Zu;* see title page) and *Umewaka and the Child Seller* (*Azuma Meisho Sumidagawa Umewaka no Furugoto;* pl. 52) of 1883, then on to the triumphs of 1885, the vast *One Hundred Aspects of the Moon* (pls. 26–30, fig. 72), *Newly Selected Edo Color Prints* (pls. 33–37, figs. 74–85), the horizontal diptych *Saint Nichiren Saves the Cormorant Fisherman* (*Nichiren Shōnin Isawagawa nite Ukai no Meikon o Saido Shitamau Zu;* pl. 53) and the vertical diptychs *The Hag of Adachigahara* (pl. 49) and *Two Valiants in Combat atop the Hōryūkaku Pavilion* (*Hōryūkaku Ryōyū Ugoku;* pl. 42). Clearly his creative powers were heightening, his vision coming into full fruition. For while these works were almost all pictorializations from history and legend, his daring to explore new possibilities in the print medium—particularly in line quality and soft color tonalities—lent these works a mounting sense of ethereality.

31. *Yoshitsune Learns Martial Arts on Mt. Kurama*
32. *Yukihira Meets the Fisherwomen Murasame and Matsukaze at Suma Beach*

Fig. 73 and pls. 31–32: from *A Yoshitoshi Storybook*

73. *Urashima Tarō Returns Home from the Dragon Palace*

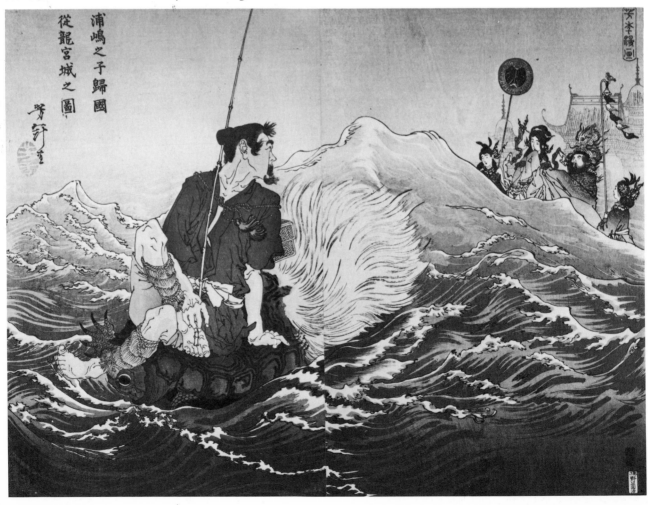

舍那王於鞍馬
山學武術之圖

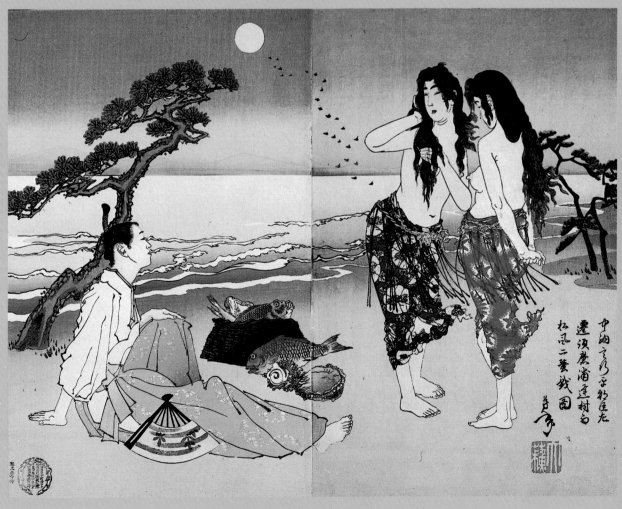

遷須廣溜連村句
松浪二望錢圖

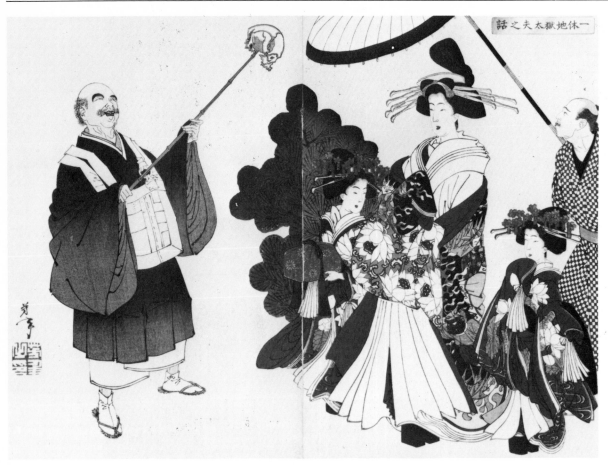

74. *The Story of Priest Ikkyū and the Courtesan Jigoku Dayū*

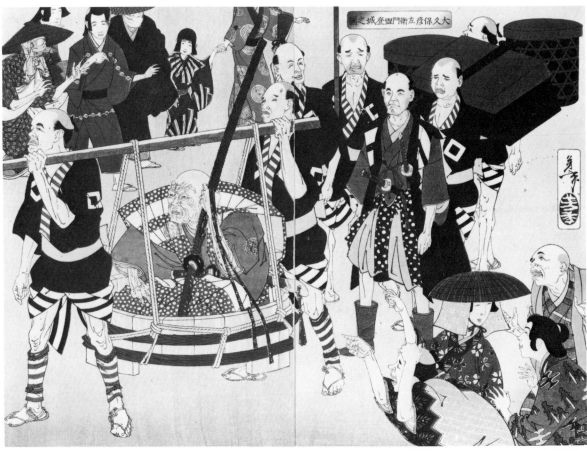

75. *Ōkubo Hikozaemon Carried to the Castle in a Tub*

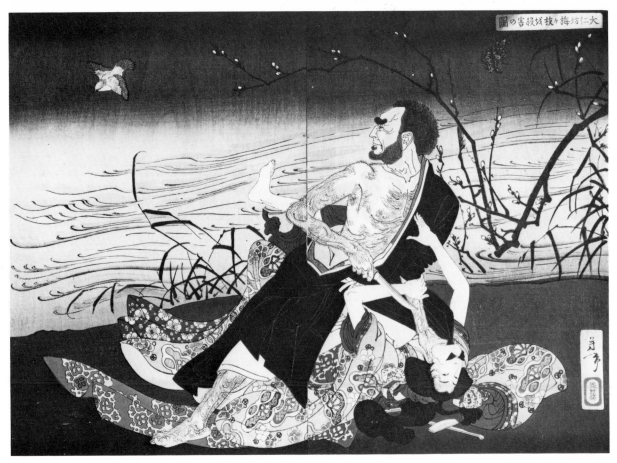

76. *Dainimbō Kills Umegae*

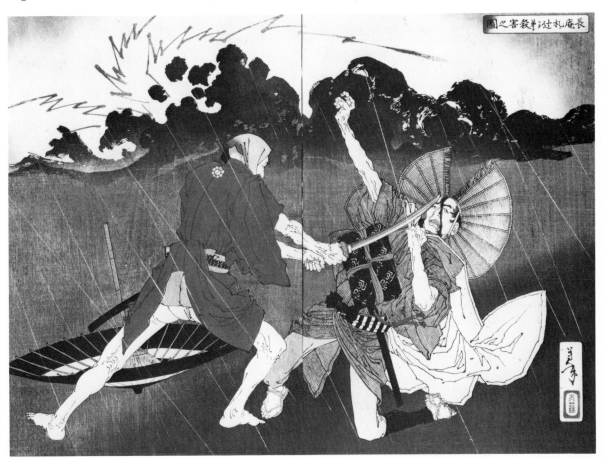

77. *Chōan Cuts Down His Brother at Fudanotsuji*

33. (overleaf) *The Story of Jirōzaemon of Sano*

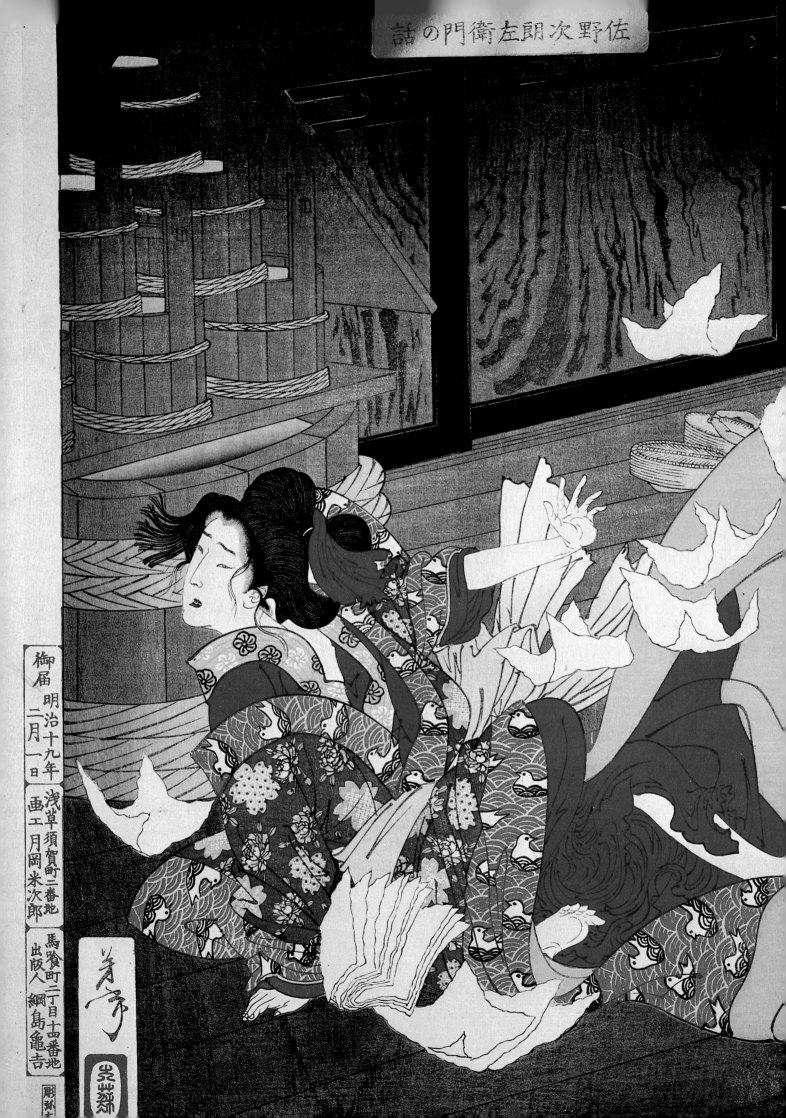

御届 明治十九年二月一日

浅草須賀町二番地
画工 月岡米次郎

馬喰町二丁目十四番地
出版人 綱島亀吉

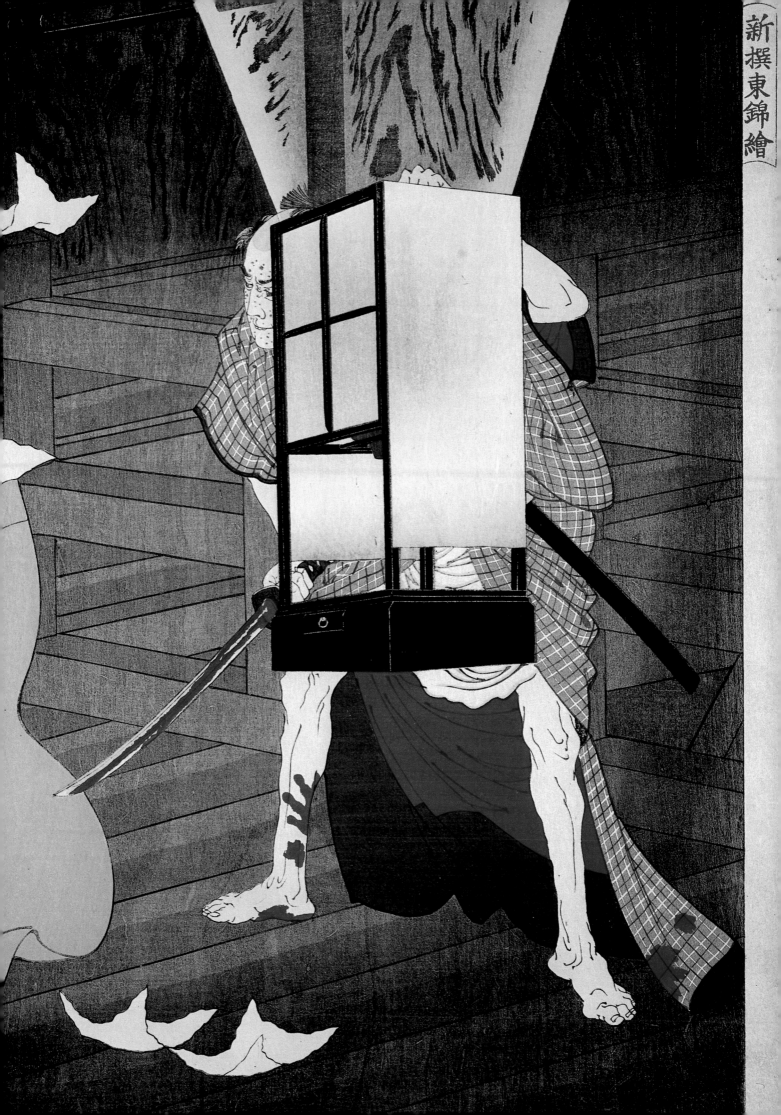

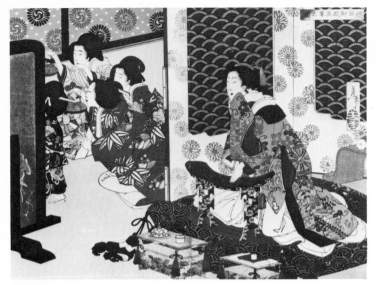

78. *The Banquet at the Koshida Palace*

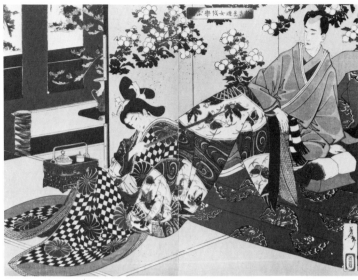

79. *Osame Learns the Courtesan's Trade*

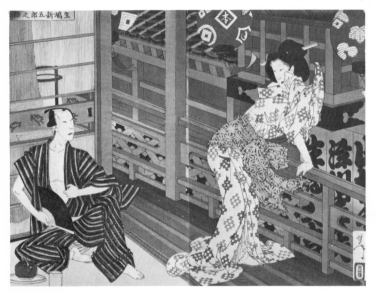

80. *The Story of Ikushima Shingorō*

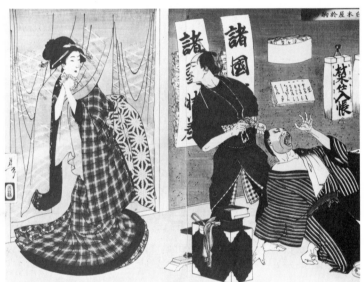

81. *The Story of Okoma of Shirakiya*

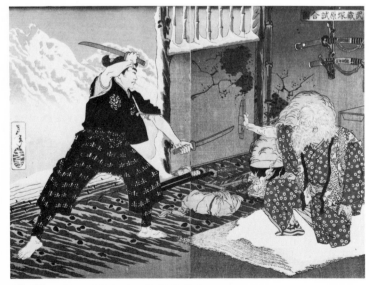

82. *Musashi and Bokuden Fight It Out*

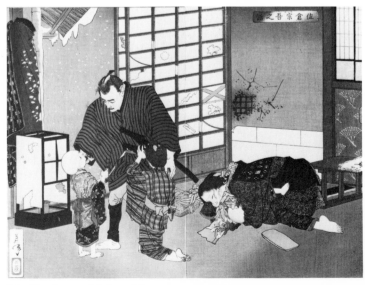

83. *The Story of Sakura Sōgo*

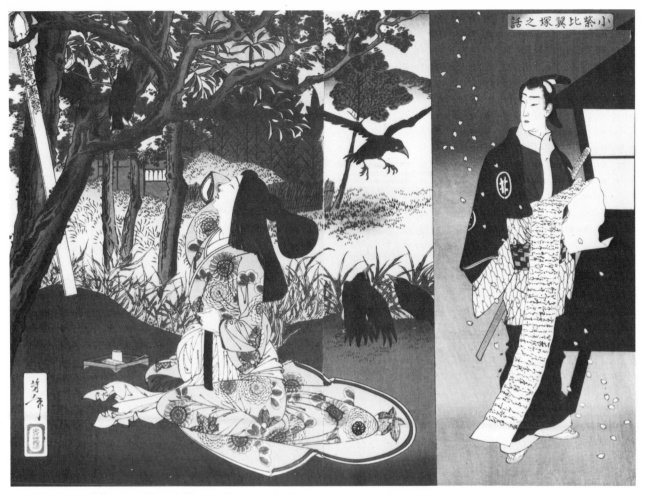

84. *The Story of Komurasaki and Gompachi*

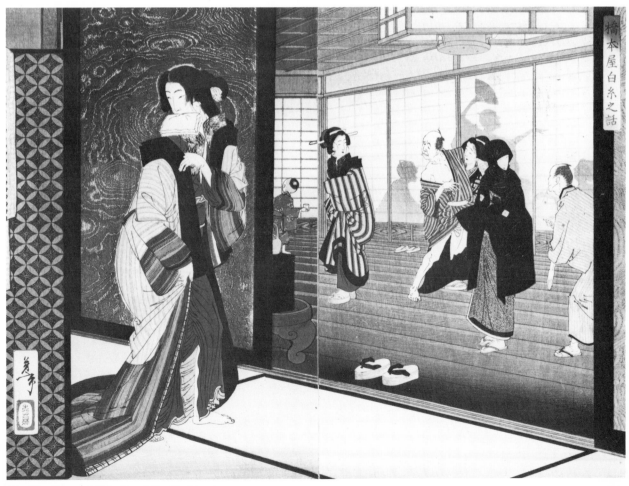

85. *The Story of Shiraito of the Hashimotoya*

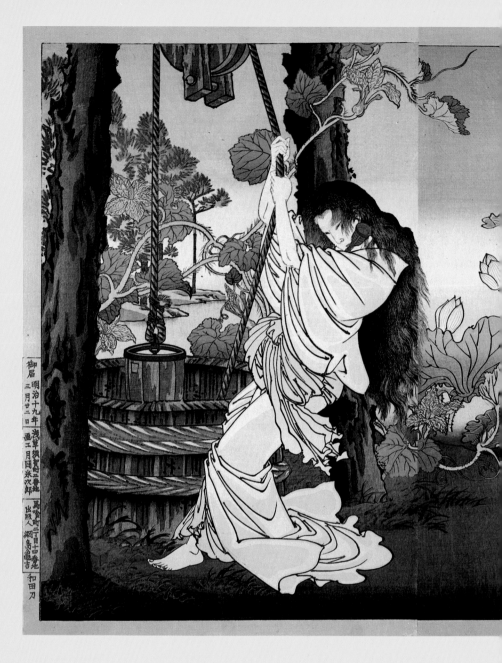

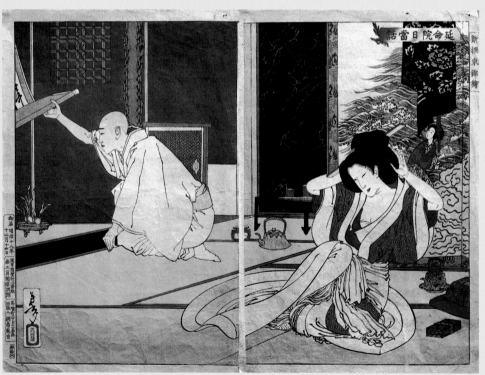

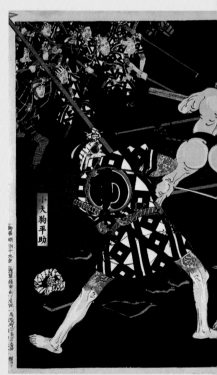

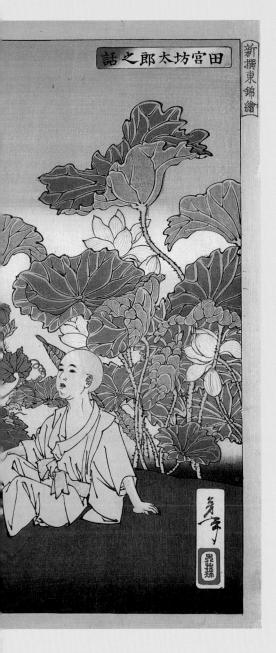

新撰東錦繪

田宮坊太郎之話

34. *The Story of Tamiya Bōtarō*
35. *The Story of Priest Nittō of Emmeiin Temple*
36. *Wrestlers Battle Firemen at Shimmei Shrine*
37. *Evil Omatsu Kills Her Husband Shirosaburō*

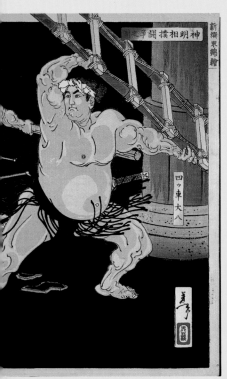

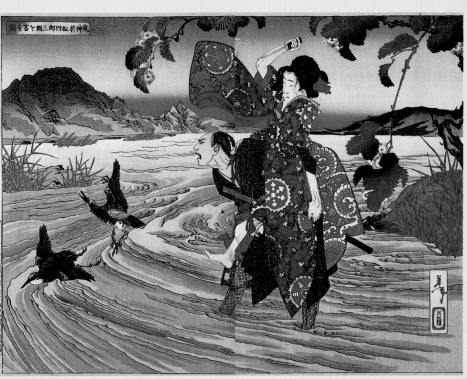

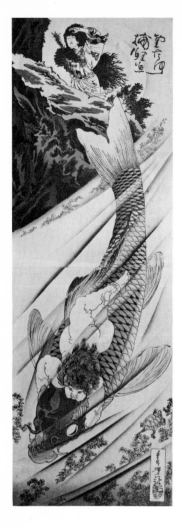

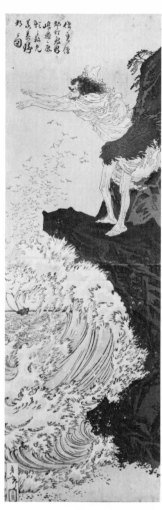

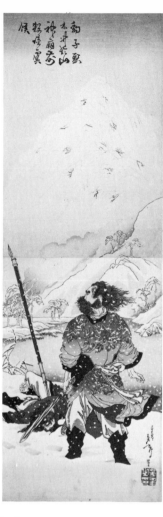

86. *Kintarō Catches a Carp*
87. *Shunkan Watches Enviously from Kikai Island*
88. *Wild Maned Lin Chung Kills Le Wuhou*

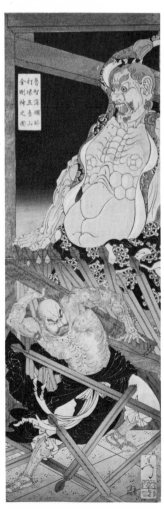

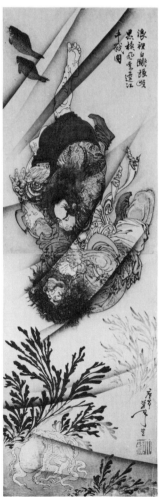

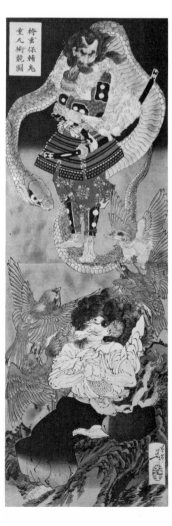

89. *Lu Chi-shen Topples the Temple Gate Guardian in a Drunken Rage*
90. *Li Kúei Battles Chang Shun Underwater*
91. *Hakamadare Yasusuke and Kidōmaru Match Skills*

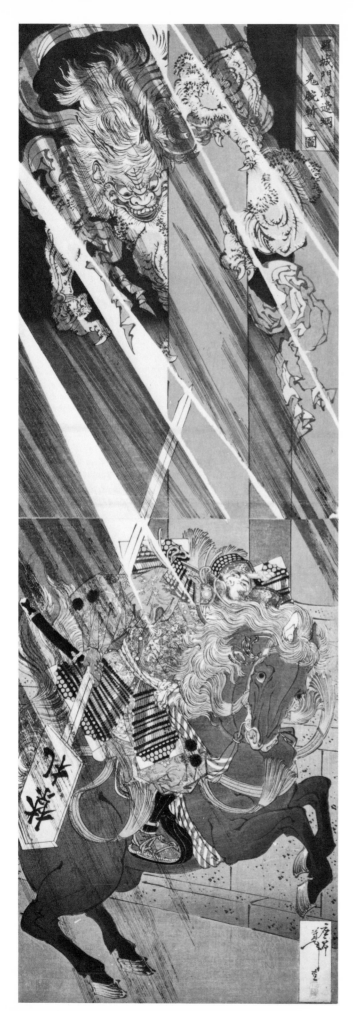

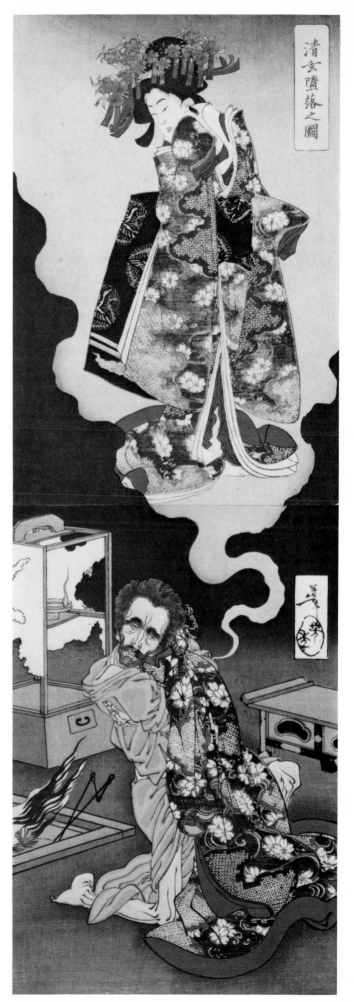

92. *Watanabe no Tsuna Severs the Ogre's Arm at Rashōmon Gate*

93. *The Depravity of Seigen*

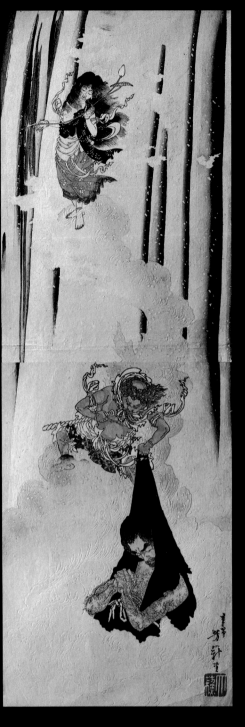

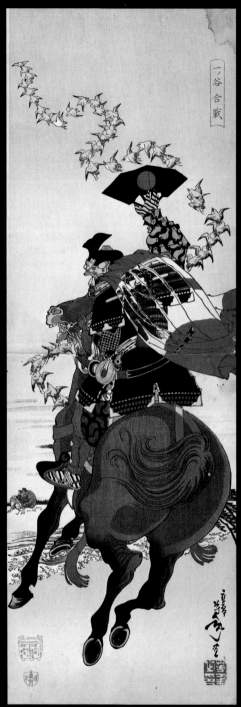

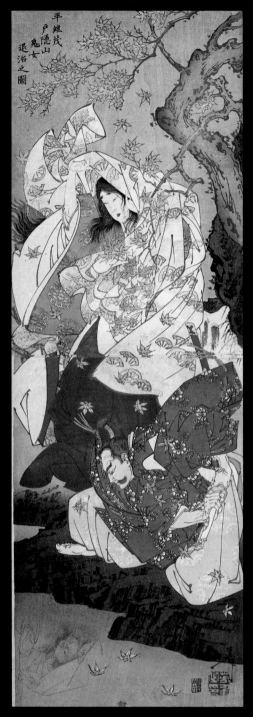

38. *The Austerities of Saint Mongaku*
39. *The Battle of Ichi no Tani*
40. *Taira no Koremochi Vanquishes
the Demon Maiden of Mt. Togakushi*

41. *Yaoya Oshichi Burns Her Own House*
42. *Two Valiants in Combat atop the Hōryūkaku Pavilion*

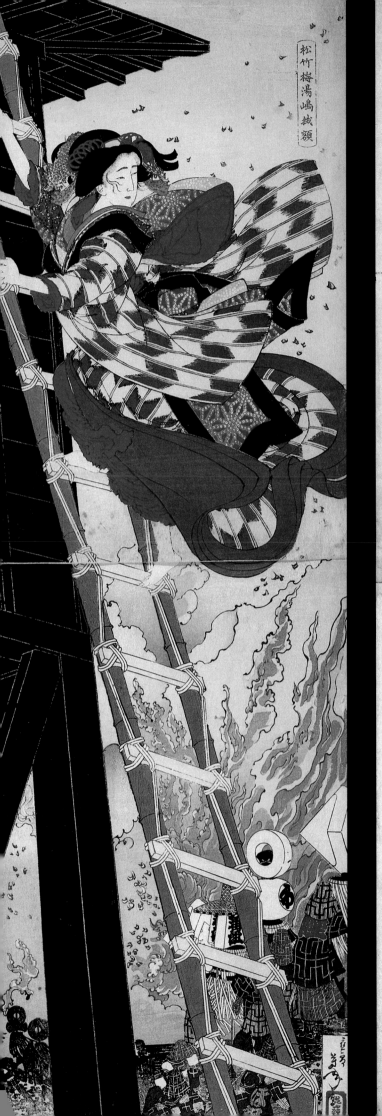

松竹梅湯嶋掛額

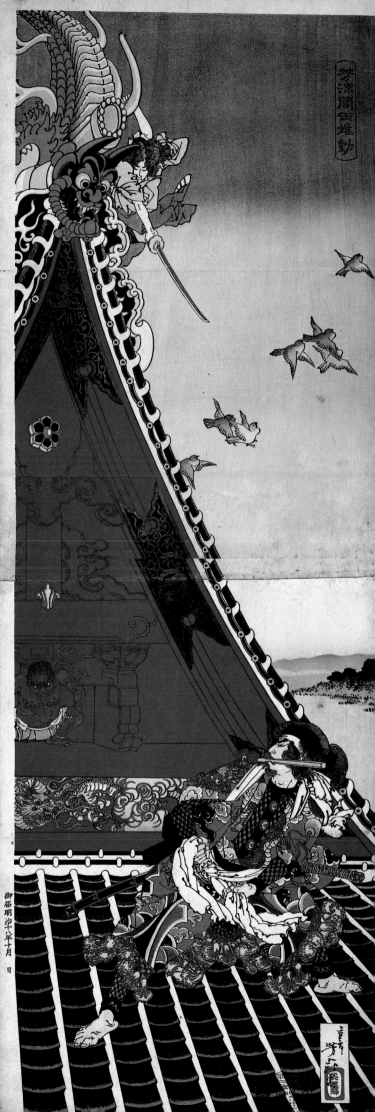

芝濱閣両雄動

御届明治八年十月　日

94. *Selected New Forms of Thirty-six Ghosts* (complete series with pls. 43–48)

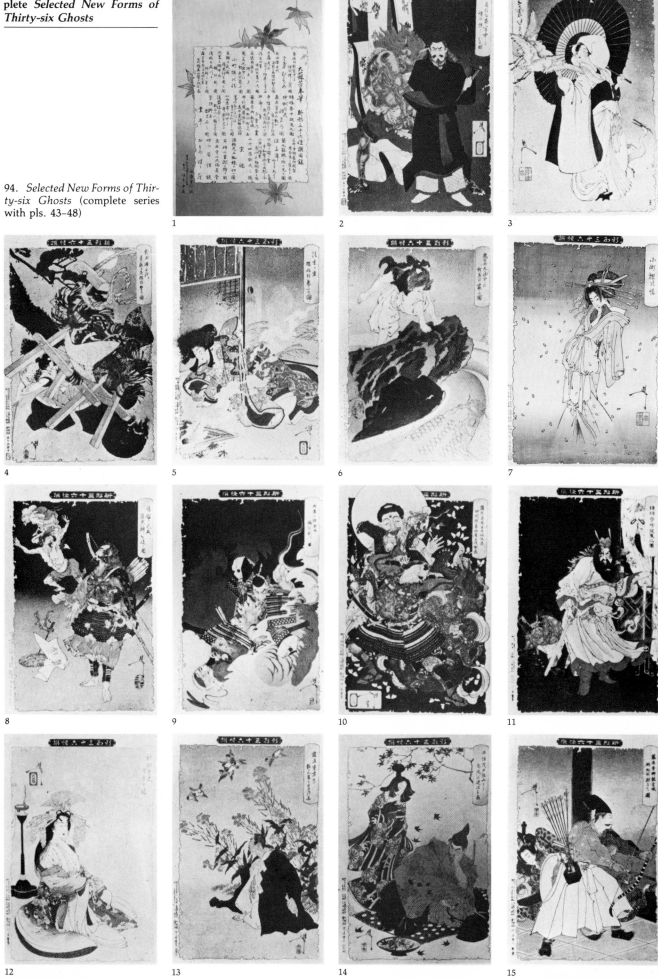

1

2

3

4

5

6

7

8

9

10

11

12

13

14

15

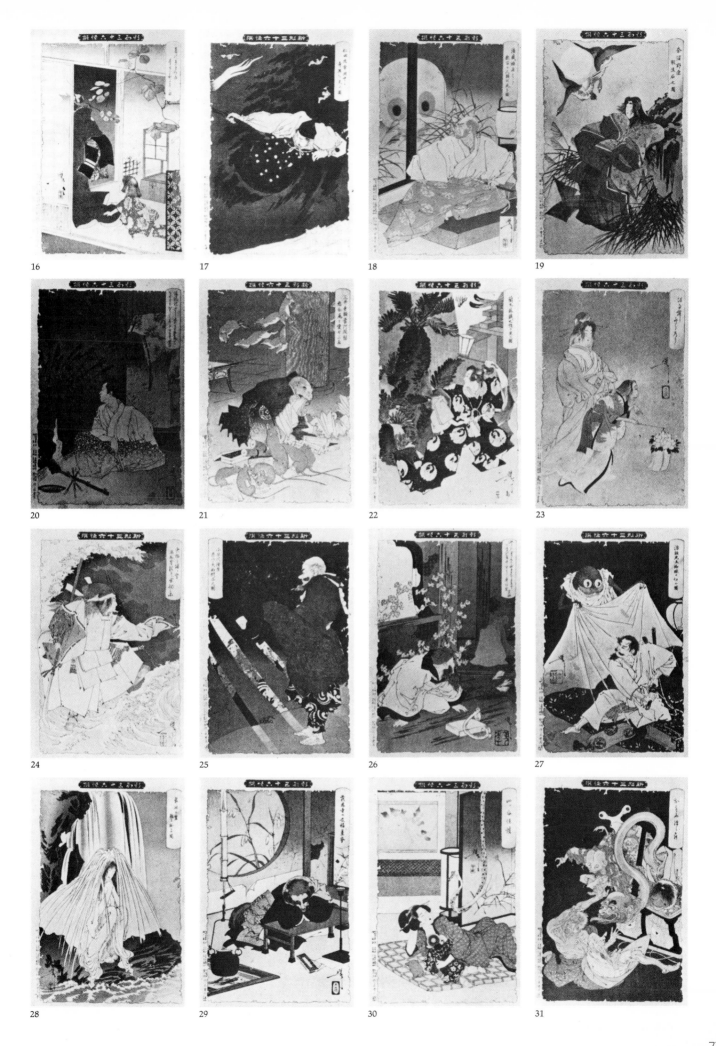

16

17

18

19

20

21

22

23

24

25

26

27

28

29

30

31

43. *Ōmori Hikoshichi Encounters a Demon*

44. *The Ghost of Okiku of the Dish Mansion*

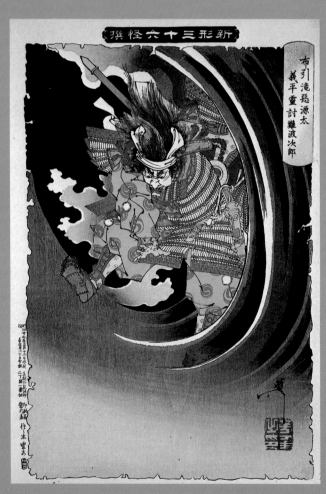

45. *Evil Genta Fells Naniwa Jirō at Nunobiki Waterfall*

46. *Fox Fires of the "Twenty-four Examples of Filial Piety"*

清姫日高川に
蛇躰と成る図

47. Kiyohime Changes into a Serpent at the Hidaka River

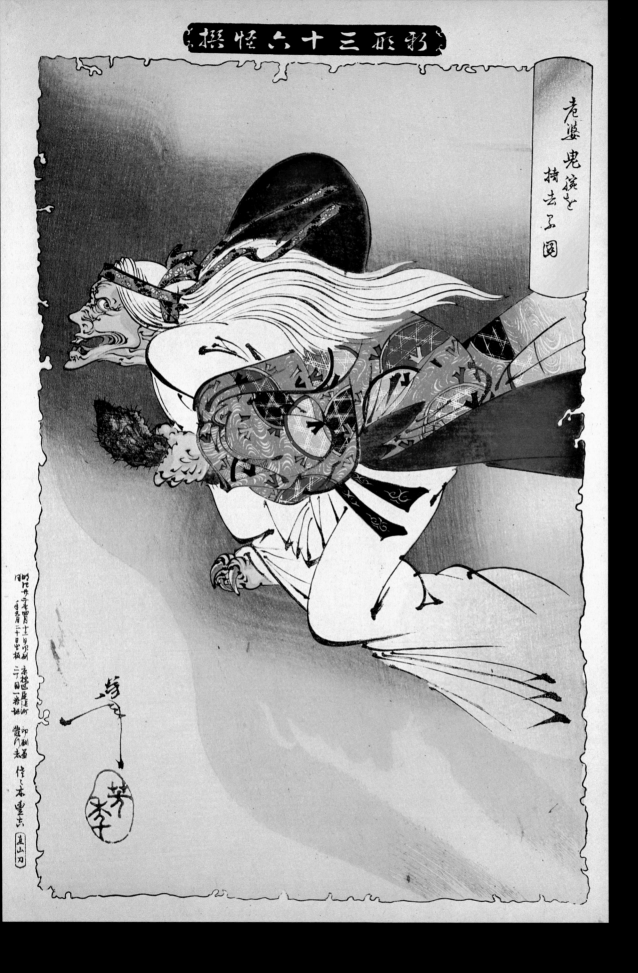

48. *The Old Woman Retrieves Her Arm*

49. *The Hag of Adachigahara*
50. *Genji in the Provinces*

80

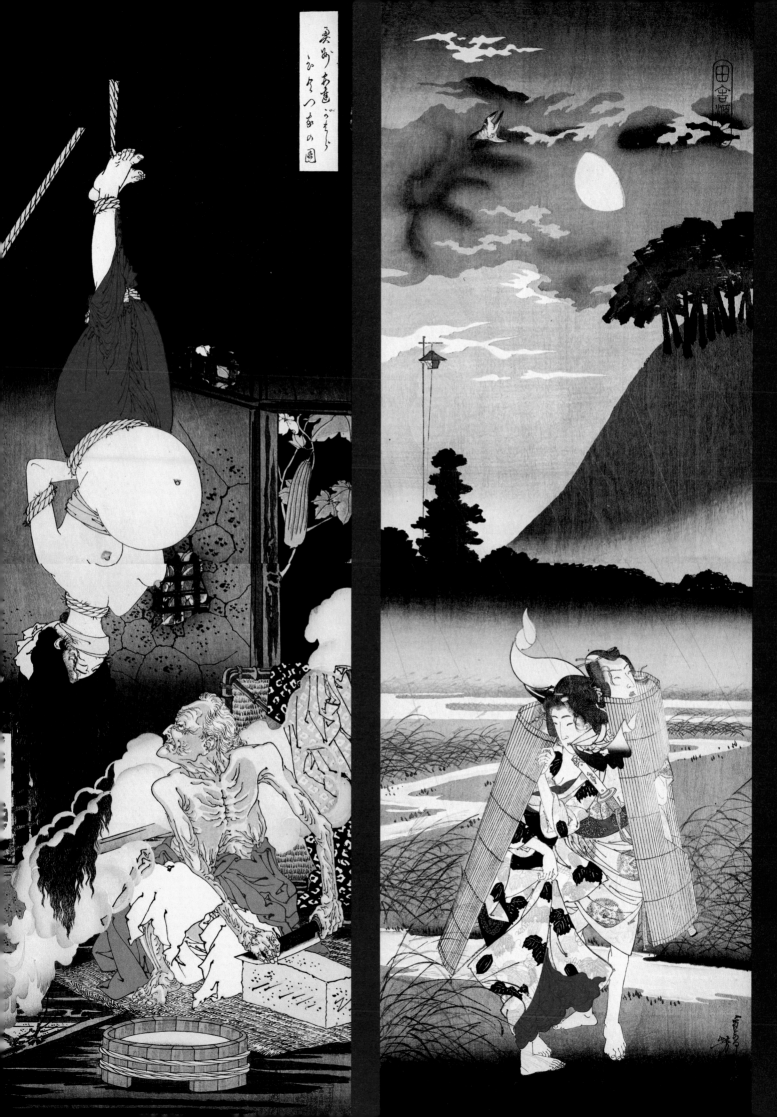

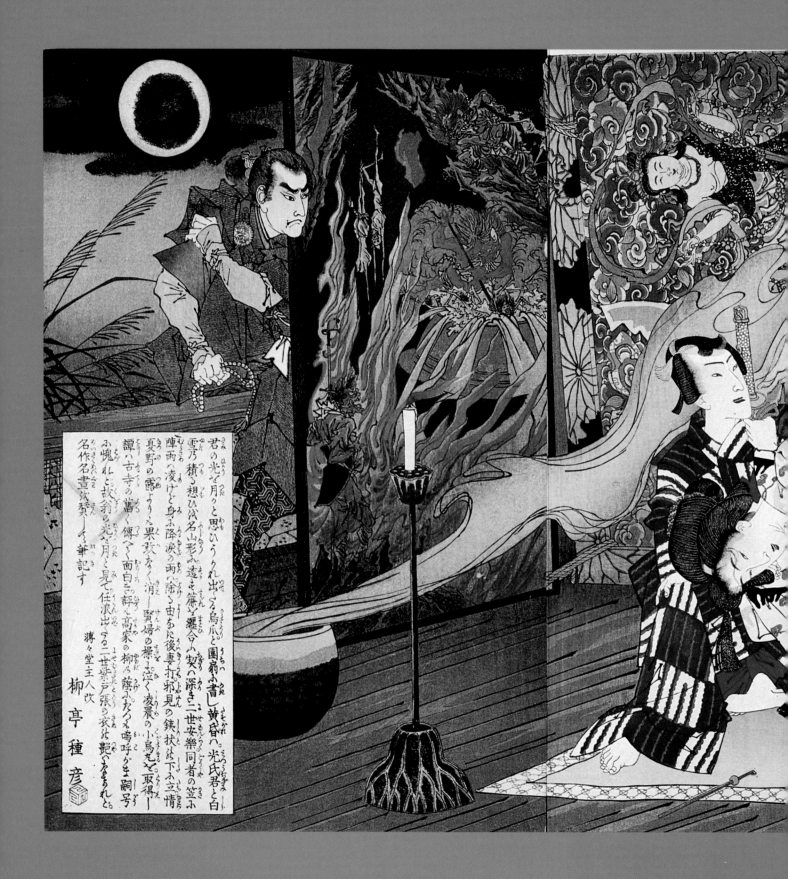

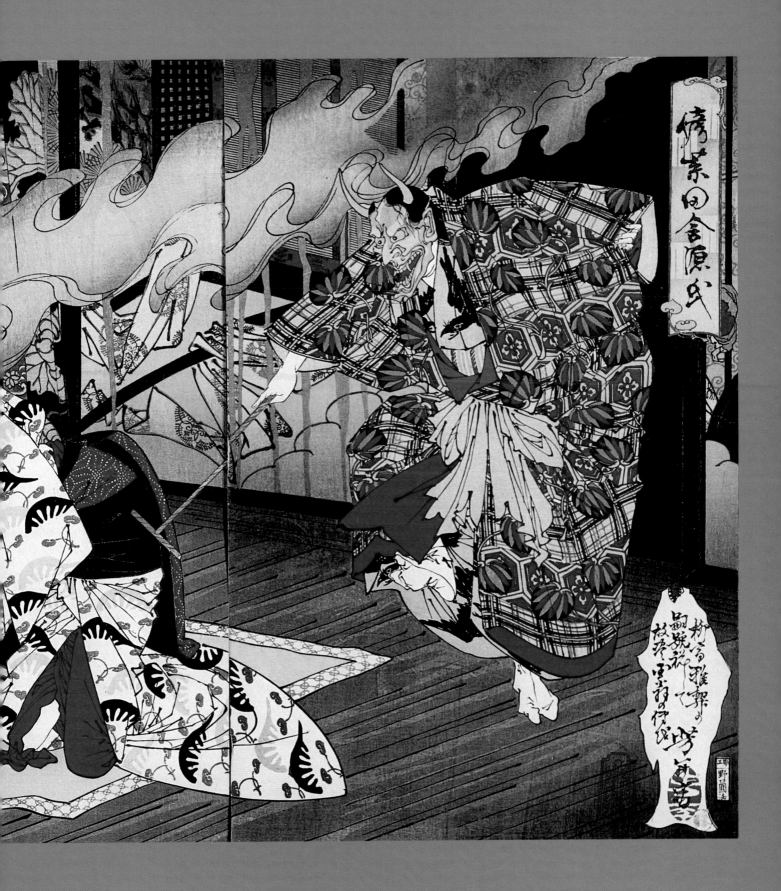

51. *The Other Murasaki with Genji in the Provinces*

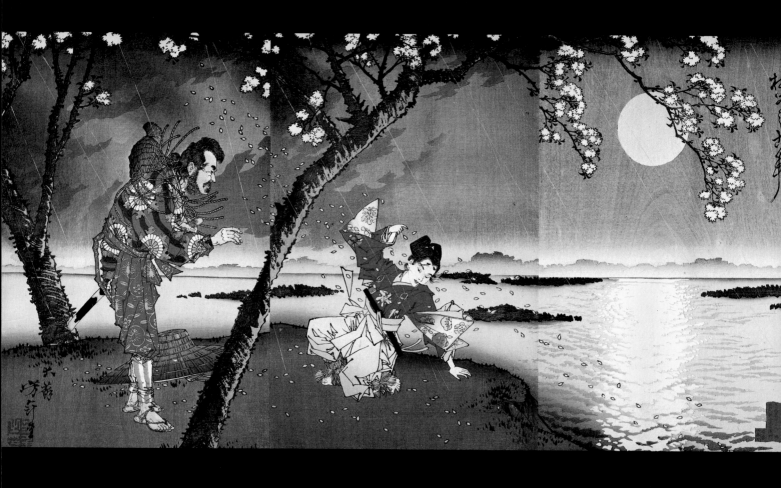

52. *Umewaka and the Child Seller*

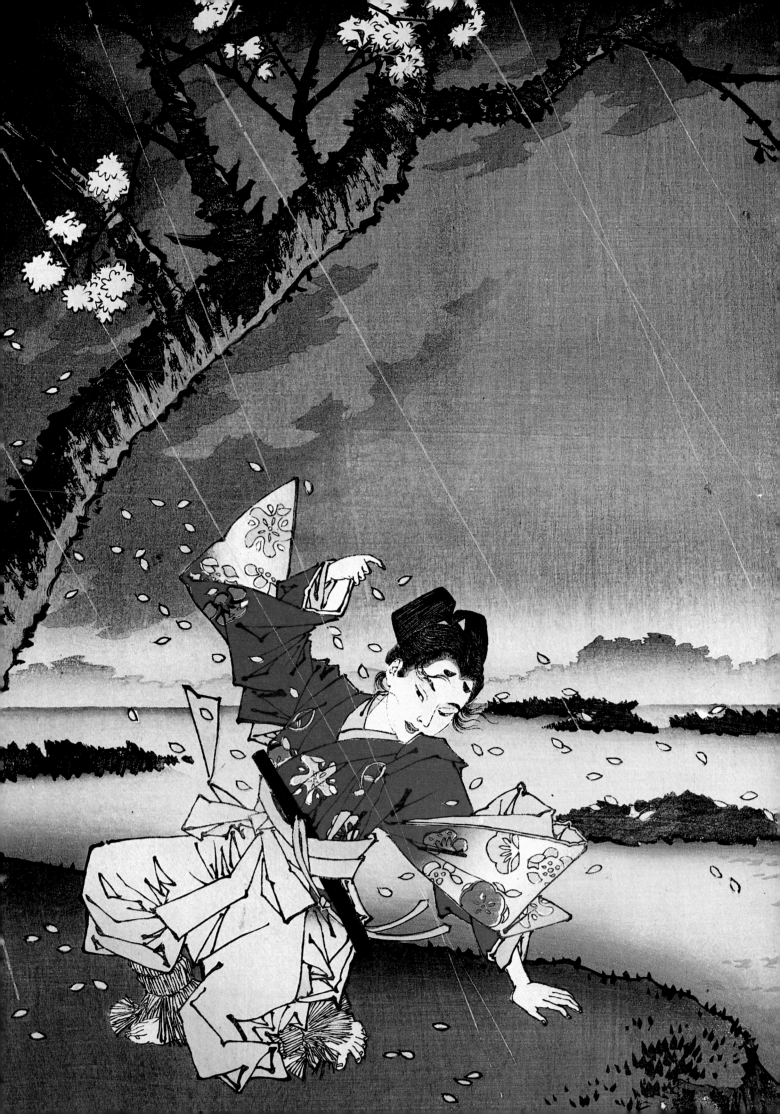

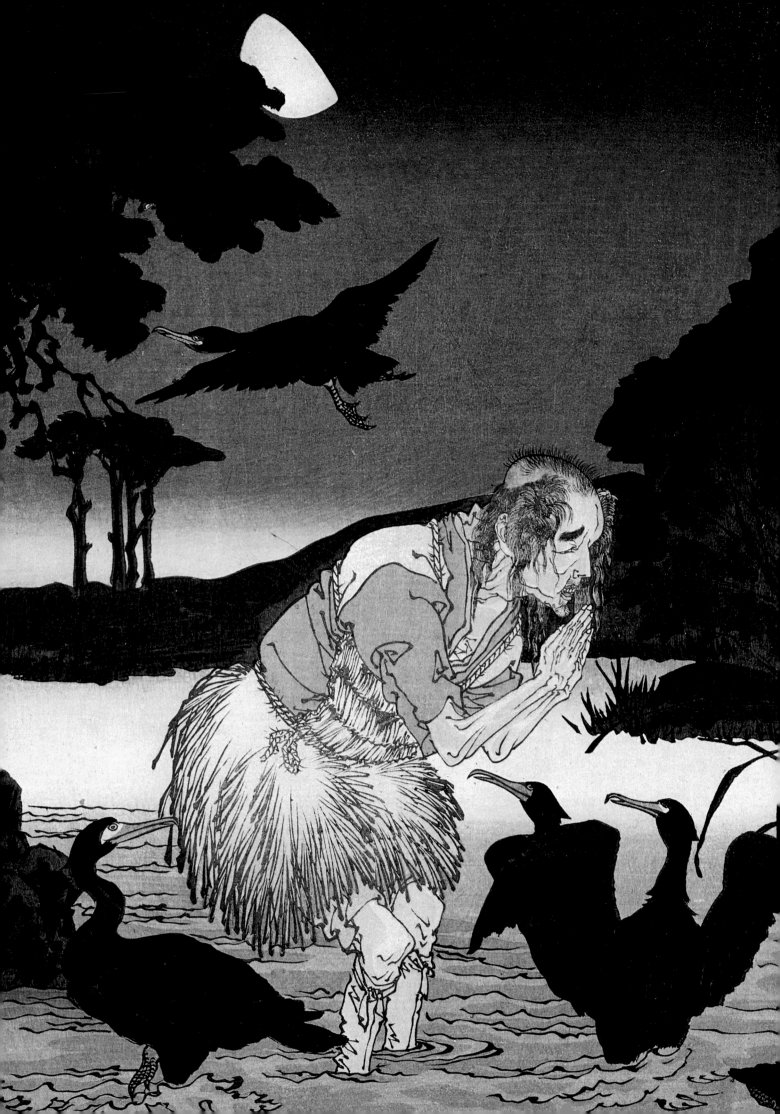

53. *Saint Nichiren Saves the Cormorant Fisherman*

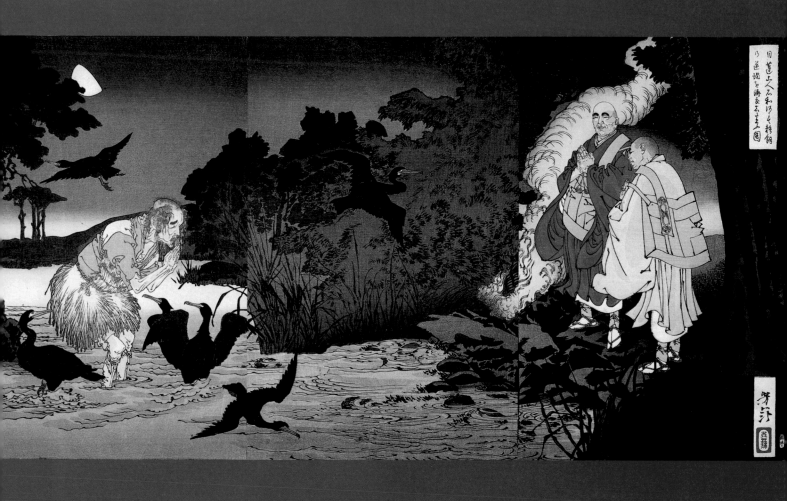

THE FINAL YEARS

Twenty years into the Meiji era, Yoshitoshi entered his fifties. By all indications he had found his place, and was fully in command of his art. His 1888 series *Thirty-two Aspects of Women* (*Fūzoku Sanjūnisō*; pls. 56–57, pp. 92–93) fulfilled the promise of his earlier genre prints. These images of beauties are graced by an ease of accomplishment and unaffected candidness that attest to the consummation of his art. Having always drawn the line at overtly sexual *shunga*, "Spring pictures," the prints of this series represent the most outstanding expression of the erotic in his oeuvre. They are also remarkable for their realism as individual portraits of women in their many different daily activities, a far cry from the idealized variations on the languid courtesan theme typical of Ukiyo-e.

In the very outset of his career he had not done prints of women at all, nor had he ever created purely decorative "bird-and-flower" nature pieces or landscapes as such. Once he had been moved to depict beauties, however, he proved himself quite equal to the task, producing a number of series from his earliest *Raving Beauties at Tokyo Restaurants* (figs. 47–48) and *A Collection of Desires* (*Mitate Tai Zukushi*; pls. 54–55, figs. 100–102) at the beginning of the Meiji era, all the way to the *Thirty-two Aspects*, his crowning achievement in that genre. In fact, Yoshitoshi proved himself adept at any genre featuring the human figure and human activities. The talent he first displayed in portraying warriors was easily and effectively transferred to historical figures and contemporary portraits when the former mode outlived its currency.

For an Ukiyo-e artist whose career spanned the late Edo and early Meiji years, Yoshitoshi's complete abstention from landscapes is something of a curiosity. This is doubly so since his own teacher, Kuniyoshi, had exerted a pivotal influence in updating landscape prints, and the earlier Hokusai, a source of inspiration to Yoshitoshi, had been one of the two greatest landscape artists in the history of Ukiyo-e. It is also worth noting that although many of his prints, particularly his multipanel spreads, do contain very handsome landscape backdrops, certain accounts contend that a good number of these were executed by disciples, leaving Yoshitoshi free to concentrate on the figures in the foreground.

For Yoshitoshi, the human factor was all important—the evocative power of the human figure, the psychological interplay of a grouping of characters, the narrative interest of event and incident—here he was in his element. Nothing claimed his interest so passionately as people, and his finest masterpieces plumbed the depths of the human psyche. If he can be said to have followed in the footsteps of Kuniyoshi and Hokusai in any way, it was in their insight into the inner life of people. In this regard, Yoshitoshi can be called their true heir, for only he was skillful and perceptive enough to bring the vision of such works as Hokusai's *One Hundred Ghost Stories* (figs. 44–45) or Kuniyoshi's macabre images up-to-date with no loss of artistic integrity.

This is not to say that Yoshitoshi was alone in depicting human affairs and the goings-on of his day. After all, that was where Ukiyo-e artists generally found their subjects. And, indeed, a majority of Yoshitoshi's works looked on the face of Meiji society in answer to the demands of the times. What did distinguish him, however, was that he never let his images descend to cut-and-dry reportage, but managed to infuse even historical fact with a living dynamism, often with

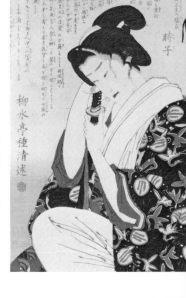

95. *Heroic Women in Edo Prints: Tokiko*
96. *Twenty-four Hours with the Courtesans of Shimbashi and Yanagibashi: Two* P.M.
97. *Twenty-four Hours with the Courtesans of Shimbashi and Yanagibashi: Ten* P.M.
98. *The Pride of Tokyo's Twelve Months: April*
99. *The Pride of Tokyo's Twelve Months: September*

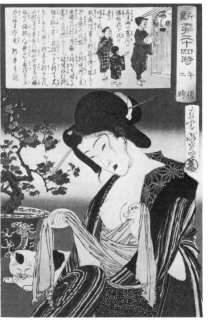

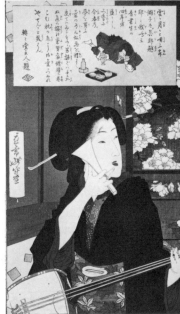

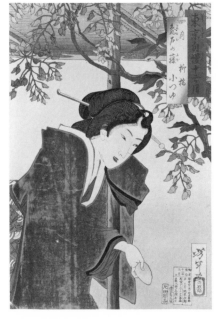

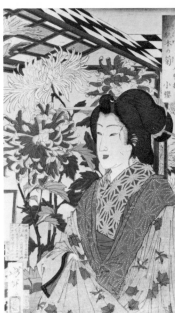

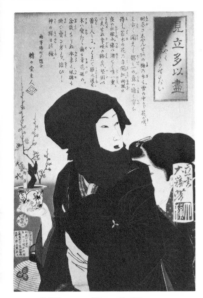

100. *I Want to Have It Bloom Soon*

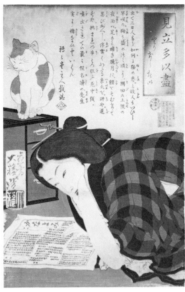

101. *I Want to Strike It from the Record*

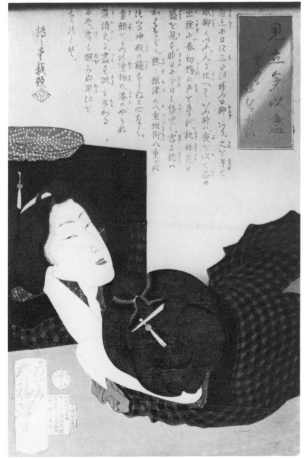

102. *I Want to Sleep Oh So Badly*

the most disturbing undertones. Thus every picture was uniquely a product of the world of his imagining, a portal into his own mental landscape.

This distinctive individuality did not always work to his advantage, though. In his early career it repelled the buying public almost as often as it proved a selling point. Yet he persisted through it all, focusing on his own intuitive sense of his art, rejecting the more superficial, temporary trends. Indeed, looking back over the whole course of his development, we find a core sensibility that transcends the times.

The works of Yoshitoshi's final years bring this aspect into clearest focus, and thus have the most timeless appeal. Undoubtedly, the ultimate expression of this individual vision was his *Selected New Forms of Thirty-six Ghosts* (pls. 43–48, fig. 94). Completed in 1892, the year of his death, the last prints of the series were issued posthumously. The outward tranquility that permeated the *One Hundred Aspects of the Moon* (pls. 26–30, fig. 72) lingers on in the muted colors of this series, but the entire theme marks a striking return to the dark and supernatural fascinations of his youth. A circle completed, these haunting images are fitting last works.

Prior to this, in 1887, Yoshitoshi apparently experienced a relapse of the illness or nervous condition that he had suffered in the early 1870s, when deep in poverty. In 1890 he had begun to come out with individual titles—the triptych *Onoe Kikugorō V as the Hag of Asajigahara* (Onoe Kikugorō; pl. 58), a three-triptych suite of *Actors with Snow, Moon, and Flowers* (Yakusha Setsugekka; pls. 59–61), another actor triptych *Kintarō Dedicating the Storehouse* (Kintarō Kura Biraki; fig. 105), and yet another of *Ichikawa Danjūrō IX as Benkei* (Benkei Ichikawa Danjūrō; fig. 104). These, together with the remaining single images of the *Thirty-six Ghosts* series, occupied him up to the moment of his death. True to form, his creative energies never wavered so long as there was life left in him. Even during his last three years when he was receiving frequent medical care, he preferred to stay active at his studio rather then enter a hospital. It was only during the early months of 1892 that his health and eyesight so deteriorated that he conceded to treatment in Sugamo Hospital. At that point he was already beyond recovery, and was eventually transferred to a local clinic and released as incurable. He died a few weeks later.

But other than the handful of paintings he did while hospitalized, none of the artwork he brought into the world was the product of a sick mind, as some critics have suggested. Only those last extremely rarefied works of his final years, wholly divorced from the early blood and gore, can be said to present problems of interpretation. It is not the grisly imagery, but its very antitheses, the unearthly purity of his last series, that is difficult to dismiss.

In a word, Yoshitoshi lived a fervently creative life in perpetual search of artistic outlet. He was possessed by his own genius, not by a demonic spirit or mental derangement. Moreover, despite his comparatively short active period—roughly half that of Hokusai—his determination to use it to the fullest is evidenced by an output that very nearly approaches that of his great predecessor, both in terms of volume and consistent quality, and with no sacrifice of his own identity.

His art kept growing and branching out, making him a master of many modes. From a backbone of warrior prints, actor prints, and humorous prints early on, he attained a sure

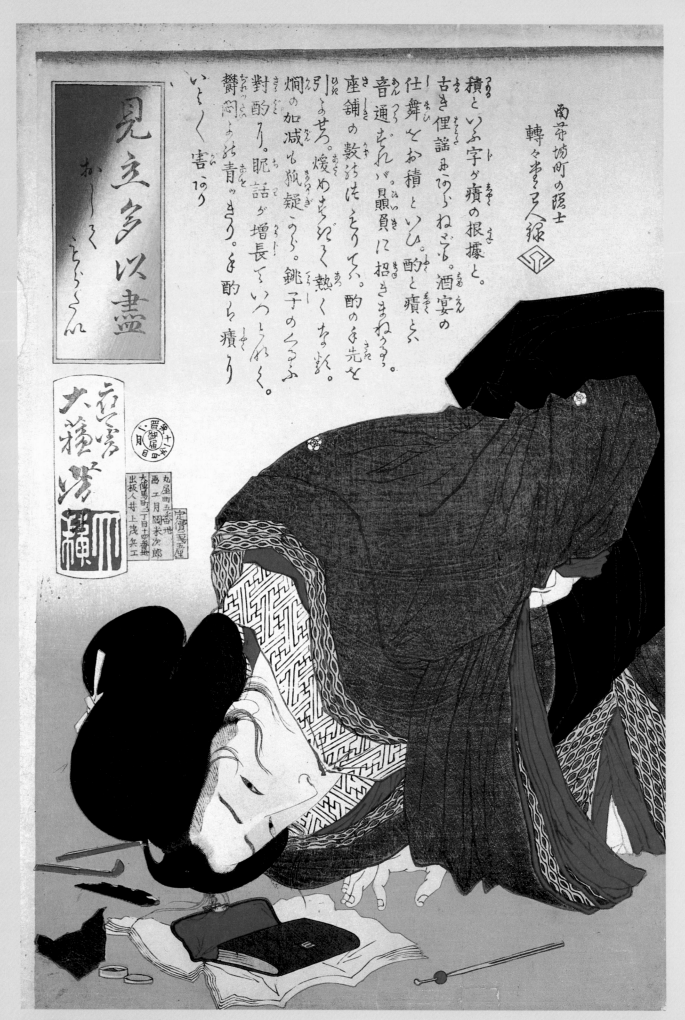

54. *I Want to be Massaged*

55. *I Want to Wash My Hands*

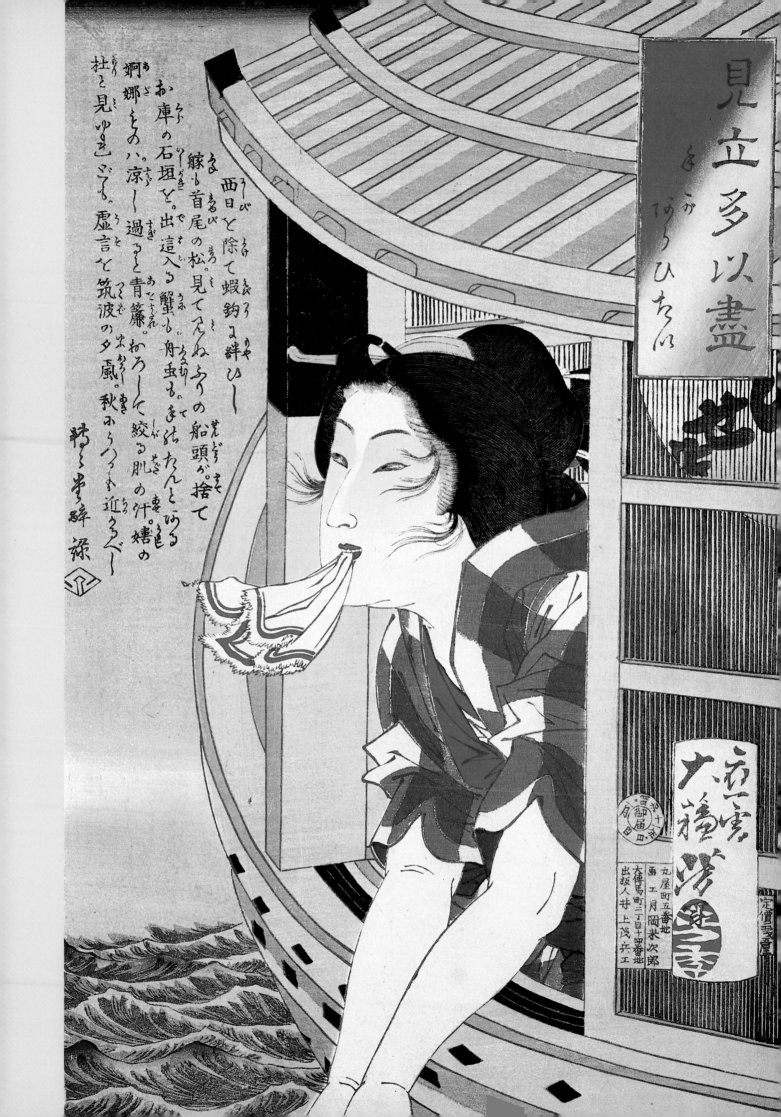

command of such diverse subject matter as legends, contemporary battle scenes, beautiful women, changing styles, historical occurrences, and portraits. Whatever he touched became inimicably his. Whatever special features of the day surfaced in his prints, never did they constrain him or forcibly define him as anything but his own artist.

It is difficult to assess all that he did in his lifetime because he did so very much. Always the upholder of Ukiyo-e tradition, yet an ever vigorous innovator, Yoshitoshi's accomplishments were remarkable, especially when considered in the context of his times. Active almost non-stop and with such an astounding yield, he was much more than a mere traditionalist in times of modernization, as he has been disparagingly labeled. Here was an artist of imaginative power and irrepressible individuality, comparable to any of the presently acknowledged "greats." He was, in short, the last great master of Ukiyo-e.

Fig. 103 and pls. 56–57: complete *Thirty-two Aspects of Women*

103. *Thirty-two Aspects of Women* (complete series with pls. 56–57)

1

2

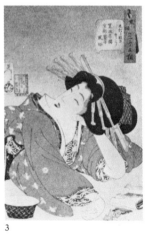

3

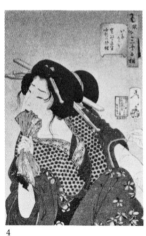

4

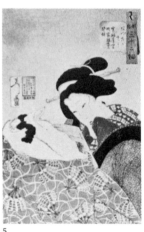

5

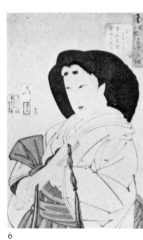

6

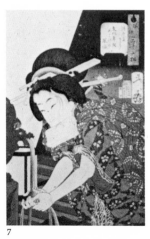

7

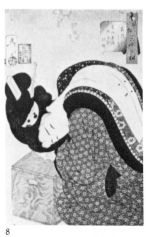

8

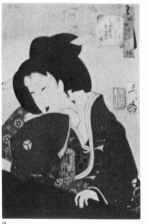

9

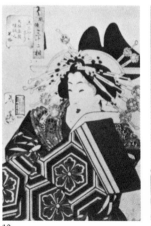

10

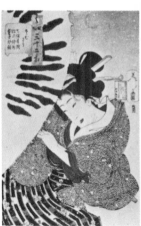

11

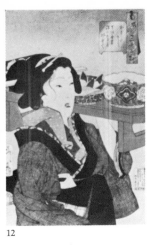

12

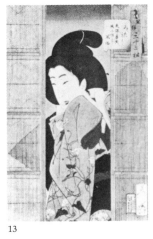

13

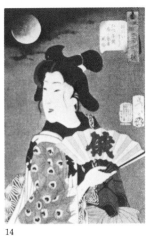

14

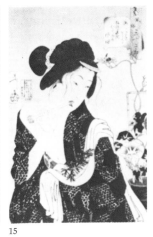

15

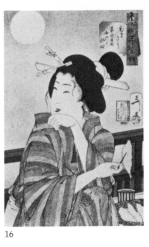

16

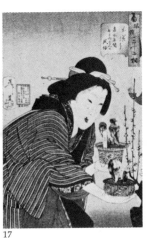

17

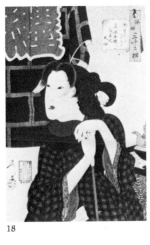

18

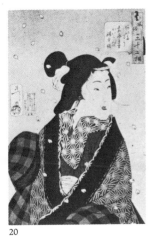

19

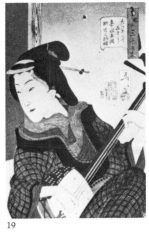

20

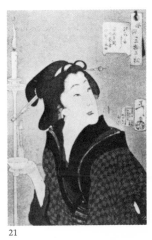

21

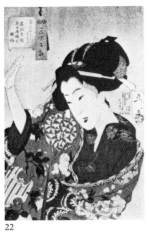

22

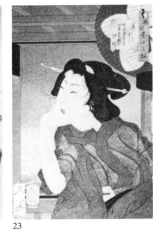

23

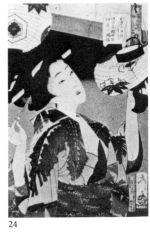

24

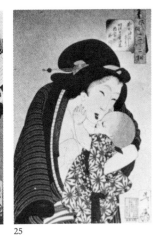

25

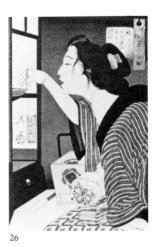

26

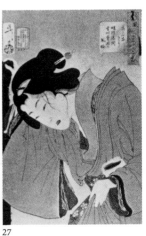

27

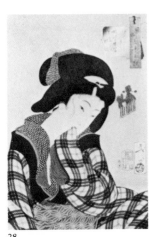

28

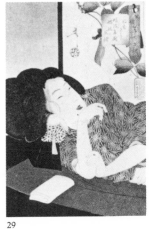

29

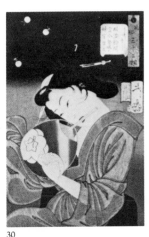

30

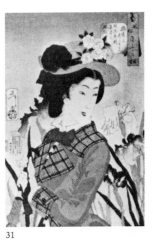

31

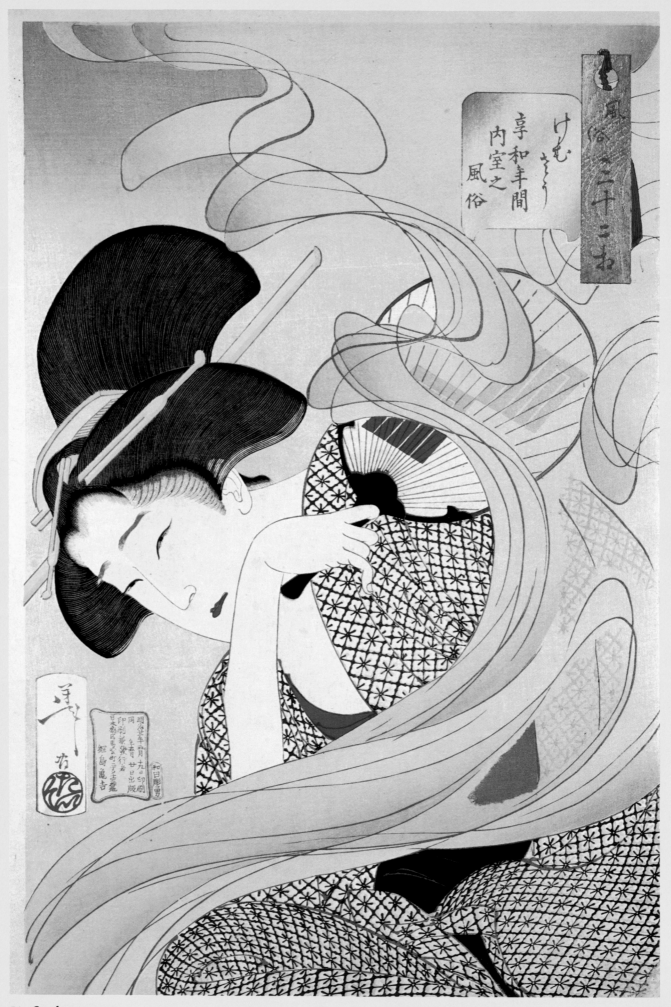

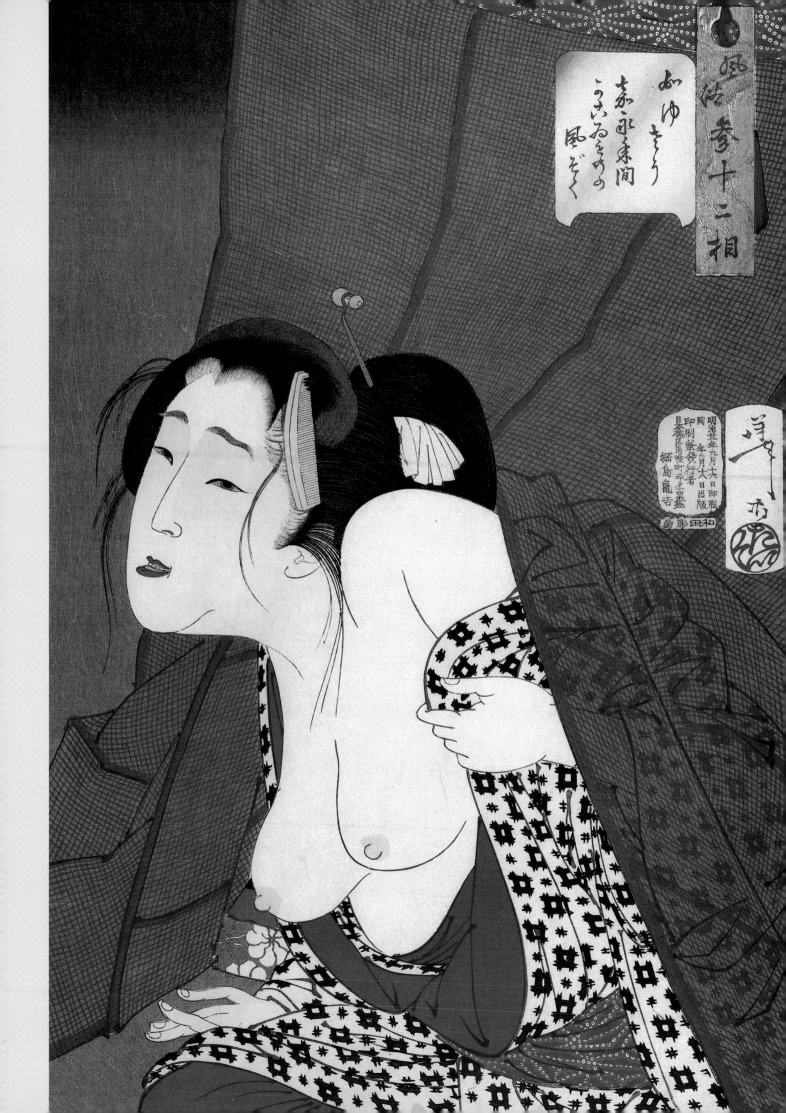

58. *Onoe Kikugorō V as the Hag of Asajigahara*

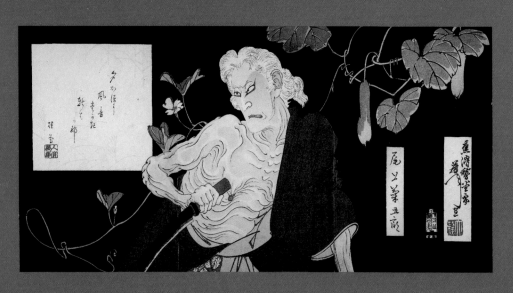

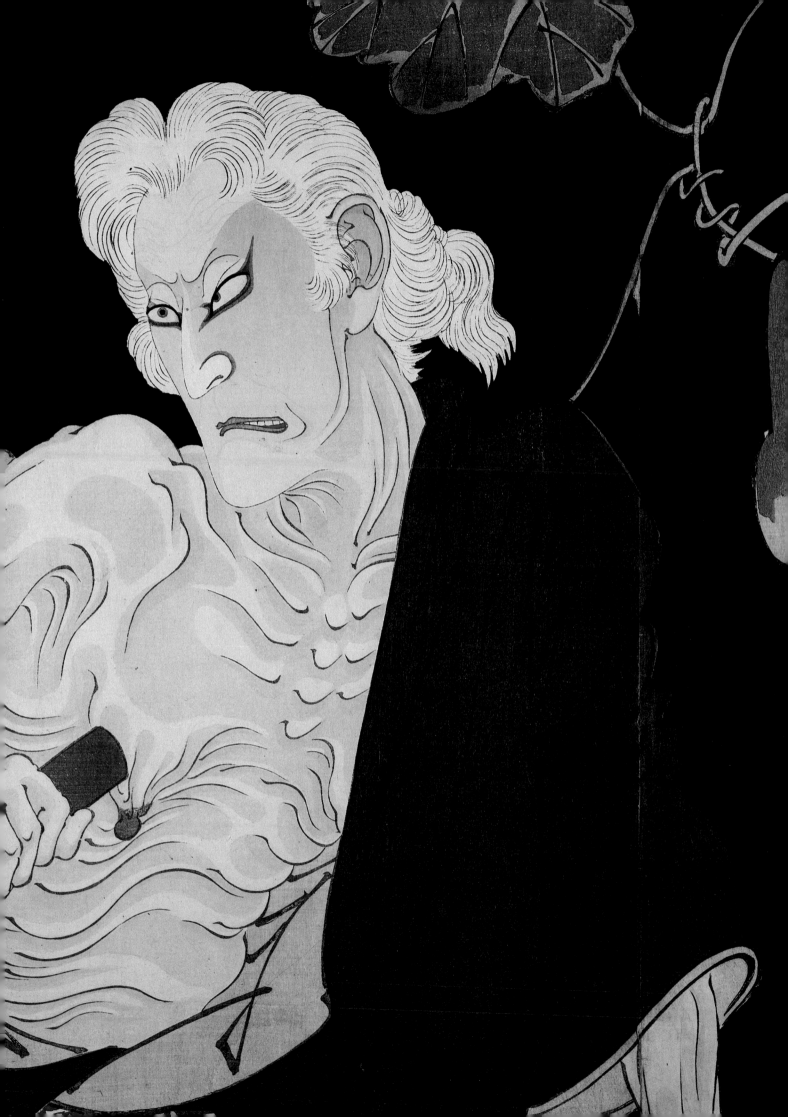

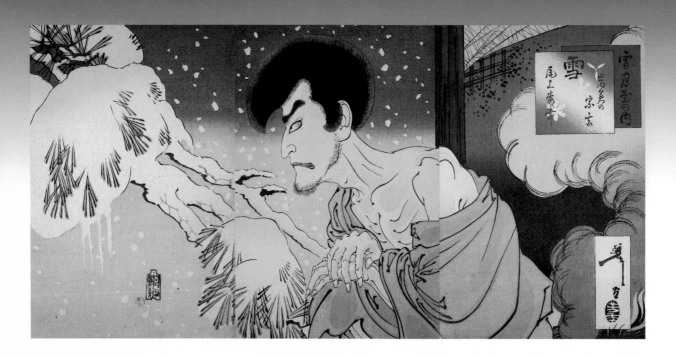

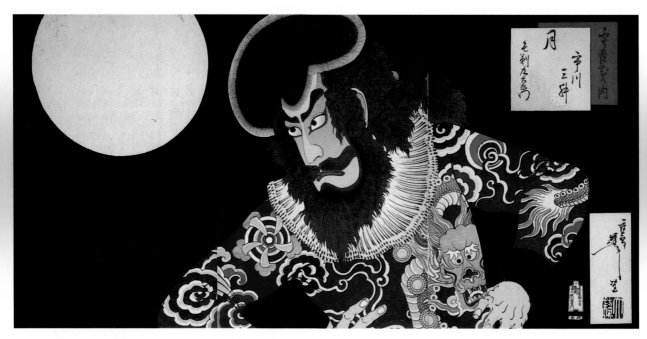

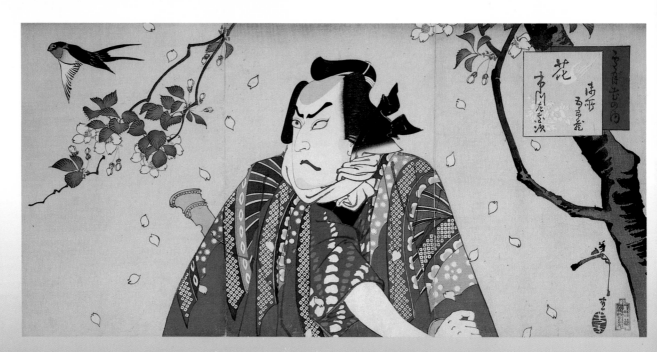

Pls. 59–61: complete *Actors with Snow, Moon, and Flowers*

59. *Snow: Onoe Kikugorō V as Iwakura no Sōgen*
60. *Moon: Ichikawa Danjūrō IX as Kezori Kyūemon*
61. *Flowers: Ichikawa Sadanji as Gosho no Gorozō*

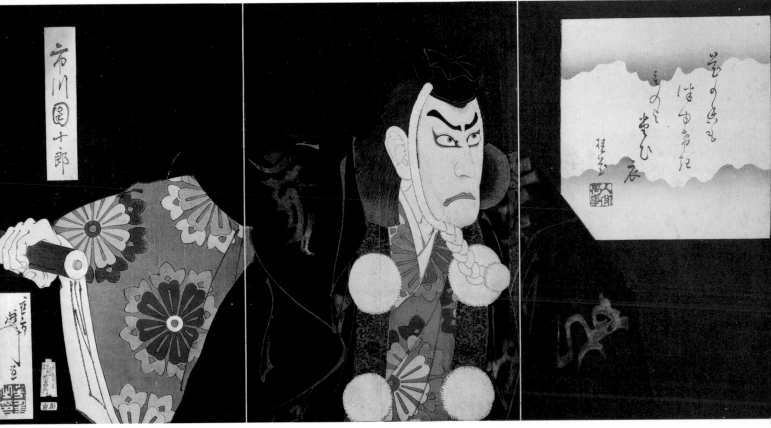

104. *Ichikawa Danjūrō IX as Benkei*

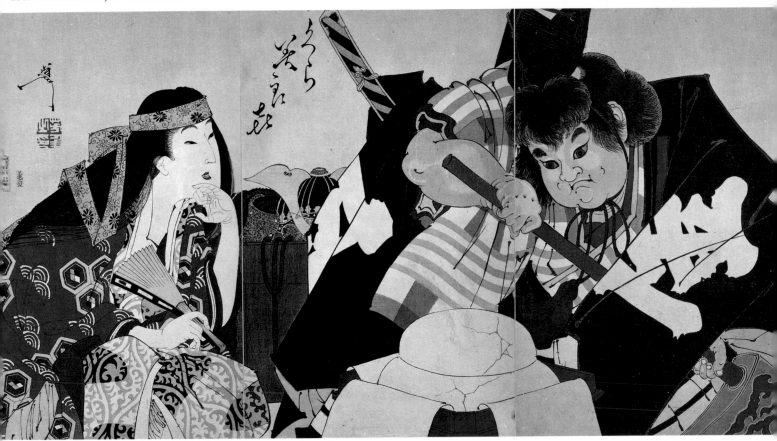

105. *Kintarō Dedicating the Storehouse*

The World of Yoshitoshi's Art

The relationship between Yoshitoshi the man and his art is particularly difficult to establish. As often as not, the man has been pictured in tones that are as harsh and distorted as Yoshitoshi's early images of blood and violence. Even though the few personal accounts left us by his friends and associates reveal his character as admirably diligent, trustworthy, and dedicated, critics have been more inclined to see him as a tortured being, ascribing his two spells of serious illness to extreme mental imbalance or neurosis, not to career-related stress and overwork.

Such misrepresentations would reduce Yoshitoshi to the level of a ghoul in one of his own hellish prints, conceding him none of the aesthetic distance required to achieve such masterful artistic expression. Incredible as it may seem, almost no one has attempted to gain a full appreciation of his technical skills—his encyclopedic vocabulary of design elements, his uncanny sense for striking composition, or his disciplined command of the brush, especially as evidenced in his later works—and then to translate this into a greater recognition of his professionalism. (For if anyone kept a detached, cool eye on his public and what the times would buy, it was Yoshitoshi.) Ironically, it appears that the overpowering strength of his images, that is to say their success as artworks, has militated against a recognition of the tremendous technical preparations and aesthetic considerations that went into their creation.

In order to fully appreciate the pains Yoshitoshi took over his art, and by extension to see the deliberating, judicious artist in Yoshitoshi, we must examine the various technical, thematic, and aesthetic aspects of his creative output.

TECHNIQUE AND FORMAT

The production of traditional woodblock prints was demanding and often thankless work. Much highly skilled labor by various hands went into every edition, although only the names of the print designer, the publisher, and occasionally the engraver (*horishi*) appeared on the finished print. An artist might initiate a project and enjoy some artistic freedom in working up pictorial treatments, but generally it was the publisher who suggested the subject material and coordinated the various efforts needed to see the project through from beginning to end. In Yoshitoshi's case, however, it seems likely, as his fame and artistry grew, that he was allowed a greater degree of control than usual over the whole process.

When designing full-color prints—*nishiki-e*, or so-called

 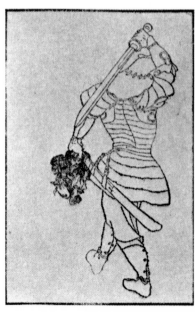

106. *Colorful Images of Famous Episodes in the Water Margin Saga*

107. Kikuchi Yōsai: *Sages of Earlier Times and Ancient Historical Events*

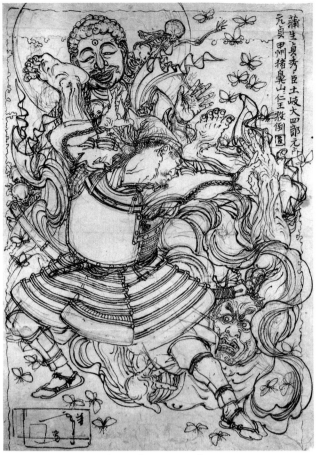

108. Working print-design for print in fig. 109

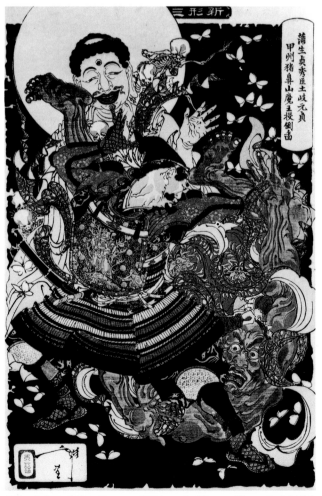

109. *Selected New Forms of Thirty-six Ghosts: Gamō Sadahide's Servant Toki Motosada Overthrows the Demon King of Mt. Inohana*

brocade pictures—the artist had to work clearly and methodically in collaboration with numerous craftsmen. Once the design was visualized in the mind's eye, the designer would make a drawing in black and white, adding notes for the engraver as to the colors. The engraver would then paste this drawing on wood, and precisely carve out the lines through the paper to make the key image block. Next, as many as sixteen or more color blocks, one for each pigment required, would be carved in registration with the key block. In this way, when every color area was printed layer on layer—in a prescribed order—the envisioned image would be built up with no slippage or unwanted overlapping of colors. That much understood, the sheer technical accomplishment of Yoshitoshi and other Ukiyo-e designers, working hand-in-hand with engravers to create pictures filled with such fine linework and detailing, becomes a thing of wonder.

Yoshitoshi was a consummate draftsman, and according to all reports was constantly drawing. An enthusiast for rendering from life as his mentor Kuniyoshi had been, as well as an all-round perfectionist, Yoshitoshi would often ask close acquaintances to pose for him so that he could be assured of anatomical accuracy and realistic draping of clothes. He frequently went on sketching trips accompanied by one or more apprentices; his eye-witness sketches of the dead and wounded at the Battle of Ueno in 1868 were extremely important in lending his early warrior prints impact and authenticity. On occasion, as an alternative to direct observation, he would adapt figures and other elements from the works of earlier masters; three illustrations in the popular storybook *Colorful Images of Famous Episodes in the Water Margin Saga* (*Shūzō Suiko Meimeiden*; fig. 106) of 1867, for instance, are unmistakably based on woodcut-reproduced figure drawings by the painter Kikuchi Yōsai (1788-1878) in his twenty-volume *Sages of Earlier Times and Ancient Historical Events* (*Zenken Kojitsu*; fig. 107), indicating that Yoshitoshi frequently did considerable background study preparatory to his own work.

Working from such preliminaries, Yoshitoshi would block out the overall composition for a particular image. Some surviving print-design drawings, ones that for some reason were not used and hence not destroyed in carving, show that he might rough in the general forms in red ink before going over the final lines in black (fig. 114). Often his lines are no wider than a single strand of hair.

As a print artist, Yoshitoshi worked entirely within formats traditional to Ukiyo-e, although his genius was to use them in many striking new schemes of layout. By far the most standard paper size was the so-called large format or *ōban*, approximately 10 x 15 inches (25.4 x 38.1 cm). Whether as single sheets or as unit panels for diptychs and triptychs, most Ukiyo-e prints were in fact done on *ōban* paper. Of course, as we have suggested, the choice of compositional applications were at the discretion of the artist or publisher.

Among Yoshitoshi's prints, single-panel works and triptychs predominate, diptychs being few in number. We do not have far to look for a reason. As a single sheet, the *ōban* presented a rather limited picture area. Thus while it was rarely used for single, independent prints, it proved just the thing for extended series of images covering the length of a popular tale, or for thematic surveys of otherwise isolated groups of portrait figures. Yoshitoshi produced such print series almost continually throughout his career, and indeed these running

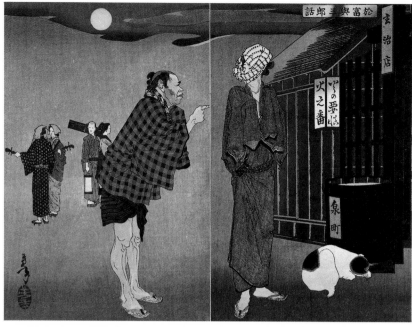

110. Studies for *The Story of Otomi and Yosaburō* (see fig. 111)
111. *Newly Selected Edo Color Prints: The Story of Otomi and Yosaburō*

112. *Newly Selected Edo Color Prints: Attack by Night*
113. Studies for *Attack by Night* (see fig. 112)

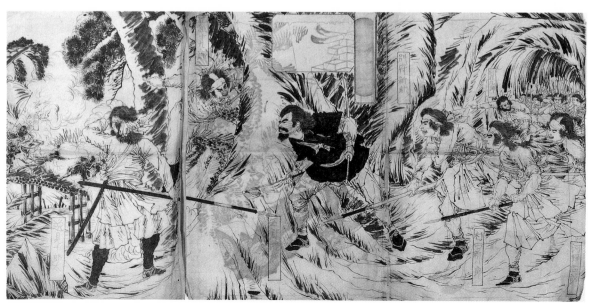

114. Untitled print-design drawing

115. *Hōjō Takatoki Tormented by Goblins*

single-sheet expositions included many ambitious works: *One Hundred Ghost Stories of Japan and China* (1865), *Twenty-eight Infamous Murders with Accompanying Verses* (1866–67), *One Hundred Selections of Warriors in Battle* (1868–69), *A Yoshitoshi Miscellany of Figures from Literature* (1872–73), *A Collection of Desires* (1877), *A Mirror of Famous Generals of Japan* (1878–82), *Yoshitoshi's Warriors Bristling with Courage* (*Yoshitoshi Musha Burui*; 1883–86, figs. 115–17), *One Hundred Aspects of the Moon* (1885–91), *Thirty-two Aspects of Women* (1888), and what was perhaps the most perfect embodiment of his vision, *Selected New Forms of Thirty-six Ghosts* (1889–92).

In his prime, Yoshitoshi was as prolific as he was talented, producing literally dozens of print series of ten or more images each. The largest of these was the full hundred-print series *One Hundred Aspects of the Moon*, followed by *One Hundred Ghost Stories* and *One Hundred Selections of Warriors in Battle*, neither of the latter, however, attaining the intended number. Furthermore, the so-called full-color newspaper prints (*shimbun nishiki-e*), which were created as supplements for various newspapers, were likewise done as *ōban* single sheets (pls. 20–21). The only major series to comprise diptychs was his *Newly Selected Edo Color Prints* (1885–86), a brilliant collection of pictorializations of well-known tales.

For an artist with Yoshitoshi's eye for drama and pageant, however, it was the spacious *ōban* triptych that proved the perfect medium for the violent action of his warrior prints and the larger-than-life, epic quality of his historical prints.

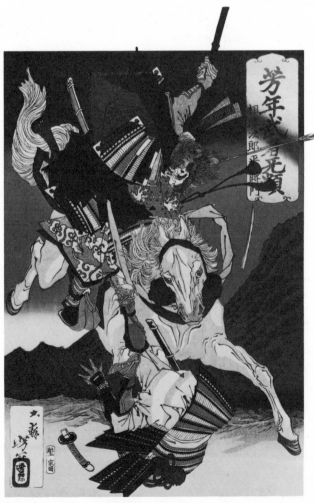

116. *Sagami Jirō and Taira no Masakado*

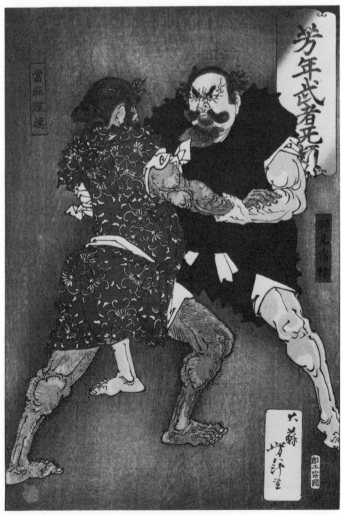

117. *Nomi no Sukune and Taima no Kehaya*

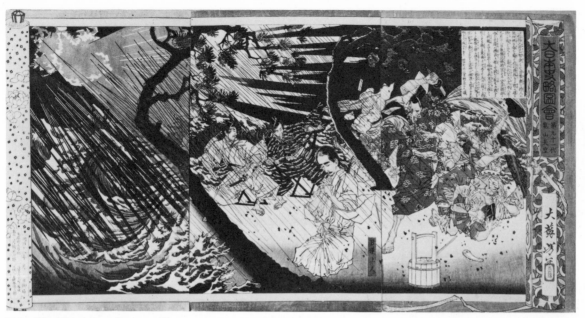

118. *The Ninety-first Emperor Kameyama*

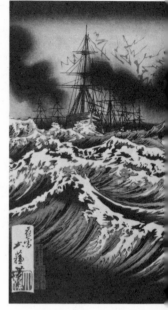

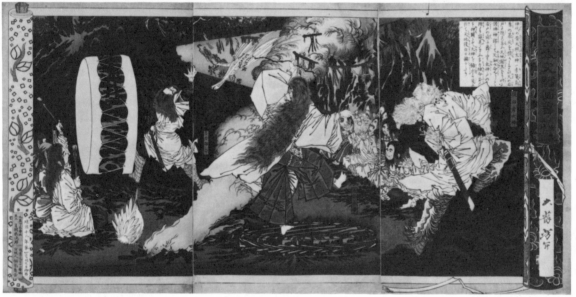

119. *Amaterasu the Sun Goddess*

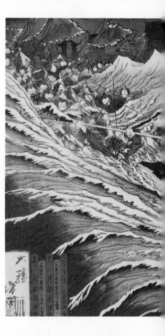

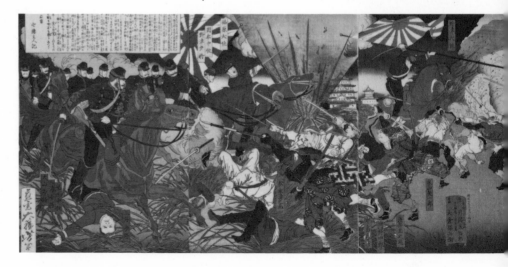

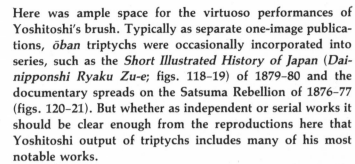

Here was ample space for the virtuoso performances of Yoshitoshi's brush. Typically as separate one-image publications, ōban triptychs were occasionally incorporated into series, such as the *Short Illustrated History of Japan* (*Dainipponshi Ryaku Zu-e*; figs. 118–19) of 1879–80 and the documentary spreads on the Satsuma Rebellion of 1876–77 (figs. 120–21). But whether as independent or serial works it should be clear enough from the reproductions here that Yoshitoshi output of triptychs includes many of his most notable works.

Aside from the triptychs, there were also a few highly unusual variants in ōban multiples, such as long scroll-like panoramas of five or more sheets (fig. 122). Although these were not wholly without precedent in the history of Ukiyo-e, Yoshitoshi took special delight in experimenting with novel schemes of composition, sometimes pushing layouts to their limits to overwhelm the viewer. The five- or six-panel print was something of a standard as these compositions went, most often used to depict parades or military maneuvers, but Yoshitoshi dared to stretch certain landscape and warrior images out to an unheard of nine, ten, even twelve panels.

And as if that was not enough, he also tried exploring another dimension in prints: the vertical. Here again, there had been others before him—notably such Utagawa-school artists as Toyohiro, who created "pillar prints" (*hashira-e*) to accentuate the full height of willowy courtesans—but the credit goes to Yoshitoshi for making the most of vertical composition. The extreme achievement in this direction was an 1868 extravaganza showing the general Taira no Kiyomori at the foot of a three-panel cataract (fig. 123). Aside from this particular piece, however, the rest were composed of two panels exclusively. These he created in some number, especially from 1885 on, so that they became somewhat of a trademark for the artist in his later years.

Over and above the five formats we have discussed, there also were an assortment of minor works on both smaller and oversize papers, as well as several examples of *sugoroku* game boards (fig. 124). With this much variety to his formats, it should be evident that Yoshitoshi possessed a surprisingly modern interest in exploring the possibilities of the print medium and an inventive bent to match. Even so, he would hardly have had the opportunity to go on experimenting as he did had he not been so good and deservedly popular at what he did. Nor would we look back on his works with such interest today had he not correlated these formats so successfully with his subjects and style to create a bold pictorial space.

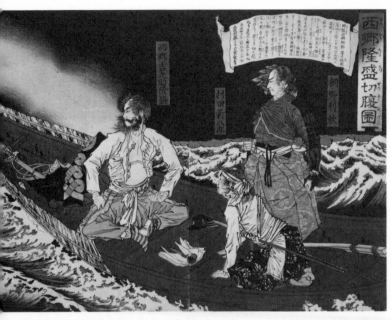

120. *Saigō Takamori Commits Harakiri at Sea*

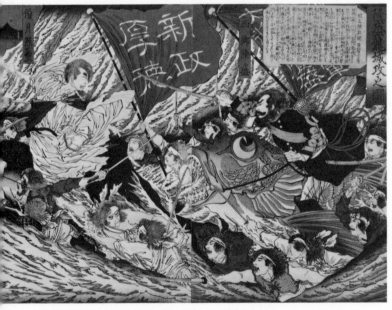

121. *Saigō Takamori Attacks the Dragon Palace*

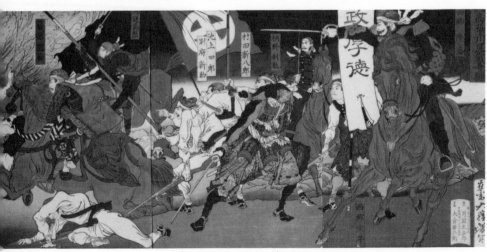

122. *Battle in Takahashi and Kawajiri*

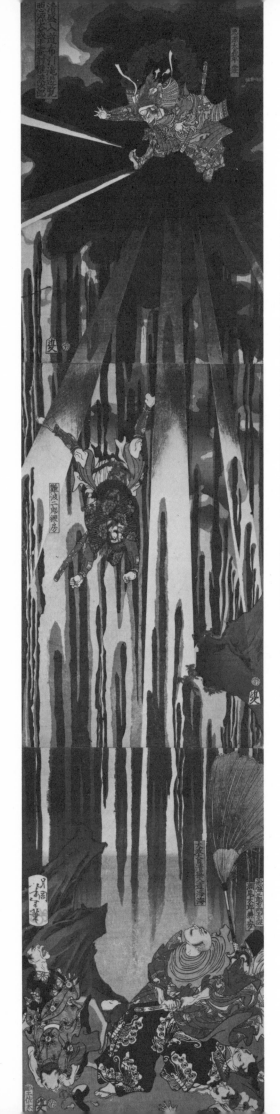

123. *Taira no Kiyomori Watches Evil Genta Strike Naniwa Jirō
Down at Nunobiki Waterfall*

124. Sugoroku game boards: *A Celebration of Battles
throughout the Provinces*

THEMES AND PICTORIAL STYLE

Any thematic or stylistic consideration of Yoshitoshi's art must first overcome the major obstacles presented by the immense quantity and diversity of his total production. If the reports made by his apprentice and self-appointed biographer Yamanaka Kodō are at all reliable, his main titles alone would range around the five hundred mark. If each individual title in all of the series were counted, however, the number would exceed ten thousand. And that excludes a vast array of illustrations for books, newspapers, and other periodical literature.

True, there have been other Ukiyo-e masters who topped this figure. Kunisada's seemingly superhuman output comprised upwards of sixty thousand works, and Hokusai managed about fifteen thousand. In both cases, however, the artists were exceedingly long-lived, and the calculations include a great many workshop-grade pieces and illustrations. The remarkable thing about Yoshitoshi is that he was able to create so many high-quality works, especially when we remember that for at least five years out of his under-forty-year active period he was incapacitated by severe illness. Yoshitoshi was unquestionably the most individual and multitalented genius since Hokusai.

How, then, are we to approach this body of work so vastly diversified in subject matter and genre of presentation? We begin by realizing that Yoshitoshi never "dabbled" in anything. Wherever his far-ranging interests led him, he always went the whole measure, learning all there was to know about his subject, feeling out the possibilities for working it up into salable art, and then leaping into full production. These leaps might tend to make his artistic development appear disjointed, but if we look for thematic clues to his thinking, we find certain threads running throughout.

The most essential overall thematic groupings in Yoshitoshi's art are either theatrical or historical in content. As an artist born at the height of Edo popular culture, Yoshitoshi would have instinctively turned to the theater or to well-known tales for material. Naturally enough, the one could be expressed rather directly from viewing plays, while the other required a more wholly inventive sort of imagination. With the latter, elements had to be "made from scratch" before they could even be composed into a picture. Yet even his more factual subjects might well be treated as starting points for free visualization. Yoshitoshi's images, for all their often traditional subject matter, frequently anticipate a modern experimental attitude toward pictorial expression.

The distinction between theatrical themes and historical themes is, of course, very delicate and at times debatable. As we have noted elsewhere, Yoshitoshi would sometimes lift an actor-in-role right off the stage; thus, some actor prints ended up as warrior prints (figs. 125–26). Conversely, the underlying image for more than a few pictorializations from the past was surely something he saw staged.

In the final analysis, except for those works clearly conceived as genre prints or portraits, the vast majority of his pictures act as vehicles for narration. Needless to say, Yoshitoshi's images abound with references—that much is only to be expected of an artist as well versed in literature and folklore as Yoshitoshi. What makes his pictorializations stand out is his conciseness in compressing a story into a single panel by means of carefully chosen details, as well as his originality in cross-referencing elements from a number of

125. *The Glory of Seven Heroes: Bandō Hikosaburō V as Hashiba Hideyoshi*

126. *The Glory of Seven Heroes: Ichikawa Danjūrō IX as Shibata Katsuie*

sources in order to create a better story. This free-thinking ability to sweep across the whole of Japanese (and frequently Chinese) history says volumes about his erudition. Yet still more significant was his lack of pretension, his willingness to bring that breadth of knowledge down to a level that would appeal to the common person. His images would have been immediately recognizable to any Japanese of his time, just as today they strike us with their vividness and immediacy even if we fail to appreciate all the references. There is never any doubt when a Yoshitoshi picture tells a story.

More than any other artist before him, Yoshitoshi succeeded in fusing drama and composition. This achievement was, in fact, a fulfillment of one current in the Ukiyo-e tradition. In Yoshitoshi's hands, pictorialization of the past—which had originally meant nothing so much as incidental illustration work, and which had been gradually elevated to the status of an art form in its own right through the pioneering efforts of Harunobu, Utamaro, Hokusai, and most notably Kuniyoshi with his warrior prints—now completely bridged the gap between descriptive and narrative art. The *Hokusai Sketchbooks* (*Hokusai Manga*), for all their wealth of insight into the lives of the people, were basically just sketches and life-studies; Yoshitoshi's people all relate to specific tales or incidents.

Stylistically, the Utagawa school to which Yoshitoshi belonged had been greatly influenced from its inception by Dutch copperplate engravings. By the time we get to Kuniyoshi, knowledge of Western perspective and anatomical studies was already quite advanced. Probably no artist in the history of Ukiyo-e tried so conscientiously to absorb such elements of Western pictorial style as Kuniyoshi. As we have mentioned, he became quite emphatic about principles of direct observation. He even kept a menagerie of

127-30. Album leaves

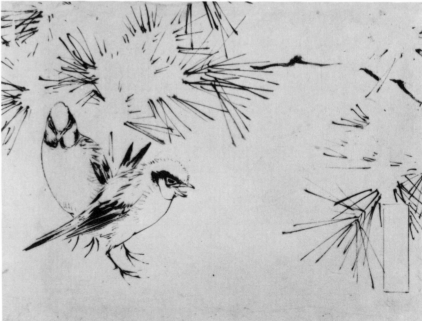

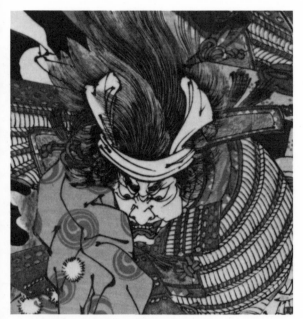

131. Detail: *Evil Genta Fells Naniwa Jirō at Nunobiki Waterfall* (pl. 45)

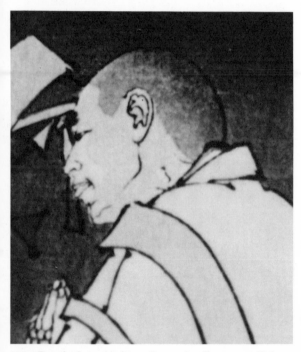

132. Detail: *Saint Nichiren Saves the Cormorant Fisherman* (pl. 53)

animals and birds at his studio for instructing his pupils in drawing. Yoshitoshi, as one of the youngest apprentices to receive such training from Kuniyoshi, naturally imbibed these principles from his earliest years (figs. 127–30). They became an almost innate part of his artistic repertoire, not particularly regarded as alien in origin.

Yoshitoshi, moreover, went on to live half his life in the Meiji era, when the open-door policy toward modernization suddenly inundated Japan with cultural and technological imports. Certainly Yoshitoshi had ample opportunity to see many Western artworks firsthand. He reputedly even studied oil painting for a period around 1879 in connection with his series *A Mirror of Famous Generals of Japan* (pl. 19, figs. 52–54). Western influence is visible in his adoption of new schemes of spatial recession and views of the human figure projected from angles never before seen in Ukiyo-e (figs. 131–32). His palette was greatly expanded, and he actively experimented with unusual color, pattern, and texture combinations. A debt to photography is noticeable in more realistic depictions of transparency, as with ghosts and smoke (figs. 133–34), but probably most obvious in the treatment of light, such as the moonlight on the water in the 1883 print *Umewaka and the Child Seller* (pl. 52). When he had occasion to portray Western-style clothing for his reportage work and genre prints, the folds of sleeves might be overprinted with darker tones in imitation of Western shading (figs. 135–36). In general, however, he drew the line at outright Western shaded rendering, preferring instead to mold kimono shapes to the body by means of contour lines and pattern offsets (figs. 137–39).

Yoshitoshi's linework, especially from the early 1880s, is particularly distinctive. Whereas figures in his earlier works were outlined in a steady hand much the same as that of

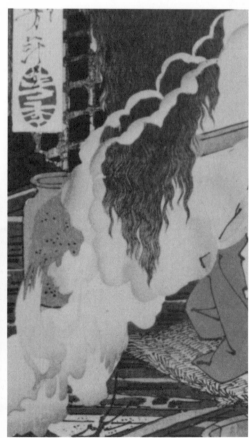

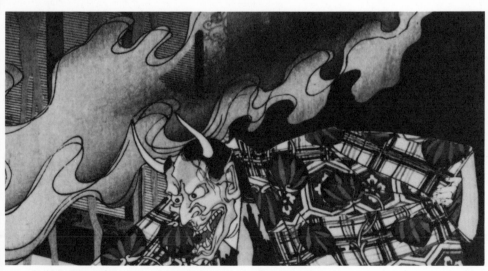

133. Detail: *The Other Murasaki with Genji in the Provinces* (pl. 51)

134. Detail: *The Hag of Adachigahara* (pl. 49)

any other Ukiyo-e artist (fig. 140), his mature style features lines that are much finer, sharper, and swifter (fig. 141). They are on the whole more calligraphic; they zigzag at a nervous pitch and terminate in quick switchbacks of the brush tip (fig. 142). The resulting contours are more detailed and responsive to forms in motion. This helped make his images more dynamic and his figures more individualized.

His mature style is characteristically more subdued. Harsh aniline dyes are applied with the greatest restraint, and only to accentuate the total color harmonies (pl. 22). He returned to a greater use of traditional vegetable dyes to yield subtle color tonalities, but the effects were in no way "classicist" because he layered them in new and different schemes of gradation and patterning. Thus, although he was essentially a traditionalist in choosing to work strictly with line and planes of color, his meticulous attention to detail took him beyond the "old school" of Edo Ukiyo-e. His was a more consciously selective and idiosyncratic expression.

It is all the more amazing, then, that within these self-imposed stylistic limits he never once repeated himself, nor stooped to mere copying of earlier greats. When he adopted elements from others' work, he invariably used them in novel ways. His prints are always boldly composed and visually appealing. Yoshitoshi's inventiveness is a constant delight as he plays across that fine line between preservation and innovation. Working within a centuries-old tradition, Yoshitoshi was constantly probing to see just how far he could stretch the mold without breaking it.

137. Detail: *Smokey* (pl. 56)

138. Detail: *Itchy* (pl. 57)

135. Detail: *The Decorated Tree* (fig. 71)

136. Detail: *Preparing to Take a Stroll* (fig. 103, no. 31)

139. Detail: *The Story of Jirō-zaemon of Sano* (pl. 33)

140. Detail: *Inada Kyūzō Shinsuke Murders the Kitchen Maid* (pl. 5)

141. Detail: *The Old Woman Retrieves Her Arm* (pl. 48)

142. Detail: *Fujiwara no Yasumasa Plays the Flute by Moonlight* (foldout)

AESTHETIC VISION

Yoshitoshi's aesthetics underwent radical change as his career progressed. While to some degree this was a function of a simple maturing process, an increased fluency in the language of print design gained over years of experience, fluency alone could not account for the eloquence of his later works. We have already noted striking stylistic differences between his initial efforts and those of his last decade. It seems fairly obvious, then, that at some point in the middle of his career Yoshitoshi came to a new and greater conception of his art.

The change comes into clearer focus if we look at one peculiar undercurrent through the whole of his life as an artist. A decidedly dark streak, much as we would wish to play it down in order to gain a more well-rounded picture of Yoshitoshi, underscores many of his works. Perhaps it was a matter of taste—rumors circulated about "sexual sadism" toward his women. Perhaps it was temperament—even when not ill, he sometimes saw ghosts. Or again, perhaps it was just that the twilight world presented the most stimulating challenge to his powers of imagination. Whatever the reason, Yoshitoshi proved himself singularly adept at depicting disturbing subjects. Almost from the outset, he was producing works such as *One Hundred Ghost Stories of Japan and China* (1865; pls. 2–4), and the two *koban* "small format" series *A Mirror of Weird Tales from Japan and China* (*Wakan Kidan Kagami*, 1867) and *Diverse Grotesques* (*Kaii Zoroi*, 1869). In 1880, supposedly after seeing the specter of his deceased wife, he began to design the series *Exposition of One Hundred Phantasms* (*Kankyo Hyakuran Kai*), which was abandoned at thirty-one drawings and never published. Then late in his career, his interest once again turned to depicting the occult in *Selected New Forms of Thirty-six Ghosts* (1889–92; pls. 43–48, fig. 94)—but what a difference in the aesthetics of depiction.

It is no coincidence that Yoshitoshi's style veered sharply away from shock-value overstatement toward the psychological power of suggestion when it did. The 1882 triptych *The Other Murasaki with Genji in the Provinces* (pl. 52) marks a major turning point, revealing at the same time the nature of the change: here we are face-to-face with a Noh performer, complete with mask and *kosode* brocade robe, acting out the part of a spiteful *hannya* she-devil. From around this very time, Yoshitoshi began to derive aesthetic inspiration from the Noh theater and its guiding principle of *yūgen*. Gone is the striving for spectacle that Yoshitoshi learned from Kabuki, and in its place is an underplayed sense of tension and poise, a restraint and poetic pathos. In *One Hundred Aspects of the Moon* (pls. 26–30, fig. 72) and *Thirty-six Ghosts* (pls. 43–48, fig. 94), the two masterful series most exemplary of Yoshitoshi's vision of *yūgen*, each image evokes a mood. There is an aesthetic detachment, a contemplative distancing that gives these works a feeling of tranquility and mystery. Characteristically, even when the subject relates to some gruesome tale, we are no longer shown the climactic deed, but the moment just preceding it. In the two treatments of the legend of the hag of Adachigahara Yoshitoshi created during these late years—one in the *One Hundred Moons* series (pl. 16), the other the vertical diptych of 1885 (pl. 49)—the sense of foreboding and horror is heightened by showing the old woman getting ready to murder her victim. The young Yoshitoshi would have had the knife plunging in.

The Noh theater, like all the traditional arts, had suffered

143–44. *Illustrated Primer for Language Students*

145–46. *Floating Clouds*

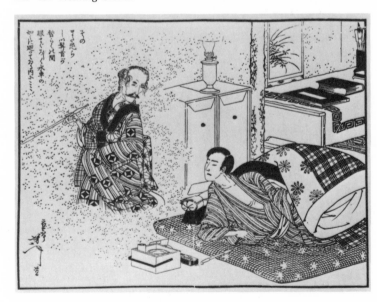

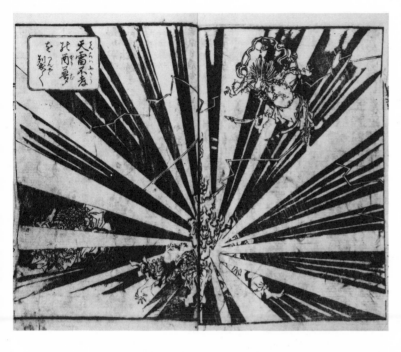

greatly as a result of Meiji Westernization. Many schools had all but disbanded. It was not until 1881 that Noh was able to gain a new following through the efforts of Iwakura Tomomi and his friends in the aristocracy. Yoshitoshi's exposure to Noh came soon thereafter. Eventually his fascination with it grew to such proportions that he himself began taking lessons in Noh recitation. Even works whose subject matter derived from Kabuki, such as the *Newly Selected Edo Color Prints* (1885–86; pls. 33–37, figs. 74–85), were now handled with a subtlety and restraint that bespoke Noh aesthetics.

There is no telling exactly how far Yoshitoshi went in his understanding of Noh, but the overall developmental scheme of his aesthetics over the course of his career bears a striking resemblance to the five-level development in classes of Noh plays. Yoshitoshi's first works, the warrior prints, were in the vein of the male-dominant *shuramono* fallen warrior plays; in these, violence reigns. Next, he moved to genre prints and assorted supernatural subjects, forays into the realms of female *kazuramono* plays and divine *kamimono* plays. And finally, Yoshitoshi's depictions of the ethereal attain the other-worldly heights of the disturbing *kyōranmono* insanity plays and demonic *kichikumono* plays.

It is in giving realistic expression to the intangible that Yoshitoshi brought his art to its culmination. Ghosts and spirits, things not usually seen, take on a chilling physical presence from his brush. Yoshitoshi's astonishing power to convince the viewer that these things are *really not there* has no equal in any artist before or since. Yet another fine line for his own discipline, it was here Yoshitoshi found his ultimate challenge, having already exhausted representation of visible phenomena. In the best of Yoshitoshi's images, we can almost hear the sound of the wind blowing through the *susuki* grass far off in the distance.

BOOK ILLUSTRATIONS

Yoshitoshi was a forerunner of modern book illustration in Japan. Starting from a rather humble first effort, the 1853 reprint of the textbook *Illustrated Primer for Language Students* (*Ehon Jitsugokyō Dōjikyō Yoshi*; figs. 143–44), an assignment that apparently fell by default to Kuniyoshi's then fourteen-year-old apprentice, Yoshitoshi eventually worked his way up to his own choice of projects. In 1858, he illustrated the narrative *Extracts from a Military Memoir* (*Gunji Kōdan Yomikiri Ichidaiki*), and followed in the final decade before the Meiji Restoration with eight volumes of humorous stories.

Soon after Japan entered the new era, he illustrated the 1869 publication *Further Funny Stories Told along the Chestnut-Burred Tōkaidō* (*Zokuhen Tōkaidō Hiza Kurige Dōchū Kokkei Banashi*). Then after a hiatus of some eleven years, he returned to book work, coming out not only with humorous pieces as before, but also illustrating informative texts and translations of foreign fiction. Year after year he kept himself busy with a steady volume of projects, culminating in the late 1880s with a number of illustrations and bound supplements for the newspaper *Yamato Shimbun*, as well as an 1887 collaboration with the younger painter and printmaker Ogata Gekkō (1859–1920) to illustrate a continuation of the novel *Floating Clouds* (*Ukigumo*; figs. 145–46) by Futabatei Shimei (1865–1909).

This last effort should be seen as one of major importance: *Floating Clouds* was the first novel to be written in modern

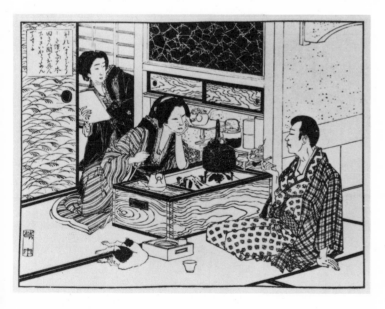

147–50. Book composed of five three-folio sets: *Prophesy at the Crossroads at Ten O'Clock One Frosty Night*

 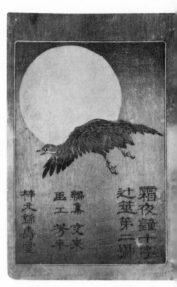

Cover-wraps for individual sets

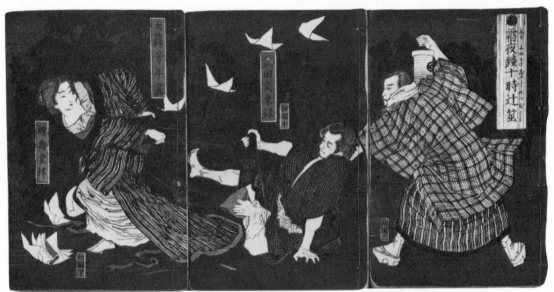

Covers of first three-folio set

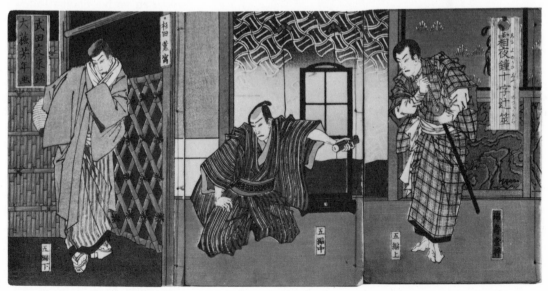

Covers of fifth three-folio set

Illustrations from book

colloquial Japanese and to deal with the modern Western-influenced theme of the sensitive, intellectual youth vacillating between ideologies. Add to this Yoshitoshi's artwork for pages of translated novels, and we begin to see how very contemporary his outlook on illustration was. Indeed, the skills and finesse he developed in his historical prints was put to good use toward the creation of a new direction in popular art, the now-dominant popular arts of mass publication. His achievements in traditional book illustration were no less impressive, however. Witness his unforgettably beautiful and inventive work for the 1880 book *Prophesy at the Crossroads at Ten O'Clock One Frosty Night* (*Shimoyo no Kane Jūji no Tsujiura*; figs. 147–50): five sets of three small folios, which spread out to form five triptychs plus an illustrated cover-wrap for each. These covers have been acclaimed as the pinnacle of achievement in Edo-style book illustration.

BRUSH PAINTINGS

Brush paintings by Yoshitoshi are extremely few. Even in prewar Japan, the very highest count reported was a mere thirty works. Today, the figure falls considerably below that, around sixteen.

The oldest recorded painting, as well as the oldest still in existence, is the so-called *Great Curtain* (*Mammaku-e*), titled *Sakuma Morimasa Foiled by Hashiba Hideyoshi* (*Sakuma Morimasa Hashiba Hideyoshi o Nerau Zu*; pl. 65), produced in 1865 for a Shinto festival in honor of the guardian deities of the thoroughfare running from Edo to the city of Kōfu in the mountains to the west. As the name indicates, the work is of immense proportions, and its grand scale gave ample room for the young Yoshitoshi to display his knowledge of the Kanō-school style. It would seem, then, that alongside his apprenticeship in Ukiyo-e print design under Kuniyoshi, he had also undertaken separate study in Kanō-style painting.

Yoshitoshi's travels took him back to Kōfu in 1874, and he is said to have executed a number of paintings there, but only one remains today. In the same year he painted a wooden votive plaque (*ema*) of the *Hundredth Fireman's Brigade* (*Hyakkumi Shōbōtai*) for Sōjiji temple in the Nishi Arai district of northern Tokyo, but alas it did not ward off fire as it was intended to, and this work too was lost. Another wooden votive plaque followed in 1879, this one depicting the *Ma Brigade Firemen* (*Ma-gumi Shōbōtai*) for Hikawa Shrine in the central Akasaka district of Tokyo; fortunately it has survived with remarkably vivid pigmentation (pl. 64).

In 1882 Yoshitoshi was invited to participate in the first government-sponsored exhibition of Japanese painting. He submitted three works: *Fujiwara Yasumasa and Hakamadare Yasusuke* (*Yasumasa Yasusuke Zu*), *The Wind and Thunder Gods* (*Fūjin Raijin Zu*), and one other; all three have since disappeared. A work thought to date from the following year, the small panel entitled *Festival Float with Orangutans* (*Shōjō Dashi no Zu*), has been preserved at Hikawa Shrine, while yet another from around the same time, *The Hag of the Lone House of Adachigahara* (*Hitotsuya Rōba no Zu*), presented to the Myōon-in subtemple of the Dempōin compound in Asakusa, deteriorated while in storage, was moved about, and eventually lost.

In 1885, he painted a wooden votive plaque of the protective deity *Fudō* (*Fudō Myōō Zu*; fig. 151) for the popular Buddhist temple dedicated to that divinity in Narita in Chiba Prefecture east of Tokyo. The temple also preserves one

more votive plaque of Gojō Bridge in Kyoto, the execution date of which is uncertain.

The next recorded mention of paintings comes in 1888, when disciple Matsui Eikichi set up shop in Asakusa, and there held an exhibition-sale of Yoshitoshi's brush paintings on silk. Most extant authenticated hanging scrolls of subjects unrelated to his prints seem to trace back to this time.

Lastly, there was the folding screen *Red Cliff Landscape* (*Sekiheki no Sansui Zu*), which Yoshitoshi painted the following year as one of twelve artists invited to exhibit at Tōyōdō Gallery; this is another work that has vanished without trace. Nonetheless, as a subject more typical to *nanga* literati painting—the "Red Cliff" here refers to the classic *Red Cliff Odes* by Northern Sung painter and poet Su Shih—it raises questions as to whether Yoshitoshi was turning away from Ukiyo-e genres at this point.

Very briefly, this sums up the recorded instances of Yoshitoshi's ventures into painting. Sadly, but not unexpectedly, few of the above works still exist. Of these, *The Great Curtain* and *Ma Brigade Firemen* must stand as the highest measure of the painter's hand. Even so, when the Seibu Museum in Tokyo held its Yoshitoshi retrospective in 1977, and every possible lead was traced, the author was able to locate no fewer than sixteen painted works by Yoshitoshi. While some of these were little more than studies, a number of impressive works did turn up on such subjects as the Noh play *Takasago* (fig. 152), the Chinese hero *Chung Kuei* (*Shōki*; figs. 153–54), the popular tale of the courtesan *Takao Dayū* (pl. 62), a rather grotesque *Severed Head* (*Sarashikubi Zu*; fig. 155), the lonely life of an exiled Heike warrior in Kyushu in the *Hyūga Shoreline* (*Hyūga no Kagekiyo*; fig. 156), the hauntings of *An Apparition* (*Yūrei no Zu*; pl. 67), *Yoshitsune and Benkei Fight on Gojō Bridge* (*Yoshitsune Benkei Gojō Hashi*; pl. 63), *Umewaka and Shinobu no Tōta* (*Umewakamaru to Shinobu no Tōta*; pl. 66), *Spontaneous Cat* (*Neko no Shibaraku*), and the legend of the enchantress *Sumizome, the Cherry Spirit* (*Sumizome Sakura*; fig. 157). None of these bear any date, but on purely stylistic grounds they would seem to date from his later years. Some are a direct continuation of the expression found in his prints; others relate more to the manner of the Shijō school of traditional Japanese painting. Later surveys have discovered something on the order of ten previously unknown paintings, but of all these works *An Apparition* exudes the most distinctive aura of sensuous mystery. This probably dates from his very last years.

In addition, there also exist some excellent picture albums by Yoshitoshi, mostly consisting of brush-and-ink life-studies, and a surprising number of studies toward print designs are still to be found scattered here and there.

This scant sampling makes it difficult to appraise this side of Yoshitoshi's art, but at the very least we can say his efforts were generally far superior to those of other Meiji Ukiyo-e artists. This view is further supported by the fact that several of Yoshitoshi's disciples demonstrated considerable talent for genre painting in the decades after his death. Yoshitoshi's favorite apprentice, Mizuno Toshikata (1866–1908), his disciples Ikeda Terukata (1883–1921), Ikeda Shōen (1888–1917), and Kaburagi Kiyokata (1878–1973), as well as Kiyokata's disciple Itō Shinsui (1898–1972) all traced their roots back to Yoshitoshi.

151. Painting of the deity Fudō

152. Painting based on Noh play *Takasago*

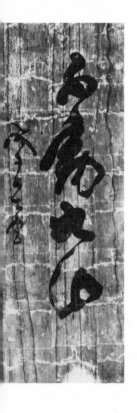

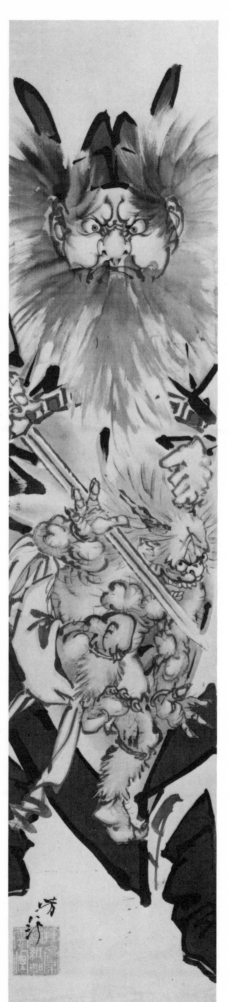

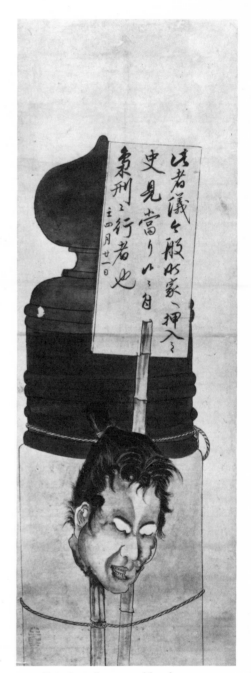

155. Painting of a severed head

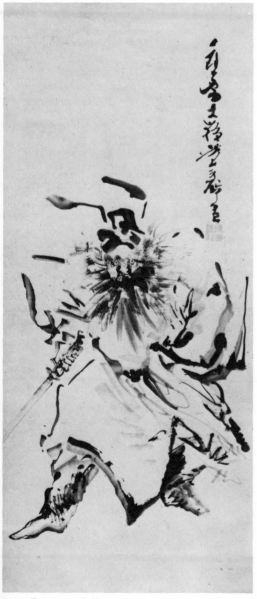

153. Painting of Chung Kuei

154. Painting of Chung Kuei

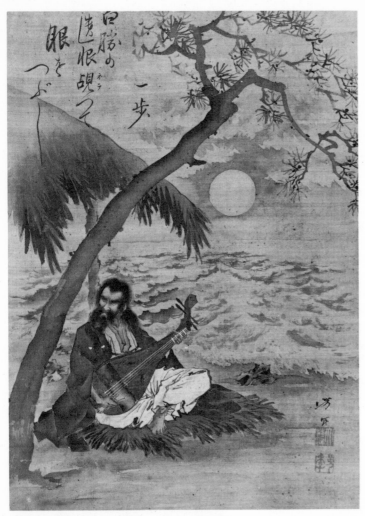

156. Painting of Kagekiyo at the Hyūga shoreline

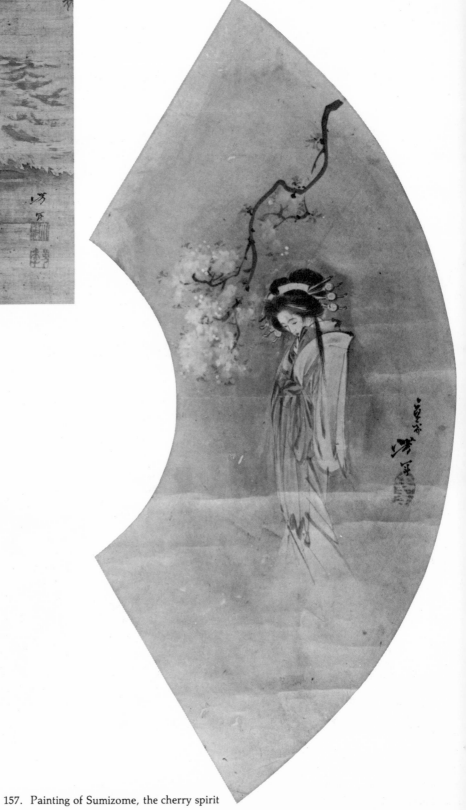

157. Painting of Sumizome, the cherry spirit

62. *The Courtesan Takao Dayū Weighs In*

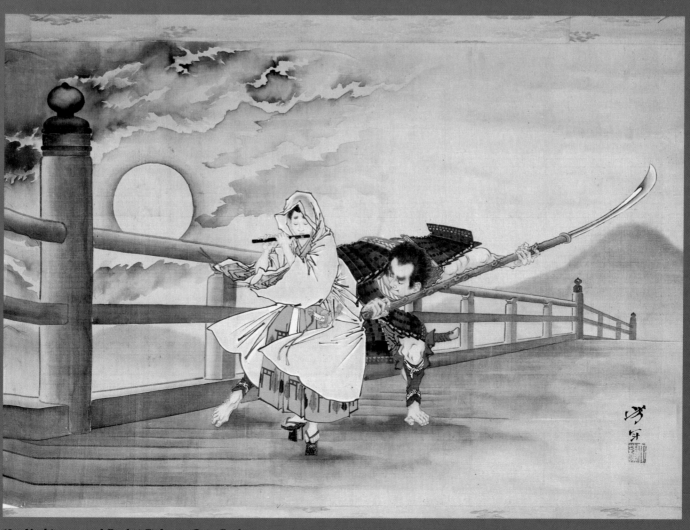

63. *Yoshitsune and Benkei Fight on Gojō Bridge*

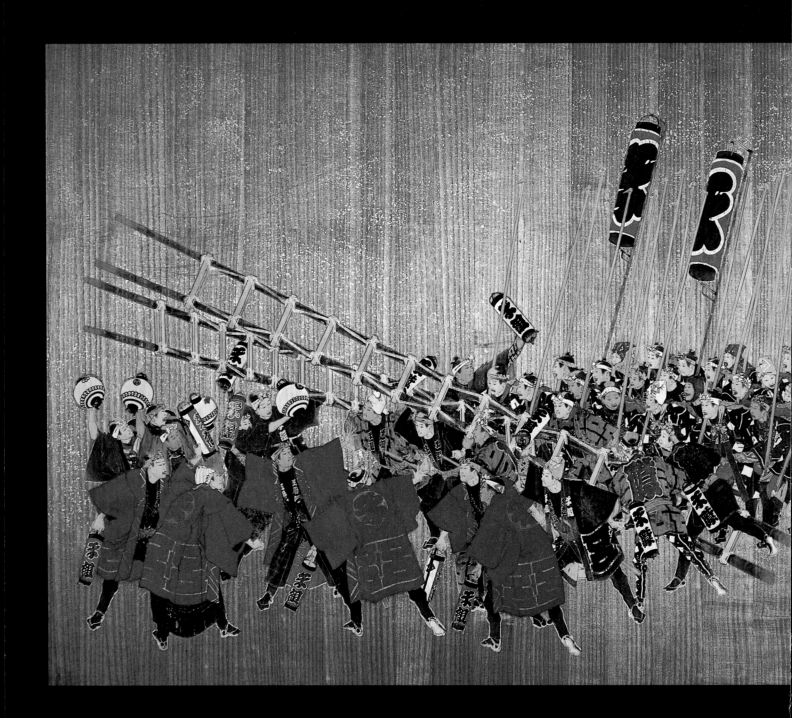

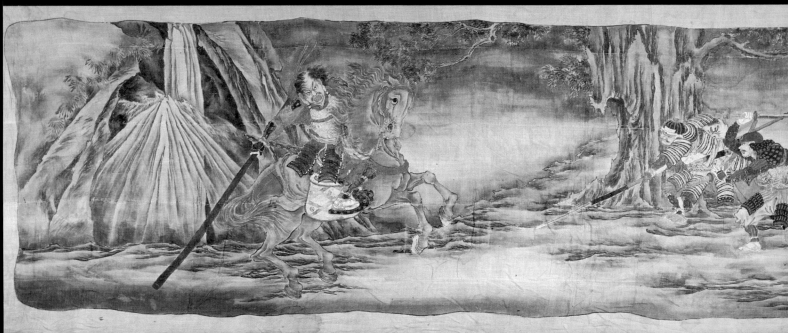

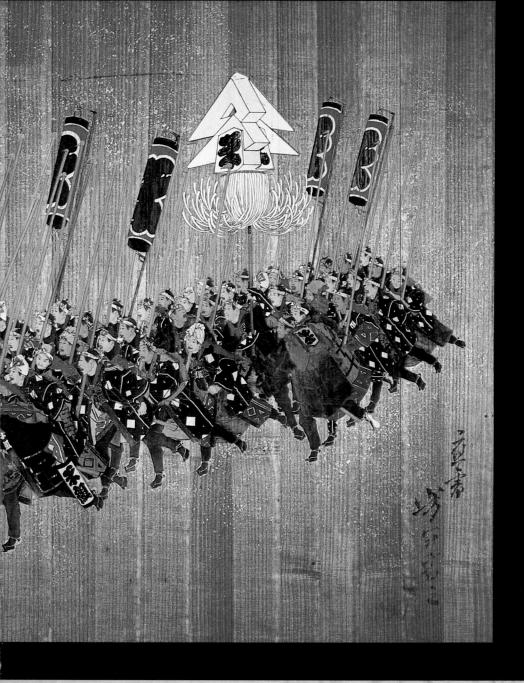

64. *Ma Brigade Firemen*
65. *The Great Curtain*

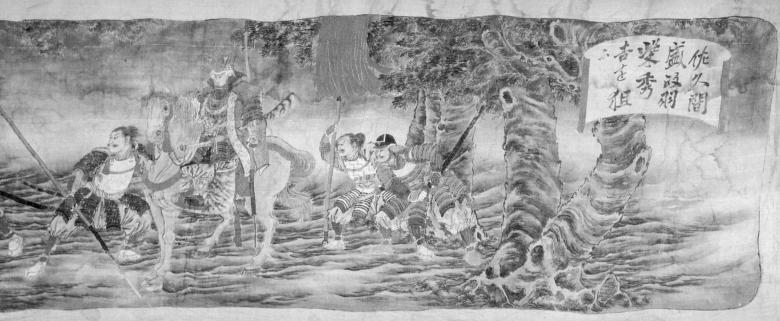

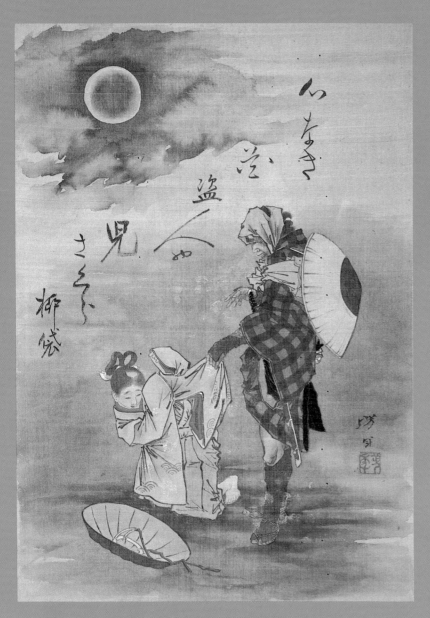

山を行く笠盗人の
見えぬ
さくら
柳翁

66. *Umewaka and Shinobu no Tōta*
67. *An Apparition*

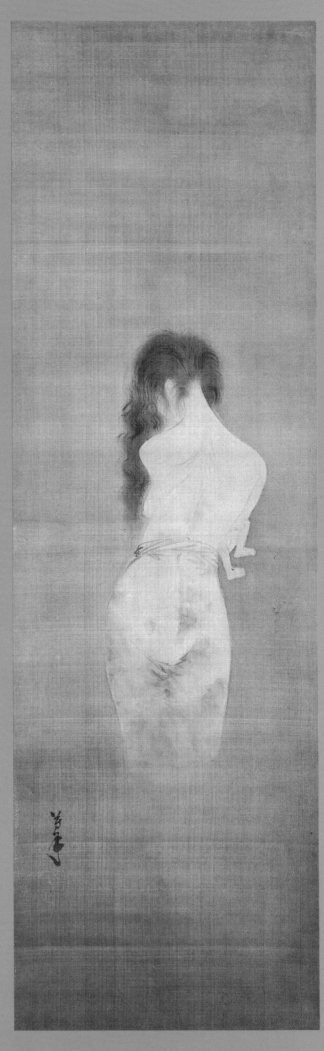

The Legacy of Yoshitoshi

158. Painting by Kawanabe Gyōsai

159. Paintings by Kobayashi Kiyochika

In the final balance, a traditional art form such as Ukiyo-e simply was not fated to survive into the modern age. The social changes that came on the heels the Meiji Restoration were too great, no longer registering on the same scale with previous Japanese history. The larger artist lineages, followers of Hokusai, Hiroshige, and Kunisada, eventually all closed up shop. Even Yoshitoshi's peers in the struggle to update and revitalize Ukiyo-e, leading Meiji printmakers Kawanabe Kyōsai (1831–89) and Kobayashi Kiyochika (1847–1915), failed to pass down their heritage to any disciple. Nonetheless, Yoshitoshi managed to instill in his more able apprentices such respect for his tradition in art that several lineages of practitioners continue to trace roots back to him.

Yoshitoshi was not soon forgotten. In the years immediately following his death, he was still much talked about. Novelist Nagai Kafū (1879–1959) eulogized him in his *Studies in Edo Art* (*Edo Geijutsuron*), saying that he offered "a last lingering glimpse of the world that was Edo Ukiyo-e."

Indeed, Yoshitoshi fired the imagination of many leading literary figures of the Meiji era. The eccentric writer Akutagawa Ryūnosuke (1892–1927), author of numerous fictional excursions into the subjective mind among which are the source stories for the Kurosawa film *Rashōmon*, admitted he could not sleep at night once his attention was riveted to the horrific visions of *Twenty-eight Infamous Murders*. Novelist Tanizaki Jun'ichirō (1886–1965) was also said to have derived inspiration from Yoshitoshi for his early stories dealing with decadence and evil. The problem was, of course, that even these writers tended to focus solely on the extreme aspects of Yoshitoshi's art rather than seeing it as a whole, and this worked to establish a widespread prejudicial view of Yoshitoshi as "that disturbed artist."

Even today, with the benefit of ninety year's perspective, the sheer quantity and diversity of Yoshitoshi's total oeuvre resists wholly inclusive evaluation. With over ten thousand images spread virtually over the entire thematic range of Ukiyo-e, there is almost too much to take in, let alone sum up.

Back in the Meiji years, Yoshitoshi's overall technical virtuosity drew occasional praise—Nagai Kafū commented on "an impenetrable precision to his draftsmanship that yet never strains for effect"—but the general public only had eyes for his genre prints of beauties. More than even his pictures of historical figures, mention of Yoshitoshi almost invariably upheld *Thirty-two Aspects of Women* as his crowning achievement, as again with Kafū: "His exacting delicacy

in handling the brush suffuses the figures' poses with graceful appeal." At the time, it was clearly the more orthodox aspect of his art in the mold of conventional Ukiyo-e that received greatest emphasis.

Later critiques likewise tended to see only one particular aspect of Yoshitoshi's art at the expense of all the rest, and this had been reflected in the publication of a number of books on one series or another, but never his total breadth. In fact, when the first Yoshitoshi retrospective exhibitions were held—at the Museum of East Asian Art, Cologne, in 1971, at the Seibu Museum of Art, Tokyo, in 1977, and at the Los Angeles County Museum of Art in 1980—the response was overwhelming. Most people, if they knew of Yoshitoshi at all, somehow assumed that he had done *only* genre prints, or *only* historical prints, or *only* images of decadent fantasy. Many viewers found it difficult to believe that all these works were by the hand of the very same artist.

Until Yoshitoshi began to recapture public attention in the late 1960s, opinion had remained sharply divided: most aficionados preferred *Thirty-two Aspects of Women* or *One Hundred Aspects of the Moon*, and perhaps even graciously allowed that stylistic similarities might be found between the two series, but it was just too much that they be asked to further extend that appreciation to the grisly scenes of *Twenty-eight Infamous Murders* or *One Hundred Warriors in Battle*. In this sense, Yoshitoshi was never wholly forgotten, but his fame rested somewhat unfairly on a rather biased sampling of his art. An almost physical aversion to his more bloody images became a blind spot.

Then, a reevaluation took place, with almost diametrically biased results. Most notably, novelist Mishima Yukio (1925–1970) extolled the decadent excess of *Twenty-eight Infamous Murders*. Once again, Yoshitoshi was reduced to half his full stature—this time the "crazed," "grotesque" half.

Both mutually exclusive verdicts on Yoshitoshi no doubt relate more to the changing tides of contemporary taste than to anything else. Both took his art out of proper historical context, which would have shown, as we have seen, that Yoshitoshi was responding in turn to changing social conditions. Yoshitoshi was decidedly not "either/or"; not strictly the last traditionalist some have tried to make him seem, nor entirely the sensational extremist, for he was as complex as the times he lived in.

Unless we weigh all his works in their polarities against what then prevailed in Japan, we will never truly understand his art. Without the counterbalance of standards for the time, we lose the sense of Yoshitoshi's art as a running commentary on an age. For if creativity consists in how one bends the rules, his creative responses to often ruthless progress must otherwise seem all too obsessive and indulgent—a random offshooting of divergent branches without a central trunk. This is the very picture we have had of Yoshitoshi until now.

The main aims of this book, then, have been to introduce readers to the total scope and development of Yoshitoshi's art, and to present a background of relevant information in which to ground all assessments. Final judgement must, of course, rest with the reader, but let it at least be suggested that Yoshitoshi not only did the most of any Ukiyo-e artist to push ahead with his tradition in the active spirit of Hokusai and Kuniyoshi, but actually came forth with untold innovations, thereby expanding the possiblities of the whole of Japanese art. If Yoshitoshi's career was the setting sun of a tradition, it was a splendid sunset indeed.

160. A letter written by Yoshitoshi

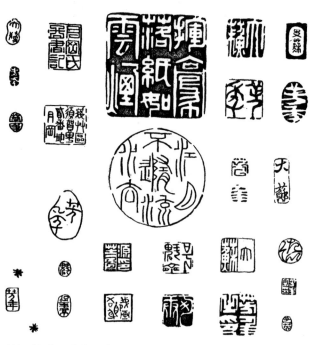

161. Yoshitoshi's seals

162. Yoshitoshi memorial stone, Hyakkaen park

NOTES
TO
THE
COLOR
PLATES

TITLE PAGE. *Taira no Kiyomori Burns with Fever* (*Taira no Kiyomori Hi no Yamai no Zu*)
 August 1883
 Ōban triptych
 Signature: Yoshitoshi *ga*
 Seal: Taiso
 Engraver: Yamamoto *tō*
 Printer: Suritsune
 Publisher: Akiyama Takeemon

True to the manner of medieval epics, the death of the tyrant Taira no Kiyomori (1118–81) takes on a supernatural dimension in the classic *Tale of the Heike Clan* (*Heike Monogatari*). First his wife Nii-dono has a nightmarish vision in which a carriage appears from the depths of hell destined to carry Kiyomori away in karmic retribution for having burned a temple. She then offers her prized possessions in the hopes of appeasing Emma-ō (Skt.: Yama), the King of Hell, but it is all in vain. Kiyomori succumbs to an intense fever, and not even the prayers of his children gathered at his bedside can relieve him of his misery, as he convulses in fits of hallucination.

In Yoshitoshi's print, Nii-dono and her son kneel in prayer while Kiyomori writhes in a fit of madness. Behind him emerges a demonic dreamscape of hell, presided over by the merciless Emma-ō in the center. Deceased souls of Kiyomori's victims drift into view along with fiendish ogres and other denizens of the netherworld. Yoshitoshi emphasizes the hallucinatory intensity of the fever-dream with an unusual yellow, green, and violet color scheme instead of the more typical flame orange and red.

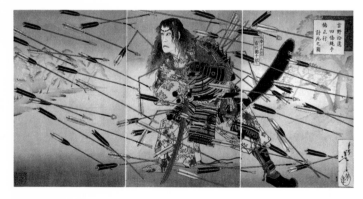

PAGES 6–7. *Kusunoki Masatsura's Last Stand at Shijōnawate* (*Yoshino Shuī Shijōnawate Kusunoki Masatsura Uchijini no Zu*)
 December 1, 1886
 Series: *Updated Theater* (*Engeki Kairyō*)
 Ōban triptych
 Signature: *ōju* Yoshitoshi
 Seal: Yoshitoshi
 Engraver: Enkatsu *tō*

Publisher: Matsui Eikichi

Kusunoki Masatsura (1326–48), eldest son of Masashige, was only ten years old when his father died at the hands the Ashikaga army of Ōmori Hikoshichi (see pl. 43). Sworn to vengeance, he led an uprising against the Ashikaga Clan in 1347, routing the troops under Hosokawa Akiuji and Yamana Tokiuji. At this juncture, the shogun Ashikaga Takauji (1305–58) reckoned he had better put down the troublemaker, and sent an army of 60,000 men against him. The twenty-two-year-old samurai put up a valiant fight, but was far outnumbered. His last stand at Shijōnawate in Kawachi (on the eastern edge of present-day Osaka) is remembered as a scene of peerless valor.

Yoshitoshi's portrait of his friend Ichikawa Danjūrō IX in the role of Masatsura is one of a handful of actor prints that he produced in his later years, after a hiatus of a solid decade. While he had continued to find subject material from the theater during the interim, it was always the story itself that concerned Yoshitoshi; actors were never mentioned. This print explicitly marked a return to the actor print genre. What prompted this decision is hard to know, but the title of the series, *Updated Theater*—a project that apparently went no further than this one image—suggests that Yoshitoshi felt that something of a Kabuki renaissance was underway at the time.

The picture is sheer drama. The pale background sets off the colorful figure of Danjūrō strutting and fretting and striking a *mie* pose amidst a literal shower of arrows (note the variety of points and feathers!). His hair is dishevelled and armor falling to pieces as he props himself up on his sword, but there is remarkably little blood. The intensity of his grimace, directed downstage, allows the left panel to remain virtually empty without upsetting the overall compositional balance. His fur-covered scabbard and boots (one already lost somewhere on the battlefield) provide a note of almost comic relief.

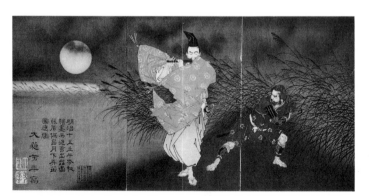

FOLDOUT. *Fujiwara no Yasumasa Plays the Flute by Moonlight* (*Fujiwara no Yasumasa Gekka Rōteki Zu*)
 February 12, 1883
 Ōban triptych
 Signature: *ōju* Taiso Yoshitoshi *sha*
 Seals: Taiso Yoshitoshi
 Publisher: Akiyama Takeemon

The legend of the Heian nobleman Fujiwara no Yasumasa (958–1036) is surely one of the most charming episodes collected in the twelfth-century anthology *Tales of Times Now Past* (*Konjaku Monogatari*). Therein is recounted the tale of this renowned poet and flutist out for a stroll on Ichiharano Moor, playing his flute in the moonlight. The autumn night was misty and chill, hinting of winter's approach. Lying in

wait among the stands of *susuki* grass was the highwayman Hakamadare Yasusuke, determined to obtain some winter clothing. Ready to draw his sword, the bandit crept up behind the aristocratic figure, clothed in many-layered robes as was the court fashion, but the courtier showed not the least sign of fear. So utterly disarming was Yasumasa's composure, so captivating his melody, that Yasusuke merely followed along behind him as if in a trance. Arriving back at Yasumasa's residence, the none-too-unmanageable ruffian was presented with a robe so that he would not go away empty-handed.

The story was adapted for the Kabuki stage, first danced in pantomime in 1822 by Onoe Kikugorō III and Ichikawa Danjūrō VII, and then revived in 1862 near the outset of Yoshitoshi's career. The subject is found in the works of Yoshitoshi's master, Kuniyoshi, and obviously appealed to Yoshitoshi as well, for he depicted it a number of times before and after this print, including once in the series *One Hundred Aspects of the Moon*. This particular composition, a definitive classic among Yoshitoshi's oeuvre, has its own remarkable history: initially painted as an entry for the first government-sponsored exhibition of modern Japanese painting in the autumn of 1882, the publisher Akiyama Buemon took interest and decided to issue this print triptych of the picture the following February; in March, Ichikawa Danjūrō IX based a highly-successful pantomime dance directly on Yoshitoshi's image; and in June, at Hie Shrine's Sannō Festival, a float of the tableau with life-size plaster figures painted by Yoshitoshi and costumed by Danjūrō was paraded down the streets, with Yoshitoshi himself seated in the prow. The outlandish festivities were parodied in Yoshitoshi's own newspaper, the *Illustrated Liberal* (*E-iri Jiyū Shimbun*).

Nishiki Ukiyo Kōdan) evoked action-packed scenes with relatively less written commentary.

This print depicts the fate of Tamigoro, who, according to the text by Sanzantei, was a famous wrestler. He took his own life after carrying out a vendetta against his father-in-law's murderer. The bloody depiction of Tamigorō firing a musket into his chest is typical of Yoshitoshi's earliest work, when publishers had him exploit even the most minor stories for their full sensational impact.

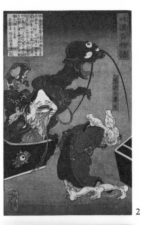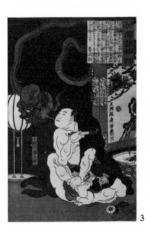

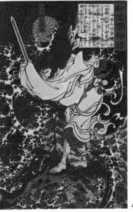

2. *The Greedy Old Woman* (*Donyoku no Baba*)
3. *Onogawa Kisaburō Humiliates a Ghoul* (*Onogawa Kisaburō*)
4. *Kung Sunsheng Conjures a Dragon* (*Nyūunryō Kō Sonshō*)
1865
Series: *One Hundred Ghost Stories of Japan and China* (*Wakan Hyaku Monogatari*)
Single *ōban* sheets
Signatures: Ikkaisai Yoshitoshi *ga* (pl. 3: Tsukioka Kaisai Yoshitoshi)
Seals: Yoshitoshi (pl. 3 only)
Publisher: Daikin

In old Japan, people would gather at night to hear a storyteller spin ghost stories, often a set number of one hundred. The best gathering place was a Buddhist temple with its nearby graveyard, and typically one hundred candles would be lit at the beginning, to be extinguished one by one after each story. By the end of the session, the audience would be huddled together in the pitch black, fully expecting a real ghost to appear (which was often obligingly provided by an accomplice of the storyteller).

Hokusai had previously started (and soon abandoned) a *One Hundred Ghost Stories* print series in the 1830s (see figs. 44–45), and Yoshitoshi never finished the requisite hundred

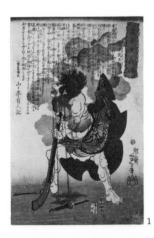

1. *Tamigorō Commits Suicide* (*Seiriki Tamigorō*)
1865
Series: *Biographies of Modern Heroes* (*Kinsei Kyōgiden*)
Single *ōban* sheet
Signature: Kaisai Yoshitoshi *hitsu*
Seal: Yoshi [Kuniyoshi's paulownia-leaf monogram]
Engraver: *hori* Ōta Tashichi
Publisher: Iseki

Between the years 1865 and 1868, Yoshitoshi produced two series of *nishiki-e* color prints on subjects made popular among the common classes via book illustrations and incidental artwork. The series in which this print appeared (see also figs. 39–40) presented figures against more or less neutral backgrounds with rather lengthy texts, while *Edo Color Images from the Annals of the Floating World* (*Azuma no*

either. Yet this series was an important thematic statement for Yoshitoshi. Some images were inspired by the macabre prints of his own teacher Kuniyoshi; some images would reappear in reworked form in later series such as the *Selected New Forms of Thirty-six Ghosts* near the end of his career. Here, then, was the first blossoming of what was to become a lifelong interest in the occult. (We should note, however, that Yoshitoshi often treated these themes in unusual ways—injecting humor or irony, for example—rather than exploit the sheer "chill factor.") The texts of these three prints are by the storyteller Kanagaki Robun.

The Greedy Old Woman is based on a well-known fable about the pitfalls of covetousness. An old woman, seeing her neighbor rewarded with a basket of riches for feeding a sparrow, cuts off the tongue of the sparrow, and then, when through devious means she too receives a basket from the enchanted sparrow, it turns out to be filled with demons. Yoshitoshi depicted this story again in a print entitled *The Heavy Basket* (*Omoi Tsuzura*) in the *Thirty-six Ghosts* series (fig. 94, no. 31).

The next print pits the sumō wrestler Onogawa Kisaburō against an evil fox that has taken to haunting the palace of a feudal lord. Late one night, as Onogawa lies in wait near where the lord has retired, a Buddhist acolyte appears, and promptly extends a snakelike neck. Far from daunted, the *yokozuna* strongman blows smoke in the ghoul's eye and subdues it.

The last selection depicts a Chinese figure, namely one of the one hundred and eight heroes from the Yüan-dynasty *Water Margin Saga* (*Shui Hu Chuan*). Kung Sunsheng was a sorcerer of considerable powers, able to evoke storms at will. Here he is enveloped in dark clouds, standing amidst a raging sea as he summons up a dragon. The gourds hanging from his waistband contain mystical potions.

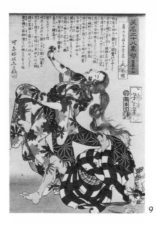

5. *Inada Kyūzō Shinsuke Murders the Kitchen Maid* (*Inada Kyūzō Shinsuke*)
1867

6. *Furuteya Hachirobei Slaughters His Pet "Cat"* (*Furuteya Hachirobei*)
1867

7. *Naosuke Gombei Kills His Former Master Shōzaburō* (*Naosuke Gombei*)
1867

8. *The Villainess Ohyaku and the Ghost of Tokubei* (*Dakki no Ohyaku*)
1866

9. *Kasamori Osen Carved Alive by Her Step-father* (*Kasamori Osen*)
1867
Series: *Twenty-eight Infamous Murders with Accompanying Verses* (*Eimei Nijūhasshūku*)
Single *ōban* sheets
Signatures: Ikkaisai Yoshitoshi *hitsu*
Seals: Yoshi [Kuniyoshi's paulownia-leaf monogram]
Engraver: Ryūzō *tō*
Publisher: Kinseidō

A collaborative effort with Yoshiiku, an apprentice senior to Yoshitoshi under Kuniyoshi, the *Twenty-eight Verses* (*Nijūhasshūku*) of the title plays upon the "twenty-eight houses" (*nijūhasshuku*) of Oriental astrology and, by extension, the "twenty-eight states of suffering" (*nijūhasshūku*) of Buddhist iconography. Each of the two artists executed fourteen images in the series, each image deriving from some scene of extreme cruelty dramatized on the Kabuki stage. In addition, each is accompanied by a haiku inscribed on a white-ground *tanzaku* rectangle in the upper right-hand corner and a larger commentary written across the top portion of the picture area. This series and the following *One Hundred Selections of Warriors in Battle* (see pls. 10–14) stand as the horrific height of Yoshitoshi's blood-bathed art. A special mixture of alum and animal-skin glue was blended into the blood pigments to yield a more realistic sheen. See also figure 46.

Although some of the stories behind the pictures are rather obscure today, they would have been readily identifiable to Yoshitoshi's contemporaries; hence the commentaries are not necessarily straightforward descriptions of the events depicted. Inada Kyūzō Shinsuke in the first print reached his murderous pique in a now-lost *sewamono* "talk-of-society" theater piece. Furuteya Hachirobei ran amok in the Kabuki play *Cherry Blossom Blade-guard and Sharkskin Sheath of Bitterness* (*Sakura Tsuba Urami no Same Zaya*), first killing his wife, Otsuma, when she sold herself to the villain Yahei in order to raise funds for Hachirobei to buy the freedom of his favorite courtesan, the "Cat," then killing the courtesan and himself to end their shame. Naosuke (also known by the alias Gombei) figures in a subplot to the famous *Yotsuya Ghost Story* (*Yotsuya Kaidan*), which Yoshitoshi again drew upon

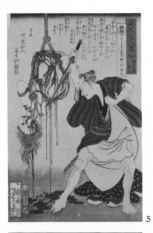

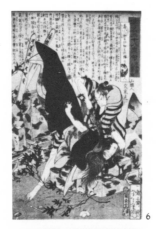

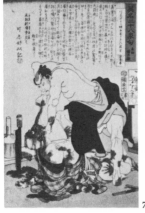

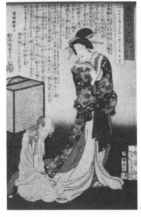

for his *Thirty-six Ghosts* series (1892) at the end of his career (fig. 94, no. 30). The Villainess Ohyaku was a role enacted by Yoshitoshi's friend Onoe Kikugorō V in the play *Clapping Both Hands of Good and Evil* (*Zen Aku Ryōmenko no Tegashiwa*): a lowly maid from Osaka elopes to Edo with her master, Tokubei, after killing his wife and burning the house down, then becomes a popular geisha under the name of Kosan and kills Tokubei, who remains the only link with her ignominious past. Kasamori Osen, of the Yanaka district of Edo (near where Yoshitoshi lived), was one of the most famous beauties of the 1760s; so great was her renown, in fact, that she became the subject of Ukiyo-e prints and Kabuki plays. According to the fictionalized staging in *The Ghostly Moon of Kasamori* (*Kaidain Tsuki no Kasamori*), she met her end at the hands of her lascivious step-father when he burst into a maddened rage because she would not accept his advances.

12. *Tsuji Yahyōe Morimasa Fights to the Last* (*Tsuji Yahyōe Morimasa*)
13. *Horii Tsuneemon Speared at the Stake* (*Horii Tsuneemon*)
14. *Torii Hikoemon Mototada Dies with Honor* (*Torii Hikoemon Mototada*)

1869
Series: *One Hundred Selections of Warriors in Battle* (*Kaidai Hyaku Sensō*)
Single *ōban* sheets
Signatures: Ikkaisai Yoshitoshi *hitsu*
Publisher: Ōhashi

The Meiji Restoration of 1868 was not bloodless, a major battle being fought within the city limits of Edo itself. In the fifth lunar month of that year, just prior to the young emperor Meiji's triumphant entrance into the city, shogunate troops made a last stand at Tōeiji temple in Ueno, near the site of the present-day Tokyo National Museum. Yoshitoshi and his apprentice Toshikage visited the battlefield to make firsthand sketches of the fighting and its aftermath. These he incorporated into a series of bloodily realistic warrior prints beginning two months later and continuing into the next year. New government or not, the ban on portraying current events in the arts remained in effect from the days when the Tokugawa shogunate sought to prevent the publication of incendiary art and literature. As a result, Yoshitoshi had to circumvent government censorship by disguising his soldiers as loyal and valiant (though curiously untraceable) samurai retainers who died in the service of feudal lords back in the fourteenth and sixteenth centuries. A thin disguise, to be sure, for no matter what the titles or texts said, the figures were often dressed in contemporary costumes and held modern weapons. The series was highly successful, boosting Yoshitoshi to the position of fourth most popular Ukiyo-e artist, but the images became repetitive, and the project stopped short at fifty-eight prints.

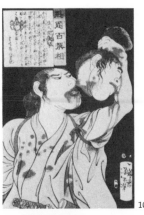

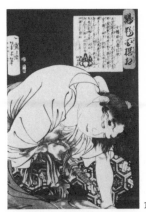

10 11

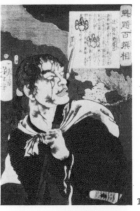

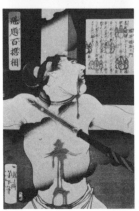

12 13

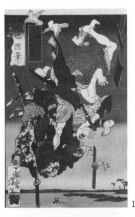

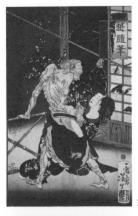

15 16

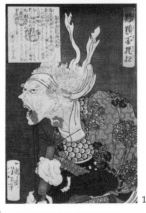

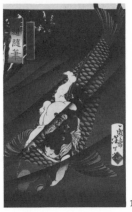

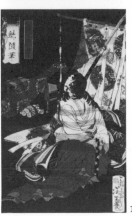

14 17 18

10. *Sakuma Daigaku Drinks His Enemy's Blood* (*Sakuma Daigaku*)
11. *Obata Sukerokurō Nobuyo Commits Harakiri* (*Obata Sukerokurō Nobuyo*)

15. *Inuzuka Shino and Inukai Gempachi* (*Inuzuka Shino Inukai Gempachi*)
1873

16. *The Hag of Asajigahara* (*Hitotsuya Rōba*)
1873

17. *Oniwaka Seeks Revenge on the Great Carp* (*Seitō no Oniwakamaru*)
1872

18. *Lady Yodo* (*Yodo no Kimi*)
1873
Series: *A Yoshitoshi Miscellany of Figures from Literature* (*Ikkai Zuihitsu*)
Single *ōban* sheets
Signatures: Ikkaisai Yoshitoshi *hitsu*
Seals: Gō Kaisai (pl. 16); Kōga (pl. 17); Kai (pl. 18)
Engravers: *horikō* Tomekichi (pl. 17); Katada Horichō (pl. 18)
Publisher: Masadaya

This was the first Yoshitoshi series of pictorializations from history and legend that toned down the blood and gore. Instead, we find colorful compositions rich with romantic appeal. Yoshitoshi bids us enter a storybook world of adventure in which all the characters of Japanese literature, real and fictional, play their parts. The artist invested considerable effort in bringing life to the thirteen or more images of the series, but inexplicably the sales were poor. The injustice came as a blow; Yoshitoshi reportedly complained to his publisher, "They're all blind!" (*"Mekura sennin!"*). Today, however, we can see in the series incipient indications of Yoshitoshi's mature style. See also figures 49–51.

Inuzuka Shino and Inukai Gempachi, of the first action-packed image, are the heroes of the Takizawa Bakin epic *Tale of Eight Dogs of the Satomi Clan* (*Satomi Hakkenden*), and are depicted again in the 1885 vertical diptych *Two Valiants in Combat atop the Hōryūkaku Pavilion* (see pl. 42). The scene pictured here immediately follows that shown in the diptych, with the two plummeting protagonists seen in mid-fall from the Hōryūkaku into the Tone River below.

The Hag of Asajigahara, another subject Yoshitoshi was to depict repeatedly over the course of his career (see pl. 58), is treated here in a way that nearly reproduces the stage setting of the Kawatake Mokuami play *The Lone House* (*Hitotsuya*). In this climactic scene, the hag Ibara has come to butcher a young traveler who has lodged for the night at her lone house on Asajigahara Moor, only to find her own daughter has switched places with the youth. The shock of recognition registers keenly in the old woman's face, and the dynamism of the figures' poses is echoed by the diagonal rope across the picture plane.

Oniwaka, the Little Devil, was the childhood nickname of Musashibō Benkei, who became famous as the loyal retainer and companion of Minamoto no Yoshitsune (see pls. 27, 63). A rambunctious waif, he was perpetually into some bit of mischief. Entrusted to the care of the priests of the temple of Hongū Daijin, he heard rumors that his mother had been devoured by a monstrous carp living in a pond at the base of the nearby Bishamon Waterfall. He headed off for the pond, dived in—knife between his teeth—and disemboweled the monster. Sure enough, his mother's remains were found in its stomach. Yoshitoshi's handling of the diagonals here becomes boldly dynamic, even abstract. The carp's tail extends out of the picture frame, providing a note of humor and grace. Yoshitoshi depicted the subject again in an 1885 vertical diptych and also in 1889, in *Thirty-six Ghosts*, with a more static image showing the instant before the plunge (fig. 94, no. 6).

A more strictly historical personage, Lady Yodo (1567–1615) was one of three daughters of the warlord Oda No-

bunaga's sister. Later adopted by Nobunaga's former vassal Shibata Katsuie (see commentary to pl. 65), she was made the concubine of his rival, Toyotomi Hideyoshi, when Katsuie died. Hideyoshi installed her at Yodo Castle to the south of Kyoto—hence her appellation—and in 1598 she bore an heir, Hideyori, thus immediately assuring herself a place of favor. In 1598, though, Hideyoshi died, and Tokugawa Ieyasu came to stake a claim for political control of Japan. Lady Yodo fled to Osaka Castle with Hideyori, and tried to raise troops to back her son's bid for power. But it was all in vain, and she and Hideyori committed suicide in 1615 when Osaka Castle fell to Tokugawa Ieyasu. A dauntless woman remembered for her decisiveness and tenacious ability to make the most of even the worst political imbroglios, she is pictured here as a heroine.

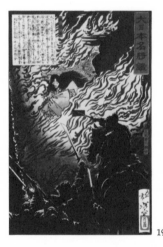
19

19. *Saohime Perishes in Flames* (*Saohime*)
February 20, 1880
Series: *A Mirror of Famous Generals of Japan* (*Dainippon Meishō Kan*)
Single *ōban* sheet
Signature: *ōju* Yoshitoshi
Seal: Taiso
Publisher: Funazu Tadajirō

According to the *Nihon Shoki*, a history of Japan compiled for the imperial family in the seventh and eighth centuries, Saohime and her elder brother, Saohiko, were grandchildren of the legendary ninth emperor Kaika. Saohime herself married the eleventh emperor, Suinin, and bore his son, but in 26 B.C., so the story goes, Saohiko conspired to overthrow imperial rule. He urged his sister to aid him in his plot, but her attachments to the emperor prevented her from doing so. When she revealed the scheme to her husband, Suinin sent Kamitsukenu no Yasunada and a contingent of warriors to Saohiko's residence, which they promptly surrounded by erecting a barricade of rice-straw bales. Saohime, now regretting the betrayal of her own brother, somehow penetrated the barricade and joined in the struggle against the imperial troops. Yasunada eventually ordered the barricade set afire, and the house went up in a blaze. Suinin commended Yasunada for his loyalty and valor; it is not recorded what he thought of Saohime's demise.

The *Mirror of Famous Generals* series was a sizable project, with a total of fifty-eight pictorializations from legend and literature spanning the entire breadth of Japanese history (see also figs. 52–54). Yoshitoshi's command of this range

of subject matter is a clear manifestation of a breadth of knowledge that can only be termed encyclopedic. This particular image is quite vivid in its presentation of the brightness of the flames engulfing Saohime, contrasted with the darkness where Yasunada and his men lie in siege.

21. *Shōdembō no Shōkichi, the Thief* (*Shōdembō no Shōkichi*)
 Summer 1875
 Newspaper illustration for the *Postal News* (*Yūbin Hōchi Shimbun*, no. 614)
 Single *ōban* sheet
 Signature: Taiso Yoshitoshi
 Seal: Tsukioka
 Engraver: Horita
 Publisher: Kinshōdō

Yoshitoshi worked for the *Postal News* from April 1875 until spring the following year, producing upward of fifty illustrations of strange, humorous, and sensational events in the news (see also fig. 56). This opportunity came as a result of the publisher Kumagaya Shōshichi's desire to become more competitive with the *Tokyo Daily News* (*Tōkyō Nichinichi Shimbun*), which had engaged the services of Yoshiiku (see fig. 55), former fellow apprentice under Yoshitoshi's mentor Kuniyoshi and collaborator on the *Twenty-eight Infamous Murders* series (see pls. 5–9, fig. 46). At last Yoshitoshi was able to reach a mass audience by portraying subjects from contemporary life.

In this print there is a curious mixture of genres: a current ghost story treated as news. Shōdembō no Shōkichi, according to the excerpted text in the cartouche above the picture, was a skillful and cunning thief of Osaka, but ultimately not elusive enough to escape the ghosts of his many victims. It is instructive to note that the transparency and ethereality of the ghost figures in this early print is not handled nearly as convincingly as in later works.

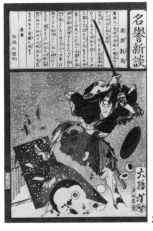

20. *Hirose Kazuma Fights Valiantly at the Sakuradamon Gate* (*Hirose Kazuma*)
 1873
 Newspaper print for *New Tales of Honor* (*Meiyo Shindan*)
 Single *ōban* sheet
 Signature: Taiso Yoshitoshi
 Seal: Tsukioka
 Engraver: Watanabe Horiei
 Publisher: Gusokuya

In the days before photogravure and mechanical reproduction of images, mass media had to rely on hand-produced picture inserts for textual illumination. In the West, these were largely in the form of engravings, and in Japan, *nishiki-e* color woodblock prints. Even though newspapers got a much later start in Japan than in the West, Japanese readers were much sooner accustomed to seeing the news in full color. Of course, Western illustrators generally engraved from photographic images—photography having already boomed by the mid-1800s—hence there was some insistence on verisimilitude. Japanese illustrators, on the other hand, were usually quite free to invent "scenes" and "semblances." Yoshitoshi was a pioneer in his field, often sketching on location and from posed models, but the "real" life of his newspaper prints was his amazing ability to visualize imaginatively. Understandably, he soon became one of the most popular graphic artists in the nation.

Here Yoshitoshi has portrayed a figure, not exactly in the news, but a participant in the events leading up to the Meiji Restoration of six years before. Hirose Kazuma, the loyal retainer of Lord Ii Naosuke (1815–60) of Hikone in Ōmi (present-day Shiga Prefecture) and later Great Elder (*tairō*) in the Tokugawa shogunate, is extolled as "tolerant" and "masterful in the martial arts"—"a veritable Mt. Fuji rising above the clouds." He always put his lord's well-being first and eventually went down defending him when imperial loyalists attacked Ii outside the Sakuradamon Gate to Edo Castle (now the Imperial Palace) on March 24, 1860, in violent protest to his signing treaties with the "foreign barbarians."

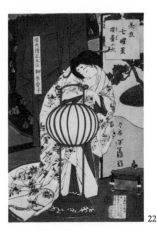

22. *The Lantern Light* (*Tōdai no Hi*)
 December 21, 1878
 Series: *Beauties of the Seven Nights* (*Mitate Shichi Yōsei*)
 Single *ōban* sheet

Signature: Tsukioka Yoshitoshi
Seal: Yoshitoshi
Engraver: Katada Horichō
Publisher: Inoue Mohei

This series stirred up more than a little trouble with the imperial household for its implications of sexual relations between the emperor Meiji and the beautiful ladies-in-waiting in his constant company. The seven prints of the series (see figs. 66–71 for the rest) are thematically titled to play upon the seven element names of the Japanese week—sun, moon, fire, water, wood, metal, and earth—the "light," or "flame" (*hi*), in the title of this print corresponding to "Fireday," Tuesday by the Western calendar.

Clearly Yoshitoshi was seeking to create a scandal. His sense of propriety may have stopped him short of outright pornographic depictions of the emperor engaged in the sexual act, but he had no qualms about recording the actual names of the women or, as with this particular image of Lady Yanagihara Aiko, showing the lady in a suggestive attitude as she extinguishes the lantern before retiring, her outer robe and red *hakama* culottes already draped over the black lacquer dressing stand to the upper left. To the right stands a screen, on which Yoshitoshi has affixed his signature, a common device in Ukiyo-e (see also pl. 3).

The colors of this series are bound to strike contemporary eyes as harsh and garish. The imported aniline red, purple, and green dyes virtually drown out the more subtle, traditional hues of the vegetable dyes used in the folding screen and kimono. The registration of this particular pull is also less than desirable, the green background block leaving worn and un-inked white spaces where color blocks should have met. Nonetheless, the print is notable for it composition of diagonals and verticals, and for its sheer topicality.

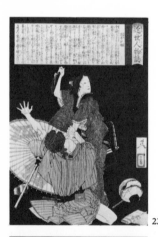

23

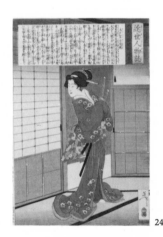

24

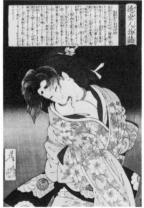

25

23. *Hanai Oume Kills Kamekichi* (*Hanai Oume*)
August 20, 1887
24. *Lady Kido Suikōinden* (*Kido Suikōinden*)
December 13, 1887
25. *Muraoka, Head Lady-in-waiting of the Konoe Clan* (*Konoeke no Rōjo Muraoka*)
November 13, 1887
Series: *Personalities of Recent Times* (*Kinsei Jimbutsu Shi*)
Single *ōban* sheets
Signatures: Yoshitoshi
Seals: Taiso
Engraver: *horikō* Enkatsu (pl. 24)
Publisher: Yamato Shimbunsha

Over the two-year period from 1887 to 1888, Yoshitoshi produced his last and most accomplished set of "newspaper prints" as irregular supplements to the *Yamato Shimbun*. The full set of twenty prints—of which these are respectively numbers 11, 15, and 14—was later bound in one volume, with the addition of a title plate (see also figs. 62–65). The series as a whole shows Yoshitoshi's mature style of figuration based on careful drawing from models. The linework is masterful, and the exactingly balanced choice of colors employs the bright, imported aniline dyes sparingly, as points of compositional accent. The subjects were people in the news, and persons who helped shape modern Japan.

Hanai Oume, a former geisha, was the proprietress of the Suigetsu restaurant in Tokyo. On June 9, 1887, a little over two months before the date of this print, Oume killed a certain Kamekichi—in self-defense, she contended. The man had been making advances for some time and finally attacked her in the dark, but she managed to wrestle free his knife. Not so, charged the prosecution; the two had been lovers, with Kamekichi living off Oume's earnings, until she resolved to rid herself of the parasite. The court case was much publicized in highly opinionated newspaper reportage. This print makes it clear that Yoshitoshi was convinced of her innocence, for he shows Oume's Suigetsu lantern slashed by an attacker's knife, an umbrella she would have held in her other hand, and a kerchief fallen from her bosom—ruling out the possibility of her having carried or concealed a weapon. Nonetheless, Oume was convicted.

Kido Suikōinden (1843–86) was the wife of Kido Kōin (1834–77), an imperial loyalist samurai who played an active part in the Meiji Restoration of 1868. Originally a geisha by the name of Ikumatsu, she became interested in the doctrine of "Revere the emperor and expel the barbarians" (*sonnō jōi*) that was professed by Kido, Rai Mikisaburō (1825–59), and their followers around the 1860s, when the first formal treaties were being drawn up with foreign powers. The loyalist band flocked to the outlying Saikyō district of Kyoto to escape the notice of agents of the Tokugawa shogunate, and there she made their acquaintance and sat in on their discussions. Eventually, however, their whereabouts were discovered, and a sudden raid caught Kido unprepared. Quick-thinking Takematsu took him in and hid him beneath the floorboards of her quarters, thereby sparing him for his role in the political drama that was soon to unfold.

Muraoka (1786–1873), head lady-in-waiting under nobleman Konoe Tadahiro, was yet another supporter of the loyalist faction that became outraged at the shogunate's new open-door foreign policy. Twice arrested, she was brought to Edo along with some forty others and tortured daily in 1858 during what came to be called the "Great Persecution of the Ansei Era" (*Ansei no taigoku*), and once again in 1863. Her unbroken loyalty under duress won her considerable acclaim once the shogunate fell. Yoshitoshi's depiction of Muraoka,

however, borders on sadomasochistic fantasy: she looks quite seductive in her ropes, and far younger than the seventy-some years she would have been at the time, even with her teeth blackened and eyebrows shaved in the manner of older married women.

yet he treats it with all the meticulous care he brings to any of his better-known themes. Even as Chikako falls to her doom, *kaishi* tissues fluttering from the bosom of her kimono, we sense a certain dignity and pathos about the scene. The naturalistic depiction of the herons and anatomical accuracy of Chikako's unusual pose are also noteworthy.

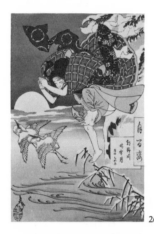

26

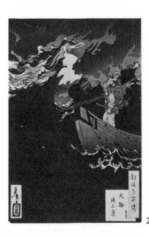

27

26. *Filial Chikako Dives into the Snowy Asano River* (*Asanogawa Seisetsu no Tsuki Kōjo Chikako*)

December 1885
Series: *One Hundred Aspects of the Moon* (*Tsuki no Hyakushi*)
Single *ōban* sheet
Signature: Yoshitoshi
Seal: Yoshitoshi
Engraver: *horikō* Enkatsu
Publisher: Akiyama Takeemon

The subject of this print might have been unfamiliar even to Yoshitoshi's contemporaries, for it deals with a lesser known and undoubtedly spurious subplot embroidered into the popular story of Zeniya Gohei (1798–1855), a risk-taking entrepreneur. Gohei was born into a family of money-changers in Kaga (present-day Ishikawa Prefecture), and worked for a local shipbuilder during his youth. At first it seemed as though fortune was against him: he borrowed the sizable sum of 1,000 *ryō* from his employer, promptly lost it all speculating, and wound up in jail for the string of debts he incurred. Later, however, he amassed a small fortune by sending a fleet of ships to various ports throughout Japan and abroad, despite the Edo shogunate's "closed-door policy," and by regulating the flow of commodities. His greatest success came when a famine hit the city of Edo, and he was able to bring in a much-needed shipment of rice from the provinces. Legend has it that he was thereafter quite free with his money in the Yoshiwara pleasure district, making himself the talk of Genroku-era (1688–1704) society (see also commentary to pl. 62). Returning to his province, he embarked on the colossal project of filling in a lake, overriding protests from local fishermen, in order to transform the area into productive rice fields. When eventually his funds ran out with the project but half-completed, his fate was decided at an official level. He was imprisoned along with his three sons, two of whom were pardoned and one beheaded after Gohei's death in prison. That much is history. This core of truth was embellished to the effect that Gohei had a daughter named Chikako. So filial was she that it was worth her own life to secure a pardon from her father's jailers, and to prove her sincerity she plunged into the icy waters of the Asano River that flows through Kaga province.

Yoshitoshi's choice of this particular subject is unexpected,

27. *Benkei Calms Daimotsu Bay by Moonlight* (*Daimotsu Kaijō no Tsuki Benkei*)

January 1886
Series: *One Hundred Aspects of the Moon* (*Tsuki no Hyakushi*)
Signature: Yoshitoshi
Seal: Taiso
Engraver: *horikō* Enkatsu
Publisher: Akiyama Takeemon

The warrior-priest Musashibō Benkei, loyal retainer of the young lord Minamoto no Yoshitsune (1159–89; see also pls. 17, 31, and 63), is one of the more colorful and popular characters in the annals of Japanese history. Needless to say, his and Yoshitsune's stories have been embellished considerably over the centuries in countless works of art and in stage productions, but the fact remains that Yoshitsune was ruthlessly hunted down by his elder half-brother Yoritomo (1147–99) after having helped the latter defeat the Heike clan in 1185. Yoshitsune and his small band sought to evade Yoritomo's henchmen by escaping to northern Japan by sea, setting out in the autumn of that year from the coast of Harima province (present-day Hyōgo Prefecture), but their ship ran into a storm in Daimotsu Bay, off what is now Osaka. Legend has it that the turbulent waters were stirred up by the wrathful ghosts of the Heike warriors that Yoshitsune and his followers had killed. At that point, Benkei tethered himself to the ship's prow and offered his prayers to the angry spirits. The seething waves soon subsided, and the ship continued its passage in peace.

This particular episode in the Yoshitsune-Benkei saga is the focus of the Noh play *Benkei on Shipboard* (*Funa Benkei*), making this one of the very first prints in which Yoshitoshi drew upon the Noh theater. Benkei was reputedly a giant of a man, and most depictions inflate him to grandiose proportions; it is curious to see this Benkei figure appear so small in the overall composition. The dry-brush texture of the brushstrokes in the surging waves has translated well to the woodblock, creating a mood more akin to ink painting than the norm for Ukiyo-e. The brooding darkness of almost the entire picture area focuses attention on the moon and the lone figure in the prow.

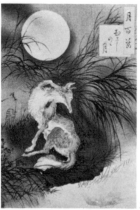

28

28. *The Moon on Musashi Plain* (*Musashino no Tsuki*)

April 1, 1892
Series: *One Hundred Aspects of the Moon* (*Tsuki no Hyakushi*)
Single *ōban* sheet
Signature: Yoshitoshi
Seal: Yoshitoshi
Engraver: Yamamoto *tō*
Publisher: Akiyama Takeemon

The fox plays a major role in the folklore of Japan. Not only is the fox sly, as it is in the West, but frequently malevolent, and possessed of the uncanny ability to change shape at will. Many a tale has been told in which someone gets seduced by an enchantress or haunted by a mysterious creature, only to discover in the end that it was a fox. Thus, what would seem to be a simple naturalistic study here has bewitching overtones for the Japanese viewer. This vixen shows telltale signs of acquaintance with human mannerisms as she preens herself, viewing her reflection in the water. What mischief has she been up to before returning to her own form?

Much of the subtlety of this print comes from a special inking technique used in the shadows of the grasses and the haze over the moon: a light pigment wash was dabbed directly on the background block and diffused slightly by soft circular brush movements. Each impression thus varies in the placement and shade of these dark color areas—truly a modern experimental approach to printmaking that foreshadows today's monoprints (see also the treatment of the landscape and sky in *Fujiwara no Yasumasa Plays the Flute by Moonlight*; foldout).

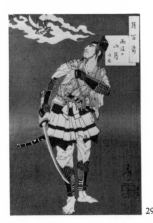

29

29. *Tokimune Views the Moon in the Mountains After Rain* (*Ugo no Sangetsu Tokimune*)

December 10, 1885
Series: *One Hundred Aspects of the Moon* (*Tsuki no Hyakushi*)

Single *ōban* sheet
Signature: Yoshitoshi
Seal: Yoshitoshi *no in*
Engraver: *horikō* Enkatsu
Publisher: Akiyama Takeemon

The brothers Saga no Tokimune (1174–93) and Sukenari (1172–93) sought revenge on one Kudō Suketsune, relative and murderer of their father. However, the shogun Minamoto no Yoritomo (1147–99), the most powerful man in Japan, had taken a liking to Suketsune, and the two were in frequent company, thus hampering plans for vengeance. Eventually the brothers' chance came when they learned that Yoritomo had led a hunting party to Hakone, toward the foothills near Mt. Fuji. Suketsune, they guessed rightly, would be relatively unprotected at the encampment there. Making their approach on a rain-swept night, they managed to locate Suketsune, and with all the rancor that is the backlash of Confucian filial piety, they made short work of him. Sukenari was caught and killed immediately after the deed, while his younger brother was taken alive, and brought before Yoritomo. The shogun, a man of swift action himself, was impressed by Tokimune's audacity, and was on the verge of pardoning him when a relative of the murdered Suketsune demanded death—once more on the grounds of Confucian ethics. Tokimune was only nineteen at the time, but his legend has endured in the hearts of the Japanese.

This print shows, once again, Yoshitoshi's genius for treating a familiar theme in unusual ways. Rather than show the expected struggle amidst the downpour, Yoshitoshi reveals the calm that followed. The rain has washed clean the sword, the clouds have parted, and as a cuckoo darts past the moon, Tokimune is struck by the fleeting brevity of his own life. The simplicity of the print is particularly beautiful.

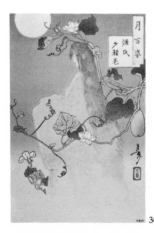

30

30. *The Ghost of Genji's Lover, Yūgao* (*Genji Yūgao no Maki*)

March 1886
Series: *One Hundred Aspects of the Moon* (*Tsuki no Hyakushi*)
Single *ōban* sheet
Signature: Yoshitoshi
Seal: Taiso
Engraver: Yamamoto *tō*
Publisher: Akiyama Takeemon

Among the many lovers known to Hikaru Genji, the "Shining Prince" of the eleventh-century novel the *Tale of Genji* (*Genji Monogatari*), the Lady Yūgao in the fourth chapter is undoubtedly the most mysterious. Genji never learns her real name, and so must associate her with the short-lived "even-

ing glory" (yūgao) vine flowers that grew by her once-opulent house where they first met. Their romance begins when Genji takes a fancy to the flowers, and sends a servant to ask permission to pick a few. Genji receives his answer in the form of a scattering of blossoms on a fan, on which is inscribed an enticing though cryptic verse in a young lady's hand. Some time later, when Genji happens by the house again one evening, he goes in to meet the young lady, and sweeps her off to secluded quarters in the Rokujō district of Kyoto. The two have their amours, then fall asleep. For Genji, it is a troubled sleep; he awakens to find dark clouds obscuring the moon, his eerie lover swooning on the verge of death. She trembles in his arms, but all too soon her spirit departs. She yielded to the prince everything of herself and yet nothing—she remains a mystery.

Yoshitoshi's print is suitably delicate and atmospheric for the subject. The soft palette and subtle gradations of color are especially lovely. The naturalistic treatment of the vines, leaves, and flowers of the background almost seem to point to the later art nouveau movement of the West.

the martial arts. Soon the young Yoshitsune was practicing almost daily with the tengu, and became adept at their most secret techniques. Or so it is written in the Annals of Yoshitsune (Gikeiki).

Yoshitoshi's print shows a very youthful Yoshitsune wielding a practice sword while leaping high over each pass of the branch that an aged tengu waves at his feet. Beside the waterfall in the background sits a bronze tripod cauldron, or tei (Ch.: ting), said to be used in the brewing of magical elixirs. Also seen issuing from a cleft in the nearby rock face is a curiously shaped growth, the mythical "immortal mushroom" (Ch.: lingchih). Both items have their origins in Chinese Taoism and the cult of the immortal sage (Ch.: hsian), as does the tengu. Once again, Yoshitoshi's erudition shines forth.

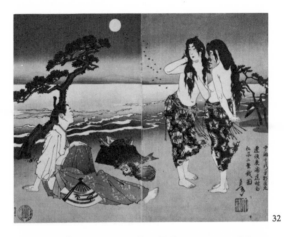

32. *Yukihira Meets the Fisherwomen Murasame and Matsukaze at Suma Beach (Chūnagon Yukihira Ason Suma-no-ura ni Sasen sare Murasame Matsukaze Niama ni Ai Tawamureru Zu)*
1886
Series: *A Yoshitoshi Storybook (Yoshitoshi Manga)*
Ōban diptych
Signature: Yoshitoshi
Seal: Taiso
Engraver: *horikō* Enkatsu
Publisher: Kobayashi Tetsujirō

Japan's Heian period (794–1185) gives the appearance in literature and art as a time of unparalleled aesthetic refinement and romance, due in no small part to its wealth of poetry and epic tales. For all the actual political intrigues of the Heian court, it is the loves of versifying cavaliers and noblewomen that have come to shape our vision of the life of the aristocracy. Hence the high-ranking official Ariwara no Yukihira (818–93), who occupied such posts as governor of Harima, Bitchū, and other provinces, tends to be overshadowed by his sensitive younger brother Narihira (825–80), who was considered one of the Six Immortal Poets (rokkasen) of the ninth century, and whose romantic exploits form the basis of the *Tales of Ise (Ise Monogatari)*. As if to compensate for the rather colorless historical details of Yukihira's career, he has been romanticized to figure into a number of apocryphal episodes. The most famous of these, his encounter with the sisters Murasame ("Village Rain") and Matsukaze ("Pine Breeze"), first appears in the Noh play *Matsukaze* attributed to Yūzaki Kan'ami (1333–84). It later entered the puppet theater repertoire and finally emerged as the Kabuki plays *As If It Were Now at Suma (Imayō Suma)*

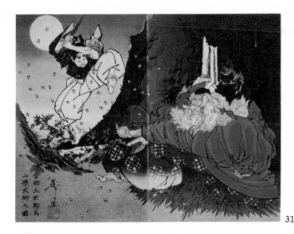

31. *Yoshitsune Learns Martial Arts on Mt. Kurama (Shanaō Kuramayama nite Bujutsu o Manabu no Zu)*
1886
Series: *A Yoshitoshi Storybook (Yoshitoshi Manga)*
Ōban diptych
Signature: Yoshitoshi *ga*
Seal: Taiso
Publisher: Kobayashi Tetsujirō (reprint publisher: Hasegawa Tsunejirō)

The legend of Minamoto no Yoshitsune (1159–89) is full of fanciful and exciting episodes long cherished by the Japanese (see also pls. 27, 63). Background on Yoshitsune's youth is lacking in historical fact, a circumstance, however, that proved favorable to later embellishment. When Taira no Kiyomori (1118–81; see title page) seized power in 1159 by massacring Minamoto no Yoshitomo and his followers, he spared Yoshitomo's offspring in an uncharacteristic act of benevolence, although in the end they would grow up to overthrow the Taira clan. One of Yoshitomo's children was none other than Yoshitsune—called Ushiwaka or Shanaō in his youth—who was placed in the care of a secluded temple on Mt. Kurama to the northeast of Kyoto. There he applied himself to scholastic pursuits, as was expected of all young Buddhist devotees, but his real interest lay elsewhere. For deep in the mountain forests beyond the temple, he came upon a den of goblins called tengu—literally "heavenly dogs"—beings of extraordinary powers and unparalleled skill in

and *The Love Song of Matsukaze by the Bay* (*Hama Matsukaze Koiuta*).

Yukihira has been temporarily sent away from the capital, and finds himself utterly dejected and friendless at Suma (near present-day Kobe), when he is approached by the two village maidens who bring the noble youth a share of their catch. Both sisters fall in love with him and compete jealously for his affections, but his social status is far above theirs, and ultimately he is called backed to Kyoto. Murasame chases him down the beach, wailing, but to no avail; Matsukaze, on the other hand, is consoled by a young village fisherman.

Yoshitoshi's version of the story seems more inspired by the Noh stage than by any Kabuki production, so poignant is its understatement and spareness. The contrast between the aristocrat, with his subtly hued *hakama* leggings and finely coifed *kammuri-shita* hairdo, and the rustic appearance of the sisters could not be more pronounced. The atmosphere fairly breathes a tranquil eroticism.

Largely based on stories from the stage, this diptych series was something of a labor of love for Yoshitoshi. From the end of 1885 through the beginning of 1887, he produced twenty extremely finished images celebrating the excitement, passion, and decadence that had been premodern Edo (see also figs. 74–85, pls. 34–37). Despite the violence depicted in many prints of the series, the overall feeling is curiously quietive, picturesque, and nostalgic. These invented "remembrances" of events long before his birth attest to Yoshitoshi's personal attachment to the city as well as to his genius for narrative conciseness. As much as possible, titles, signatures, and other writing are kept unobtrusively to the periphery to allow the visual presentation to speak for itself. The series title and publication information are printed in the margins to further enhance the impression of a picture album.

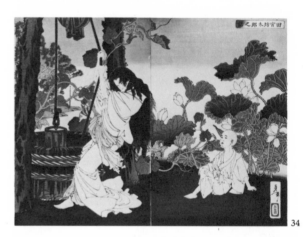

34. *The Story of Tamiya Bōtarō* (*Tamiya Bōtarō no Hanashi*)

March 22, 1886
Series: *Newly Selected Edo Color Prints* (*Shinsen Azuma Nishiki-e*)

Ōban diptych
Signature: Yoshitoshi
Seal: Taiso
Engraver: Wada *tō*
Publisher: Tsunashima Kamekichi

Tamiya Gempachirō, a dazzling swordsman in the service of the Lord of Sanuki (present-day Kagawa Prefecture), aroused such jealousy in the lord's fencing instructor, Hori Gentazaemon, that Gentazaemon decided to eliminate him before his own position was threatened. In 1624, he realized his goal by employing an underhanded scheme to trap and kill the swordsman. Gempachirō left behind a pregnant wife, who soon bore a son named Bōtarō. As Bōtarō grew, he heard tales of his late father, of his mastery of the sword and unjust end at the hands of Gentazaemon. And as any samurai youth would have done, he swore to avenge him, devoting himself from that moment on to the necessary training. Eventually, at the age of seventeen, he did cut down the evil Gentazaemon, then committed harakiri in accordance with the dictates of the Tokugawa shogunate.

The Kabuki play *A Child's Revenge* (*Osanago no Adauchi*) enhances the story by having Gentazaemon, realizing he would some day have to deal with Bōtarō, arrange to have him placed in a remote temple where he might easily be disposed of, out of the notice of the lord. Bōtarō's nurse, Otsuji, reading the signs and fearing for the child's life, prayed to the Buddhist deity Kompira that her life might be taken instead. Her prayer was answered, and Bōtarō lived to fulfill his mission.

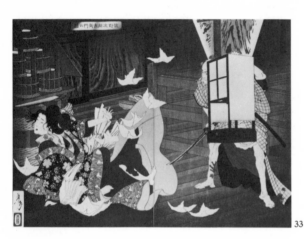

33. *The Story of Jirōzaemon of Sano* (*Sano Jirōzaemon no Hanashi*)

February 1, 1886
Series: *Newly Selected Edo Color Prints* (*Shinsen Azuma Nishiki-e*)

Ōban diptych
Signature: Yoshitoshi
Seal: Taiso
Engraver: Horiyata
Publisher: Tsunashima Kamekichi

Jirōzaemon, a farmer from the village of Sano in Shimosuke province (present-day Tochigi Prefecture), traveled south to Edo in the 1720s. He became infatuated with the courtesan Yatsuhashi of the Daihyōgoya brothel in the Yoshiwara pleasure district, but she had a patron, and so refused to see the brutish peasant. Finally, Jirōzaemon's jealousy mounted to such burning intensity that he lay in wait for Yatsuhashi and her lover at the Yoshiwara gate, murdered them both and seriously wounded several others who attempted to restrain him. The events were dramatized in the 1850 Kabuki play *Aftermath in the Flower-bedecked Streets* (*Kago Tsurube Sato no Yoizame*).

Yoshitoshi presents us with the climactic scene where Jirōzaemon pursues Yatsuhashi along the veranda of a building after killing her patron. She stumbles in sheer terror, a flurry of *kaishi* tissues falling from the bosom of her deep red undergarments. The sadistic leer on the pock-marked face of the farmer seems all the more menacing when viewed in oblique projection—a Yoshitoshi innovation.

Here we see the child Bōtarō, already with the garb and shaven head of a temple acolyte, gazing half-mystified at his nurse, who holds a Buddhist ceremonial bell in her mouth while hauling up a well-bucket of water for ablutions. In a later treatment of the same story included in the *Thirty-six Ghosts* series (fig. 94, no. 28), Otsuji is pictured by herself in a print titled *The Virtuous Woman's Spirit Praying Under a Waterfall* (*Seppu no Rei Taki ni Kakaru Zu*). In this print, however, the lotus blossoms in the background, with their Buddhistic associations, would seem to indicate that the setting is already at the remote temple, in which case the figure of Otsuji is a ghostly apparition—the maid having already forfeited her life at Bōtarō's parental home—which accounts for the child's bewilderment.

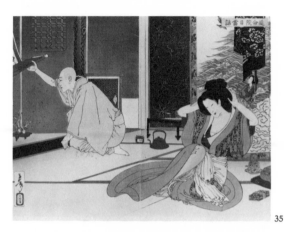

35

35. The Story of Priest Nittō of Emmeiin Temple (*Emmeiin Nittō Banashi*)

December 14, 1885
Series: *Newly Selected Edo Color Prints* (*Shinsen Azuma Nishiki-e*)
Ōban diptych
Signature: Yoshitoshi
Seal: Taiso
Engraver: Horiyata
Publisher: Tsunashima Kamekichi

This is a pictorialization of the story made famous by the Kawatake Mokuami play *The Star-fated Verdict of 1803* (*Jitsugetsusei Kyōwa Seidan*). Ushinsuke, the strikingly handsome son of Kabuki actor Onoe Kikugorō I, was given to sensual pursuits. By an unlucky turn of fate, one emotional entanglement resulted in a murder, causing him to flee Edo, renounce his claim to the name Kikugorō II, and enter the priesthood of the Nichiren-sect temple of Emmeiin in outlying Taninaka. This did not put an end to his sexual exploits, however, for even after he rose to head priest of the temple under his Buddhist name of Nittō, he continued his affairs with the women of the town. His liaison with the head servant girl Okoro of the wealthy Wakizaka family was especially notorious. Ultimately, his profligacy saw him put to death in 1803.

Yoshitoshi's picture exudes an air of the exotic and mysterious. The boyish Nittō lifts the hanging scroll suggestively and peers at some hidden recess of the *tokonoma* alcove, while Okoro adjusts her coiffure, her eyes gleaming knowingly. Their tryst has been consummated in the seclusion of a guest room of the Wakizaka mansion. Every detail of the decor evidences the taste of her master, from the Chinese screen behind her to the *sukiya*-style *tokonoma* post and lattice portal near Nittō. Yoshitoshi's skill in depicting the textured *momigami* paper of the sliding door is quite ac-

complished, and the color contrast of Okoro's red undergarments with the green of the new *tatami* mats is particularly striking.

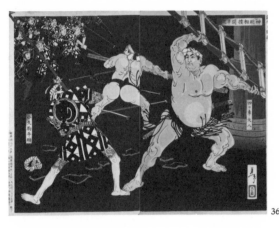

36

36. Wrestlers Battle Firemen at Shimmei Shrine (*Shimmei Sumō Tōsō no Zu*)

March 22, 1886
Series: *Newly Selected Edo Color Prints* (*Shinsen Azuma Nishiki-e*)
Ōban diptych
Signature: Yoshitoshi
Seal: Taiso
Engraver: Enkatsu *tō*
Publisher: Tsunashima Kamekichi

Sumō wrestling has its origins in Shinto ritual; wrestlers to this day still "purify" the ring with salt, a Shinto practice. Wrestling matches used to be held at shrines throughout the country, and it seems that on just such an occasion at Shimmei Shrine in the Shiba district of Edo, during the first part of 1805, a group of firemen showed up to heckle the shows of strength. Fighting broke out, and the bloody brawl that ensued—the famous "*Me* Brigade Riot" (*me-gumi no kenka*)—was eventually dramatized for the Kabuki stage.

In Yoshitoshi's print, the wrestler Yotsuguruma Daihachi fends off the *Me* Brigade leader Kotengu Heisuke, while a fellow wrestler handles the other firemen. The composition is animated, the figures placed on crossing dynamic diagonals. Heisuke's long-handled pick extends out of the frame at a slant, as does Daihachi's ladder, which apparently is long enough to have knocked down the roof tiles that lie at their feet. The figure of the wrestler appears to derive from a Kuniyoshi print in the *Kisōkaidō* series thirty years earlier, which may explain its curiously tranquil feeling despite the full-bodied action.

37

137

37. Evil Omatsu Kills Her Husband Shirosaburō (Kishin no Omatsu Shirosaburō o Korosu Zu)

1886
Series: *Newly Selected Edo Color Prints* (*Shinsen Azuma Nishiki-e*)
Ōban diptych
Signature: Yoshitoshi
Seal: Taiso
Engraver: Enkatsu *tō*
Publisher: Tsunashima Kamekichi

The story of wayward Omatsu apparently has its origins in the popular recitations of street performers at the end of the Edo period, and had numerous variations before being set down in script for the Kabuki stage—and even then, the plotting continued to change in different productions. In the most common rendition, Omatsu is the wife of one Shirosaburō, an unemployed, blind samurai desperately searching for the prized sword of his former master so that he can regain his position. Meanwhile, Omatsu supports them both by teaching fencing by day and robbing wayfarers by night. One evening she seductively lures and kills a samurai at Kasamatsu Pass, not realizing that he was her husband's elder brother. Shirosaburō and his father then trace the killer, but the blind samurai cannot recognize his wife dressed as a man, and strikes her dead. Miraculously, her blood restores Shirosaburō's eyesight and he recovers the lost sword.

Obviously, Yoshitoshi's *Omatsu* belongs to some other version of the tale, in which the roles are reversed. Despite its obscurity, the print image is supremely dramatic—we *know* there is a story here, even if the details are lost. The real-life poses of the two figures and swirling lines of the flowing water infuse the picture with energy. The birds seem to dart right out of the picture frame. The predominantly blue and red color scheme is a beautiful example of the Meiji aesthetic at its best, especially in the sky—so often shaded from blue to white to red, but rarely with this artistry.

38

38. The Austerities of Saint Mongaku (Mongaku Shōnin Aragyō)

1885
Vertical *ōban* diptych
Signature: *ōju* Yoshitoshi *ga*
Seal: Taiso

Late in the Heian period, when Japan was plunged into wars between the Genji and Heike clans, the son of a minor courtier on the Taira (Heike) side, one Endō Moritō, became infatuated with his cousin Kesa Gozen, who was already betrothed to Minamoto (Genji) Wataru. Moritō went to great lengths to court her, and Kesa, torn between the two men, finally consented to give herself to Moritō if he would first eliminate Wataru. Kesa concocted a plan whereby Moritō was to steal into his rival's chamber by night, but she herself exchanged places with Wataru and received the fatal blow. Moritō then renounced the world and became a monk, taking the name Mongaku. He retired to the sacred precincts of Mt. Nachi in Kii province (present-day Wakayama Prefecture), and there practiced the austerities of penance, but even here troubles of the secular realm sought him out. A warrior passing nearby, intent on capturing any member of the Heike clan he could find, recognized Mongaku as Moritō and attacked him. In the struggle, Mongaku somehow ended up killing the soldier. A priest avowed never to take life, he now had the karma of two murders weighing on his shoulders. Mongaku decided to put an end to his infamy, and leaped off a bridge into the plummeting Nachi Waterfall, itself revered as a sacred embodiment of supernatural forces by Buddhists and Shintoists alike. Suddenly, as Mongaku was in midfall, the Buddhist deity Fudō Myōō (Skt.: Acala) became manifest—"the Unmoving," the rock-steady guardian of the faith against all delusions—and Mongaku was saved from certain death on the rocks below. This much of the story was dramatized in the Kabuki play *Mongaku's Sanscrit Devotions on the Bridge* (*Hashi Kuyō Bonji Mongaku*), first staged in 1883 with Yoshitoshi's friend Ichikawa Danjūrō IX in the duel role of Mongaku and Fudō. It is said that when Danjūrō came on stage as Fudō, the audience was moved to throw coin offerings at his feet. In actual history, Mongaku went on to become a powerful warrior-priest who repeatedly involved himself in political schemes—a far cry from the holy man pictured here.

In Yoshitoshi's print, the vertical diptych format creates the perfect layout for the plunge of the waterfall. Fudō grabs Mongaku's robes just in time, as the unshaven recluse slips into the spray near the bottom of the falls. High above hovers the Bodhisattva Kannon (Skt: Avalokiteśvara), the so-called Goddess of Mercy—here the famous Nachi Kannon associated with nearby Seigantoji temple. The printing of this image is a marvel: barely tinted layers of empty space overlap and cover most of the lower panel, drifting up into the deep blue, down-sweeping arcs of the cataract. A fine cloudlike texture has been rendered in the spray by a hand-embossing process called *karazuri*—"blank rubbing" on uninked blocks (note how the embossed lines create a feeling of transparency, even crossing over and enveloping the outlines on the feet of Kannon and Fudō). Varying scale in the three figures works to create a "three-point perspective," greatly enhancing the pictorial recession and height of the image.

the only real focus of attention. The tiny figure of Atsumori is barely visible to the lower right. Accents of aniline red in the fan, cape, and horse trappings enliven an otherwise subdued palette. The naturalistic yet foreshortened portrayal of the horse is quite remarkable, as is the curving trail of sparrows that echo the *chidori* plover pattern of Naozane's legging and upraised sleeve.

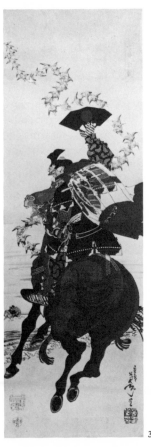

39

39. *The Battle of Ichi no Tani* (*Ichi no Tani Kassen*)
December 25, 1885
Vertical *ōban* diptych
Signature: *ōju* Yoshitoshi *ga*
Seal: Yoshitoshi *no in*
Engraver: Negishi Chokusan *tō*
Publisher: Matsui Eikichi

In the wars that closed out the Heian period (794–1185), samurai armies of the Minamoto family, or Genji clan, waged a protracted campaign against those of the Taira family, or Heike clan, the former eventually routing the latter at the naval battle of Dan no Ura in the third month of 1185. A little over a year earlier, during the second month of 1184, a decisive battle was fought at Ichi no Tani, to the west of what is now Osaka. There the Minamoto forces under Yoshitsune (1159–89; see pls. 31, 63) drove the Taira to the sea, whereupon they escaped by boat.

The most famous story associated with this battle is told in the epic *Tale of the Heike* (*Heike Monogatari*), from which Yoshitoshi invented this pictorialization. It seems that the sixteen-year-old Taira no Atsumori had been too late to make the boat, and rode his horse out into the waves to overtake it. It was then that the first of the Minamoto forces arrived at the beach in the person of one Kumagai Naozane (d. 1208), who saw the retreating figure of Atsumori and called out to him to return and fight like a man. Since a true samurai never showed his back to his opponent, the Taira youth turned to face his pursuer. When Naozane saw that Atsumori was only sixteen, the very same age as his own son, he was struck with compassion, and thought to spare the boy. But it was already too late: the rest of the Minamoto troops arrived on the scene, and Naozane had no choice but to kill him as one of the enemy. Soon thereafter, Naozane renounced his samurai status and entered the Buddhist priesthood by way of atonement.

This print is sparse in pictorial detail by Yoshitoshi's standards, the main figure of Naozane and his horse comprising

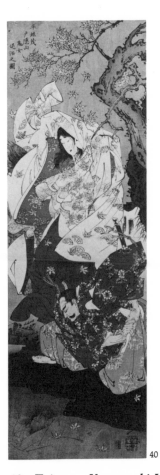

40

40. *Taira no Koremochi Vanquishes the Demon Maiden of Mt. Togakushi* (*Taira no Koremochi Togakushiyama Kijo Taiji no Zu*)
November 1, 1887
Vertical *ōban* diptych
Signature: Yoshitoshi
Seal: Yoshitoshi *no in*
Engraver: Negishi Chokusan *tō*

Taira no Koremochi, a warrior of the Heike clan, was hunting deer one autumn toward the first part of the tenth century. Deep in the mountains of Shinano (present-day Nagano Prefecture), he happened upon a party of women, a princess and her maidservants on an outing to view the maples, gold and crimson. They invited him to join in the merriment, the drinking and dancing. An uncontrollable drowsiness came over him and just as he fell asleep, the princess bade him farewell with an ominous tone in her voice. A dream revealed the horrible truth behind these strange circumstances: a messenger from Hachiman, god of war and guardian of samurai, appeared to tell him that the princess was in fact a demon who made its lair in these woods surrounding Mt. Togakushi, and who now intended to devour him. The messenger left Koremochi with an enchanted sword, with which he slew the hungry demon on awakening.

A well-known legend dramatized in the Noh play *In Maple-viewing Time* (*Momiji-gari*) and later brought to the

Kabuki stage by Yoshitoshi's close friend Ichikawa Danjū-rō IX, the subject seems to have been one of Yoshitoshi's favorites. He depicted it three times in his career. In the 1879 print of the series *A Mirror of Famous Generals of Japan*, he shows Koremochi locked in mortal combat with the demon (fig. 53). More typical of his mature style, this print opts for a more delicate, suggestive treatment. Here, at the moment before the bloodshed, Yoshitoshi plays with the bipolarities of illusion and reality, depicting Koremochi as he peers at the demonic reflection of the princess in a mountain pool. Again in the 1890 print of the *Thirty-six Ghosts* series (fig. 94, no. 14), Yoshitoshi uses a reflected demon's image, this time in a large saucer of saké, but with considerably less subtlety.

Yoshitoshi used a highly diversified palette in this print, yet the effect is not strained in the least. The key block shows some wear in the outlines of the maple tree and the princess's robes, indicating a late pull, but otherwise the image is beautifully printed, its color harmonies fresh and natural.

zens would take refuge from the flames in nearby temples, which recommended themselves not only by their charitable function but also by the relative spaciousness of their grounds.

So it was in the year 1681, when a fire swept through the Hongō and Yushima districts of north-central Edo, the local populace fled to Enjōji temple in the Koishikawa district slightly to the south. Among the crowd was a young girl, Oshichi, daughter of a rather well-off Hongō vegetable merchant. According to the later Kabuki play based on her story, her myopic mother was trying to help a young man remove a splinter, but getting nowhere. She called Oshichi over, and the daughter immediately fell in love with the handsome Kobori Samon. That night, when everyone was fast asleep on the sea of bedding that virtually filled the temple, she searched him out, and the two secretly consummated their passion. Inevitably the time came for the people to return to their homes, and the two were parted. Oshichi, heartbroken at the prospect of never seeing him again, determined to find a way to merge their fates at any cost. Taking the unethical and imprudent advice of the neighborhood ne'er-do-well, Kichizō, she set fire to her own house, thinking this would once again unite her with Samon at the temple. She was discovered, however, and had to face punishment as an "adult" of seventeen, whereas she would not have been punishable by law if a minor of fifteen or under. As a result, she was burned alive, and her lover committed suicide when he heard of the tragedy.

Yoshitoshi's composition is full of pageant and action, yet the figure of Oshichi remains graceful through it all. The long diagonals of the bamboo ladder and the dark building link the two vertical panels with a grounded solidity that contrasts with the light and airy treatment of the flames and Oshichi's windblown garments. Oshichi's expression shows the mixture of foreboding and uncomprehending innocence we would expect of the pampered and unworldly daughter of a rich merchant.

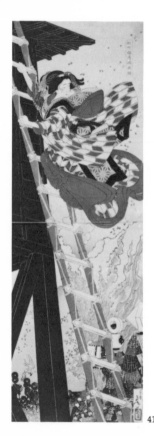

41

41. *Yaoya Oshichi Burns Her Own House* (*Shōchikubai Yushima Kakegaku*)
 1888
 Vertical *ōban* diptych
 Signature: *ōju* Yoshitoshi *ga*
 Seal: Taiso
 Engraver: Negishi Chokusan *tō* (not credited in this reprint)
 Publisher: Matsui Eikichi (reprint publisher: Hasegawa Tsunejirō)

The city of Edo, densely populated and tightly packed with wood-frame houses, was subject to frequent conflagrations. Precautionary reminders were posted everywhere—especially the ubiquitous "Be careful with fire" (*hi no yōjin*). A whole body of folklore built up around the heroic figures of the firemen (see pl. 64). On the other hand, people became used to packing up their belongings at a moment's notice, and in fact many unique forms of traditional Japanese furnishings, such as the "wheeled chest" (*kuruma-dansu*), were designed specifically for that purpose. Not infrequently, citi-

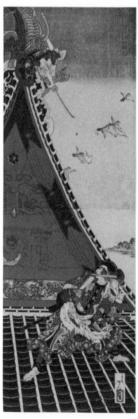

42

42. *Two Valiants in Combat atop the Hōryūkaku Pavilion* (*Hōryūkaku Ryōyū Ugoku*)

October 1885
Vertical *ōban* diptych
Signature: *ōju Yoshitoshi ga*
Seal: Taiso
Engraver: Chokusan *tō*
Publisher: Matsui Eikichi

The valiants Inuzuka Shinobu and Inukai Gempachi figure in one of the more famous episodes of the fifty-three-volume epic *Tale of Eight Dogs of the Satomi Clan* (*Satomi Hakkenden*) by Takizawa Bakin (1767–1848). The long, involved plot tells of the exploits of eight heroes, all of whom are magically descended from a princess and the courageous dog who won her hand by capturing an enemy castle for her warlord father. The eight were born into different families since the princess committed harakiri rather than bear the dog's children, whereupon eight jewels flew from her womb to implant themselves in eight other women. Thus, none of the eight "brothers" knows anything of the others, yet miraculously all are born clasping a jewel emblazoned with a character for one of the eight Confucian virtues. Moreover, each has the character "dog" (*inu*) in his family name, as well as a peony-shaped birthmark somewhere on his body.

In the episode Yoshitoshi depicts, Inuzuka and Inukai—both ignorant of the other's identity—are fighting on the roof of the Hōryūkaku Pavilion of Koga Castle on the banks of the Tone River. Ultimately, both plummet to the river below (see pl. 15), land unconscious in a boat, and float downstream to further adventures.

The depiction is full of colorful action, augmented by the brilliant aniline red of the tower gable. The overall composition borrows from a print of the same subject by Yoshitoshi's teacher Kuniyoshi (fig. 26), while the clouds to the upper left seem to derive from the conventional portrayal of clouds in northern European copperplate engravings.

1336–92)—Ōmori Hikoshichi served in the army of Ashikaga Takauji (1305–58), which defeated Kusunoki Masashige (1294–1336) at the Battle of Minatogawa in 1336, thus establishing Takauji as the first Ashikaga shogun. Legend has it that soon after the battle, Ōmori met a young noblewoman who asked to be carried across a stream. Ōmori obliged, but noticed as he was in midstream that the lady's reflection in the water had horns. Japanese demons are often given away by shadows and reflections (see also pl. 40), and the tale, as usually told, ends with Ōmori putting the she-devil to the sword. According to a somewhat more prosaic version, Ōmori met the noblewoman at a Noh performance staged to celebrate the victorious battle, and was accompanying her home on the far side of the stream when she donned the horned *hannya* mask that symbolizes vengeance in Noh drama, and attacked him with a dagger. Ōmori reacted quickly, threw her down, and at once recognized her as the daughter of the defeated Masashige. He then related the details of how her father bravely met his end, committing harakiri rather than surrender, and then let her go free after presenting her with a dagger that had belonged to her father.

The *Thirty-six Ghosts* series, of which this is the fourth image (as listed on the series' contents page), was Yoshitoshi's last major undertaking, and is often considered his crowning achievement (see fig. 94, pls. 44–48). Begun in 1889, the year of this print, Yoshitoshi's health was already beginning to wane, and so he received considerable help from his disciples Toshikata and Toshihide in realizing the project. The linework in this print is crisp and highly disciplined, the colors bright and decorative. The vermilion robe of the noblewoman features hand-application of precious mineral pigments in wide brushstrokes that are layered horizontally across the printing block to give a rich textural effect. The bulk of her robes bears down heavily on the suspicious Ōmori.

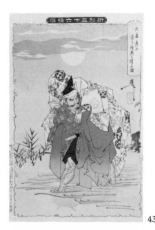

43. *Ōmori Hikoshichi Encounters a Demon* (*Ōmori Hikoshichi Michi ni Kaii ni Au Zu*)

May 10, 1889
Series: *Selected New Forms of Thirty-six Ghosts* (*Shingata Sanjūrokkaisen*)
Single *ōban* sheet
Signature: Yoshitoshi
Seal: Taiso
Engraver: Horiyū
Publisher: Sasaki Toyokichi

Toward the outset of the war-torn period when Japan was divided between two lineages within the imperial family—the so-called Northern and Southern Courts (*nambokuchō*;

44. *The Ghost of Okiku of the Dish Mansion* (*Sarayashiki Okiku no Rei*)

August 1889
Series: *Selected New Forms of Thirty-six Ghosts* (*Shingata Sanjūrokkaisen*)
Single *ōban* sheet
Signature: Yoshitoshi
Seal: Yoshitoshi
Engraver: Chokusan *tō*
Publisher: Sasaki Toyokichi

The tale of Okiku is one of the two or three best known ghost stories in all Japan, but like all ghost stories it varies according to the teller. One version runs that Okiku was a maidservant in the mansion of a powerful retainer under the

child-shogun Tokugawa Ietsugu (1709–16), Aoyama Tessan, to whom Dutch merchants had entrusted ten rare pieces of Delft porcelain. When the lady of the house accidentally breaks one, she throws the pieces down the well and blames Okiku. The young girl pleads innocence, but to no avail. She is locked in a room until half-starved, before managing to escape. Finally, she flings herself down a well, where her ghost continues counting to nine and then stopping, night after night. It is only when someone gets the notion of capping off the count with a shout of "ten" that her spirit is appeased.

Another version related in the Kabuki play *The Dish Mansion of Banchō (Banchō no Sarayashiki)* has Aoyama make advances to Okiku. She refuses, and her master malevolently hides one of the dishes, which he then asks to see. She is understandably flustered to find herself one short of the full set, but Aoyama slyly says he will overlook the whole mishap if she will sleep with him. She again refuses. Infuriated, Aoyama murders the young maid and throws her body down the well, where she moans the nine-count as above.

Yoshitoshi's image is the epitome of understatement, the muted colors and pathos of the figure of the poor servant girl seeming the very antitheses of Hokusai's grotesque, serpentine Okiku who slithers out of a well in that artist's *One Hundred Ghost Stories* series (fig. 45). The subtlety of this print is due in no small part to the consummate skill of the printer: the gradations of colors within the near-monochrome palette are amazing for their transparency, blending out in many directions at once, while the linework is crisp and lively.

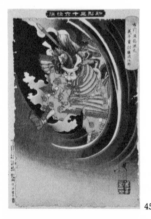

45

45. Evil Genta Fells Naniwa Jirō at Nunobiki Waterfall (*Nunobiki no Taki Akugenta Yoshihira no Rei Naniwa Jirō o Utsu*)

December 12, 1889
Series: *Selected New Forms of Thirty-six Ghosts (Shingata Sanjūrokkaisen)*
Single *ōban* sheet
Signature: Yoshitoshi
Seal: Yoshitoshi *no in*
Engraver: Wada *tō*
Publisher: Sasaki Toyokichi

Samurai youths came of age very quickly, often taking the formal attire (*gempuku*) of manhood as early as eleven years of age. Minamoto no Yoshihira (1140–60), or Evil Genta, was a mere fifteen years old when he earned a reputation as a ruthless warrior, having slaughtered his uncle Yoshitaka and other relatives in the line of duty. When his own father, Yoshitomo, was murdered by an agent of the Taira clan in 1159, the nineteen-year-old Yoshihira disguised himself as a peasant and made his way into the Taira stronghold of Kyoto

to seek revenge. He was recognized, however, and taken before the warlord Taira no Kiyomori (1118–81), who ordered him to be executed at Nunobiki Waterfall near the present-day city of Kobe. Legend has it that the instant the blade of his executioner, Naniwa Jirō, cut through the youth, his body sprang high into the air and was transformed into the God of Thunder. A flash of lightning split the sky, and Naniwa was struck dead on the spot.

Yoshitoshi's intensely hateful Genta is shown high in the clouds, peering down far below to see the lightning bolt just released from his outstretched palm hit the unsuspecting Naniwa. A reworking of an earlier print of the same subject, Ukiyo-e's only known vertical triptych, *Taira no Kiyomori Watches Evil Genta Strike Naniwa Jirō Down at Nunobiki Waterfall (Kiyomori Nyūdō Nunobiki no Taki nite Akugenta Yoshihira no Rei Naniwa Jirō o Utsu o Yūran Suru*, 1868; fig. 123), the bottom quarter of the picture area is left blank to render a sensation of height. The story of Yoshihira's exploits and execution was fairly popular in Yoshitoshi's youth, and many other apprentices of Kuniyoshi also depicted the subject.

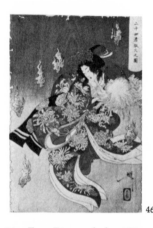

46

46. Fox Fires of the "Twenty-four Examples of Filial Piety" (*Nijūshikō Kitsunebi no Zu*)

1889
Series: *Selected New Forms of Thirty-six Ghosts (Shingata Sanjūrokkaisen)*
Single *ōban* sheet
Signature: Yoshitoshi
Seal: Taiso
Publisher: Sasaki Toyokichi

The play *Twenty-four Examples of Filial Piety (Honchō Nijūshikō)* was first performed in 1766 as a piece for the Bunraku puppet theater, and only later adapted for Kabuki, but in either case the dance of Princess Yaegaki pictured here comes at the climax of a long and very involved plot.

Princess Yaegaki and Takeda Katsuyori were star-crossed lovers, the daughter and son of the warlord Uesugi Kenshin (1530–78) and his arch rival Takeda Shingen (1521–73), respectively. At one point in the on-going feud between the Uesugi and Takeda families, however, a truce was called so that they could hunt for the assassin of the fourteenth Ashikaga shogun, Yoshihide (1540–68). Both families pledged to kill their heirs if they failed to come up with the murderer, and three years later the search was still unsuccessful. The Takeda family soon had second thoughts about their side of the bargain, and substituted a loyal retainer for execution in place of Katsuyori, who was forced to disguise himself. Then Katsuyori stole into the Uesugi castle incog-

nito, intent on reclaiming a Takeda family treasure: a magic helmet formerly entrusted to the priests of Suwa Shrine, and later transferred to the Uesugis' keeping. Uesugi Kenshin secretly recognized Katsuyori, and dispatched him on a mission—straight into an ambush. Princess Yaegaki was horrified to hear of the danger awaiting her lover, but could not reach him because of an intervening frozen lake. She prayed to the god of Suwa Shrine, who sent an enchanted white fox to guide her across the ice to deliver the magic helmet that is Katsuyori's salvation.

Here in Yoshitoshi's print, the princess is seen to dance as if floating in mid-air, escorted by the mystic fox fires that will lead her to her lover. Her kimono is splendidly embroidered with chrysanthemum motifs, her hair adorned with a coronet of silver flowerlets, and she holds the horned and shag-covered helmet. The empty space of the gray background is enriched by the natural grain of the cherry printing block.

and bites her lip just thinking of Anchin. The design is almost identical with that of an image Yoshitoshi drew for his *One Hundred Ghost Stories of Japan and China*. Minor differences merely intensify the poignant intensity of her presence: she bends over further in this print; her trailing sash is patterned more like serpent scales; a half-clouded moon now keeps a vigil in the sky. Both versions show cherry blossoms wafting down through the midnight air, in reference both to the springtide of the Kumano pilgrimage and to the ephemerality of human existence.

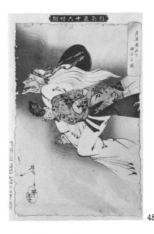

48. *The Old Woman Retrieves Her Arm (Rōba Kiwan o Mochisaru Zu)*
April 12, 1889
Series: *Selected New Forms of Thirty-six Ghosts (Shingata Sanjūrokkaisen)*
Single *ōban* sheet
Signature: Yoshitoshi
Seal: Yoshitoshi
Engraver: Chokusan *tō*
Publisher: Sasaki Toyokichi

The year was 976, a time when the Heian capital (present-day Kyoto) was overrun by bandits and demons. The general Minamoto no Yorimitsu (948–1021) had waged an all-out campaign against these villains, but rumors had it that one ogre still haunted the Rashōmon Gate (the famous Rashōmon of Akutagawa's short story and Kurosawa's film). One of Yorimitsu's lieutenants named Watanabe no Tsuna accepted the challenge to camp out overnight at the gate in the hopes of catching this last demon, Ibaraki, for a trophy. Long after midnight, as Tsuna dozed by the ruined gate, he felt something gripping his helmet. He quickly slashed at whatever was behind him, and was startled to see that his sword had claimed the demon's forearm. He took the clawed and hairy arm to a Shinto priest the very next morning, and asked his advice. The priest had Tsuna put the demon arm in a box and then performed special rites over it, making sure that absolutely no one be allowed to observe them. This he did, or was doing, when Tsuna's aged aunt Mashiba showed up unexpectedly and took an interest in the strange goings-on. Reluctantly, Tsuna gave in to the old woman's curiosity and opened the box. Immediately, the harmless, frail aunt grabbed his prize and flew into the air, laughing, "At last, I've got my arm back!" The ogre Ibaraki-as-Mashiba disappeared into a storm-swept sky.

The story is recounted in the Noh play *Ibaraki* and the 1883 Kabuki play of the same name, and forms part of a large tale of the ogres of Oeyama. Yoshitoshi depicted the climactic battle between Yorimitsu, Tsuna, and the last of the ogres

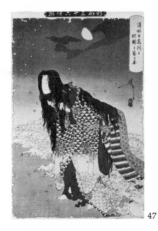

47. *Kiyohime Changes into a Serpent at the Hidaka River (Kiyohime Hidakagawa ni Jatai to Naru Zu)*
January 15, 1889
Series: *Selected New Forms of Thirty-six Ghosts (Shingata Sanjūrokkaisen)*
Single *ōban* sheet
Signature: Yoshitoshi
Seal: Taiso
Engraver: Enkatsu *tō*
Publisher: Sasaki Toyokichi

Kiyohime was the daughter of an innkeeper in the village of Masago, which was situated on the pilgrimage route to Kumano Shrine. Each year there passed through the young priest Anchin, and each year the girl grew fonder of him. Finally she declared her love for him, and although he humbly turned her down by explaining that priests could not have amorous entanglements, she would not be spurned. Driven by her passions, she pursued Anchin until her path was blocked by the raging Hidaka River. Her emotions in as full flood as the river, she was transformed into a serpent, and swam across. Meanwhile, Anchin hid himself under the huge bronze temple bell back at his monastery. Kiyohime found him out, however, and coiling herself around the bell, melted it in the heat of her rage, killing them both.

The story was set down at the request of the emperor Go-Komatsu (1377–1433), and the scrolls are still preserved at Dōjōji temple. It later became dramatized as the Noh play *Dōjōji* and even later in the Kabuki play *The Maiden of Dōjōji Temple (Musume Dōjōji)*, first staged in 1753.

Yoshitoshi's Kiyohime is the picture of determination. Emerging from the river dripping wet, she wrings her hair

in an early triptych, *Yorimitsu and His Four Heavenly Generals Vanquish the Ogres of Oeyama* (*Raikō [Yorimitsu] Shitennō Oeyama Kijin Taiji no Zu*, 1864; fig. 35). He also created a dramatic vertical diptych, *Watanabe no Tsuna Severs the Ogre's Arm at Rashōmon Gate* (*Rashōmon Watanabe no Tsuna Kiwan Giri no Zu*, 1888; fig. 92). In this print, however, there is no bloodshed. Only the grotesque claws protruding from the old woman's feet and the gnarled arm reveal the horrible truth.

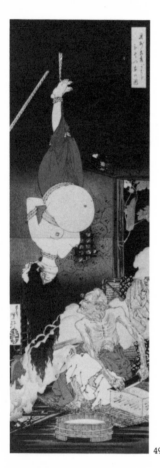

49. *The Hag of Adachigahara* (*Ōshū Adachigahara Hitotsuya no Zu*
 September 1885
 Vertical *ōban* diptych
 Signature: *ōju* Yoshitoshi *ga*
 Seal: Yoshitoshi
 Engraver: Chokusan *chōkoku*
 Publisher: Matsui Eikichi

The legend of the hag of Adachigahara (not to be confused with Asajigahara) was known to every Japanese in Yoshitoshi's time from the Noh play *Kurozuka*. The classic telling of the tale has the crazed old woman brutalize pregnant young women en route to their parental home town to give birth—as was the custom—and drink the blood of their unborn children, perhaps the most horrible thing imaginable in a traditional family-oriented society.

In this, quite likely the most galvanizing of all Yoshitoshi's images, the tensions are heightened to an almost unbearable pitch by forgoing direct graphic representation of the gruesome scene, and instead leading the viewer to imagine what is to come. The shriveled hag hones her knife, glaring viciously at the doomed young woman. This image was, in fact, considered so intensely disturbing that it was suppressed

by the Meiji government, and never released (as likewise was pl. 50).

Yoshitoshi surely gained an appreciation for the dramatic potential of this story from his teacher Kuniyoshi, who had portrayed the subject many times. Yoshitoshi himself depicted this and the related Asajigahara story in several treatments: once in *The Hag of Asajigahara* print of the *Yoshitoshi Miscellany* series (pl. 16), once in the *One Hundred Moons* series, yet another time in *Onoe Kikugorō V as the Hag of Asajigahara* (pl. 58), and here in this vertical diptych, which is undoubtedly the most striking of all. These four prints all incorporate conventions borrowed from Kuniyoshi—the gourd vines, the crumbling walls of the house, the androgynous-looking old woman. The representation of the victim's hair hanging in the smoke in this print is noteworthy for its photographically-mannered representation of transparency. Also of note is the loose, scratchy linework on the ropes and folds of her undergarments. The use of bright aniline red serves to illuminate the otherwise dark upper panel, and so balances the overall composition.

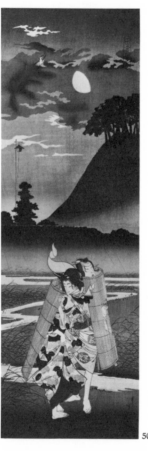

50. *Genji in the Provinces* (*Inaka Genji*)
 August 20, 1885
 Vertical *ōban* diptych
 Signature: *ōju* Yoshitoshi *ga*
 Seal: Yoshitoshi
 Publisher: Matsui Eikichi

In this pictorialization of Ryūtei Tanehiko's popular novel *The Other Murasaki with Genji in the Provinces* (*Nise Murasaki Inaka Genji*; see also pl. 51), Yoshitoshi shows Ashikaga Mitsuuji and the Lady Tasogare huddled together in a split-bamboo *sudare* blind as they wander through the desolate countryside in the rain. Although hardly explicit by

today's standards or, conversely, even by those of the Edo period, depiction of even this degree of sexual intimacy was considered licentious by the touchy Meiji authorities. The print was never issued.

The vertical composition and subdued color scheme work to isolate the figures in the landscape. Carefully placed accents of aniline red and purple dyes also serve to focus attention. The subtle black-on-gray gradations of the clouds and ink-splash trees of the background relate to the world of ink painting, in contrast to the sharp outlining of the figures, more indicative of the Ukiyo-e style.

sash strike a surprisingly modern note, while the block patterns repeated in Mitsuuji's kimono and the title cartouche of the upper right-hand corner derive from traditional *genjikō* designs associated with the various chapters of the *Tale of Genji*.

52

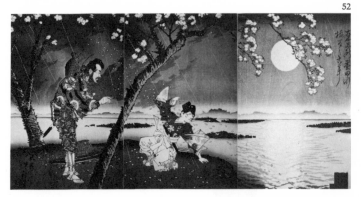

52. *Famous Places Around Edo: The Sumida River—Umewaka and the Child Seller* (*Azuma Meisho Sumidagawa Umewaka no Furugoto*)

 July 1883
 Ōban triptych
 Signature: Taiso Yoshitoshi *ga*
 Seal: Yoshitoshi *no in*
 Engraver: Yamamoto *tō*
 Printer: Suritsune
 Publisher: Akiyama Takeemon

Umewaka is a semilegendary figure dating from Japan's war-torn middle ages. His story, as immortalized in the Noh play *Sumida River* (*Sumidagawa*) and later in Kabuki, has the boy a student at a temple on Mt. Hiei, a center of learning not far from Kyoto. He runs away down the other side of the mountain, away from Kyoto toward Lake Biwa, but is apprehended by a slave trader called Shinobu no Tōta, that is, "Tōta, the Thief." His captor leads him to the far eastern provinces before the boy succumbs to illness and exhaustion on the banks of the Sumida River, which runs through what is now Tokyo. Umewaka's grief-stricken mother searches everywhere for her lost son, and ultimately finds his grave.

Curiously, Yoshitoshi chose not to portray the boy as the conventionally helpless victim. Indeed, for all the drama of the scene, it is difficult to know just what is going on. The boy does not appear particularly frightened, nor for that matter ill or tired. If anything, he looks seductively feminine, dressed in the fineries of an aristocratic acolyte. The Tōta figure, on the other hand, is hardly menacing. This ambiguity no doubt adds to the appeal of the print, but even so, what did Yoshitoshi mean to express here?

This image seems to have been intended as one of a series on the legends and folklore surrounding his own home city, Tokyo, but the project went no further. A mysterious print, it nonetheless stands as a remarkable experiment in combining elements of diverse pictorial styles, from the fine detailing of the figures, the "splashed-ink" texture of the tree trunks, to the photo-influenced reflection of the moon on the water. This is perhaps the closest of any of Yoshitoshi's works to the spirit of modern *sōsaku hanga*, the so-called original print of the Taishō (1912–26) and early-Showa (1926–) eras.

51

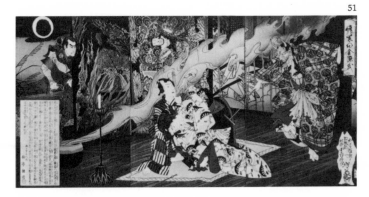

51. *The Other Murasaki with Genji in the Provinces* (*Nise Murasaki Inaka Genji*)

 1882
 Ōban triptych
 Signature: Yoshitoshi *sha*
 Seal: Yoshitoshi
 Engraver: *horikō* Noguchi Enkatsu
 Publisher: Akiyama Takeemon

Here Yoshitoshi presents us with his visualization of a scene from the fifth volume of Ryūtei Tanehiko's (1783–1842) popular novel of the same name, which was serialized from 1829 through 1842 and later dramatized for the Kabuki stage. The story was an updating of *The Classic Tale of Genji*, set in the Muromachi period with the lord Ashikaga Mitsuuji taking the part of the Shining Prince.

Wayfaring through the countryside, Mitsuuji and his lady Tasogare have taken shelter from the rain in an old abandoned temple. Suddenly there appears a dancer wearing the mask of a jealous *hannya* she-devil, who, acting out the role of the enraged ghost of Mitsuuji's wife Futaba, threatens to kill them both. The demon dancer turns out to be none other than Tasogare's own mother, and she and her daughter commit suicide to put an end to their shame.

Despite its theatricality, this particular presentation makes no overt reference to Kabuki staging. It is not an actor print, but an embellishment of the tale as imagined by Yoshitoshi. A key work in Yoshitoshi's career, it signals a shift toward the Noh aesthetics that prevailed in his later prints. Characteristically, the *hannya* she-devil figures more in Noh drama than in Kabuki, while the actual horror of the double suicide is not shown in order to render a sense of impending tragedy. The temple has fallen into disrepair, and two painted panels depicting Buddhist hell and paradise are roped together as a windbreak. The pilgrim peering in from the left, clutching his *juzu* rosary, also serves to heighten the dramatic tensions. The overall color scheme is subdued, drawing attention to the three main figures in their bright garb. Loose, flowing linework in the wafting smoke and the *hannya*'s yellow

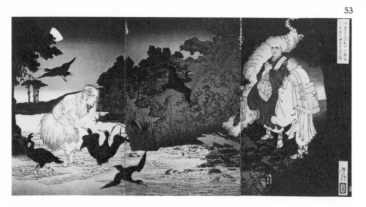

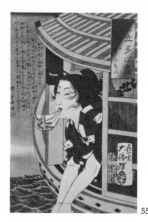

54 55

53. *Saint Nichiren Saves the Cormorant Fisherman* (*Nichiren Shōnin Isawagawa nite Ukai no Meikon o Saido Shitamau Zu*)

1885
Ōban triptych
Signature: Yoshitoshi
Seal: Taiso
Engraver: Enkatsu *tō*
Publisher: Akiyama Takeemon

In medieval Japan, the populist priests Hōnen (1133–1212), Shinran (1173–1262), and Nichiren (1222–82) all rebelled against the established aristocratic and esoteric schools of Buddhism, founding their own sects—Jōdo, Shin, and Nichiren, respectively—which were geared to redemption of the common classes. Each incurred the wrath of the authorities more than once, and each in turn came to be regarded as a saint, especially among the less-privileged sectors of society.

Nichiren was a particularly colorful character, given to proselytizing on street corners and challenging leading Buddhist scholars to public philosophical debate. A number of miracles are attributed to him as well. On one such occasion, in 1274, it is said that Nichiren stopped for the night at a roadside shrine in the Isawa fief of Kai province (present-day Yamanashi Prefecture). In a dream he was visited by the ghost of a cormorant fisherman who had been swept underwater in karmic retribution for taking life, that is, fishing, in a sacred area. The specter of the fisherman begged the holy man to intercede on his behalf, then vanished. At once Nichiren began to offer prayers for the salvation of the errant spirit, and the next morning the priest awoke to find himself not in any roadside shrine, but out in the open on the banks of the Isawa River. This story forms the basis of the Kabuki play *Saint Nichiren and the Waters of the Dharma* (*Nichiren Shōnin Minori no Umi*).

Yoshitoshi's triptych spreads before the viewer an eerie panorama full of dreamlike detail. In the fanning leaf patterns and grasses of the dense undergrowth, in the handling of the rocks showing through the swirling water, and especially in the meticulous linework of the fisherman figure, Yoshitoshi lets nothing escape his notice. Note also the split brush-tip effect of the curving lines in the smoke trailing from the torch basket (*kagaribi*) set on shore, and the delicate overprinting of shadows on the river surface and figures. The two priests, Nichiren and his companion and later successor, Nikkō (1246–1333), wear the typical monastic robes and *kesa* surplices of their sect as they pray with *juzu* rosaries. The stylized three-quarter moon (see also pl. 47), a convention dating back to Heian-period picture scrolls and later revived and incorporated in craftwork decoration by Hon'ami Kōetsu (1558–1637) and the Rimpa school, provides an interesting counterpoint to the naturalism of the cormorants.

54. *I Want to Be Massaged* (*Oshite Moraitai*)
55. *I Want to Wash My Hands* (*Te ga Araitai*)

January 4, 1878
Series: *A Collection of Desires* (*Mitate Tai Zukushi*)
Single *ōban* sheets
Signatures: *ōju* Taiso Yoshitoshi
Seals: Taiso (pl. 54); Yoshitoshi (pl. 55)
Publisher: Inoue Mohei

A Collection of Desires is easily one of the two finest genre print series Yoshitoshi ever produced, the other being *Thirty-two Aspects of Women* (see pls. 56–57, fig. 103). Here we are shown twenty women from all walks of life, depicted as real personalities and as engaged in real-life activities instead of merely as languishing courtesans (see also figs. 100–102). Each image represents some particular desire—the phrase "I want to" (*tai*) in the titles—and the accompanying text by the humorist, Master Tentendō, is full of wit and wordplay. Many titles lean toward a slightly lewd double-entendre, yet more than their sensuality, it is a sense of women's intelligence and indomitable spirit that shines through.

The geisha who wants to be massaged is doubled over with convulsions (*shaku*) after serving and accepting one too many rounds (*shaku*) of saké . A pill case lies open on the floor in front of her. The boat girl wants to wash her hands of all the "crabs" and "sea lice" that she has to deal with in her line of work. She holds a handkerchief in her teeth, a convention that had immediate sexual connotations.

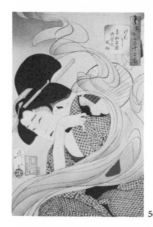
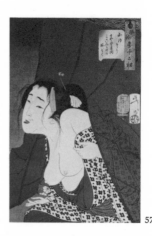

56 57

56. *Smokey: The Indoor Fashion at the Turn of the Nineteenth Century* (*Kemusō Kyōwa Nenkan Naishitsu no Fūzoku*)

May 19, 1888

57. *Itchy: The Fashion of the Kept Woman of the Early 1850s* (*Kayusō Kaei Nenkan Kakoi Mono no Fūzoku*)

September 16, 1888

Series: *Thirty-two Aspects of Women (Fūzoku Sanjūnisō)*
Single ōban sheets
Signature: Yoshitoshi *ga*
Seal: Taiso
Engraver: Wada Horiyū
Publisher: Tsunashima Kamekichi

As a series, the *Thirty-two Aspects* brings considerable historical and sociological interest to the genre print (see fig. 103 for the rest of the series). Physiognomic "aspects," or *sō*, which presented types of women not only according to their facial expressions but also their clothing, mannerisms, and poses, had been a popular theme for Ukiyo-e artists since Utamaro (1756–1806). Yoshitoshi took this analytical approach to new heights of unified presentation, every individual title playing on the aspect idea with catchy descriptive phrases suffixed with *sō*, "seems so." The two titles here, for example, might be rendered "seems so smokey" (*kemusō*) and "seems so itchy" (*kayusō*). More importantly, the entire series is conceived as a chronology of changing women's fashions from the late Edo period into the Meiji era, each treatment typifying the dress, coiffure, and life-style of a woman of a particular social background during a certain decade. The majority of images are spread over the span of time from the 1850s to 1880s, the decades to which Yoshitoshi himself felt the most attraction.

This series was one of his more popular, many images undergoing several printings, and continued to sell quite well even after Yoshitoshi's death. Some appear to have been printed from recarved blocks after a first set wore out. For many years before the Yoshitoshi revival in the late 1960s, this series was singled out for remembrance among all his other works.

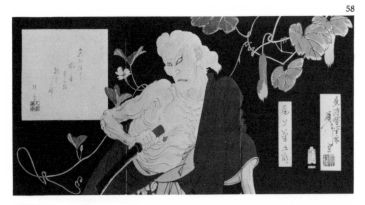

58

58. *Onoe Kikugorō V as the Hag of Asajigahara* (*Onoe Kikugorō*)
January 1890
Ōban triptych
Signature: *ōkokkeidōju* Yoshitoshi *ga*
Seal: Taiso
Engraver: Horiyū
Publisher: Akiyama Takeemon

Yet another pictorialization from the legend of Asajigahara (see also pl. 16), this was followed in August of this same year by still one more image of the hag in the *One Hundred Aspects of the Moon* series (fig. 72, no. 6), just before the close of Yoshitoshi's career. Here, however, Yoshitoshi pays tribute to his actor friend Onoe Kikugorō V in the role of the hag during a recent revival production of the Mokuami play on the legend. An exemplary work among his later actor prints, Yoshitoshi makes optimum use of the triptych format

in a dramatically simple composition. The actor wields the fatal knife, and steals through the dead of night amidst the *yūgao* gourd-flower vines overgrowing the lone house on the moor. A poem by Keika, a poet of Yoshitoshi's acquaintance, is inscribed on a *shikishi* paper square underprinted with a light pattern of autumnal *susuki* grasses:

Yūgao ni	Through the *yūgao* vines
kazeoto takaki	A high wind moans:
nokiha kana	At the eaves.

Keika's seal reads "Humanity: all things" (*Ningen banji*), which was the poet's motto.

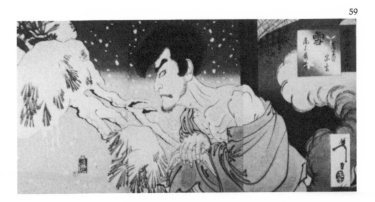

59

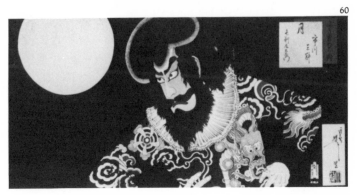

60

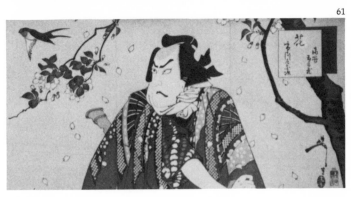

61

59. *Snow: Onoe Kikugorō V as Iwakura no Sōgen* (*Yuki Iwakura no Sōgen Onoe Baikō*)
August 1890

60. *Moon: Ichikawa Danjūrō IX as Kezori Kyūemon* (*Tsuki Kezori Kyūemon Ichikawa Sanshō*)
1890

61. *Flowers: Ichikawa Sadanji as Gosho no Gorozō* (*Hana Gosho no Gorozō Ichikawa Sadanji*)
January 1890
Series: *Actors with Snow, Moon, and Flowers* (*Yakusha Setsugekka*)
Ōban triptychs
Signatures: Yoshitoshi *ga*

Seals: Yoshitoshi (pls. 59, 61); Taiso (pl. 60)
Engraver: Horiyū (pls. 59, 60)
Publisher: Akiyama Takeemon

Together with the auspicious "pine-bamboo-plum" (*shōchikubai*) motif triad, one of the most often encountered groupings of traditional Japanese motifs is the "snow-moon-flower" (*setsugekka*) combination. Here, in his last series of actor prints, Yoshitoshi plays upon this standard arrayment in a novel way. As with his portrait *Onoe Kikugorō V as the Hag of Asajigahara* (pl. 58), Yoshitoshi dramatically places the figures of his actor friends against full three-panel backgrounds for a "larger than life" effect.

In the first triptych we see acted out the last throes of the fallen priest Sōgen from Iwakura, to the north of Kyoto. A variant on the story of the priest Seigen and the woman Sakurahime—which Yoshitoshi had depicted earlier in the 1889 vertical diptych *The Depravity of Seigen* (*Seigen Daraku no Zu*; fig. 93)—the beautiful courtesan Orikotohime happens to visit Sōgen's temple, where the two immediately become infatuated with one another. From that moment on, the lovers are inseparable. Sōgen is expelled from his temple for breaking his vows of celibacy, but is wholly unconcerned about throwing away the prospect of salvation for a few nights of bliss. When Orikotohime dies inexplicably, Sōgen is left a broken man with nothing but a memory. Onoe Kikugorō IV (under the stage name Baikō) pours pathos into his Sōgen, who stares vacantly at the snow, unmindful of the cold, his once priestly tonsure now unkempt.

The second triptych shows Ichikawa Danjūrō IV (under the stage name Sanshō) in the role of Kezori Kyūemon, the pirate who haunts the brothel district of Hakata in northern Kyushu. There he meets up with Komachiya Sōshichi, a Kyoto merchant whom he had previously robbed and thrown overboard on a ocean voyage west to Hakata, and engages him in a duel for the love of the courtesan Kojorō. Originally written by Chikamatsu Monzaemon (1653–1724) for the Jōruri puppet theater as *Hakata Kojorō's Pillow on the Waves* (*Hakata Kojorō Namimakura*), the tale was later adapted from the Kabuki stage in abbreviated form. The Ichikawa Danjūrō of this portrait strikes a climactic pose as he waits in the darkness for Sōshichi to appear, the full moon his only witness.

The last triptych of the suite features Ichikawa Sadanji, younger brother of Danjūrō, in the lead role of the Mokuami play *Gosho no Gorozō, a Gallant in the Manner of the Tale of the Soga Brothers* (*Soga Moyō Tateshi no Goshozome*), which is very loosely based on the vendetta of Soga Tokimune and Sukenari (see pl. 29). The long, convoluted plot centers on Gosho no Gorozō, former retainer of the lord Asama Tomoe-no-jō of Ōshū (present-day Fukushima Prefecture), now an extortionist and assassin-for-hire. The climax comes when Gorozō meets up with Hoshikage Doemon, another of Tomoe-no-jō's former retainers, strolling in the Gojozaka pleasure district of Kyoto. Both cutthroats know their former lord is dissipating a large sum of money in the vicinity, and both have an eye toward taking a share. Little known to Gorozō, however, his wife Satsuki, once a maidservant of the lord and now fallen to selling herself at the very same teahouse where Tomoe-no-jō is lodging, has been entertaining Doemon on the side. The dashing Gorozō of this print, *shakuhachi* flute tucked under his arm and sporting a woman's kimono in the dandy fashion, readies himself for the confrontation with Doemon.

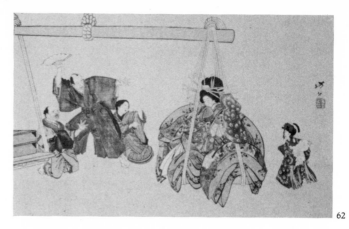

62

62. *The Courtesan Takao Dayū Weighs In* (*Takao Dayū*)
No date
Hanging scroll: ink and light colors on silk
Signature: Yoshitoshi
Seal: Yoshitoshi *no in*

No less than eleven courtesans of Edo's Yoshiwara pleasure district went by the name Takao at one time or another. The Takao Dayū pictured here figures in a humorous anecdote dating from the exciting Genroku era (1688–1704), a story made famous through Kabuki plays and Ukiyo-e prints.

An extremely wealthy merchant—possibly the entrepreneur Zeniya Gohei (see pl. 26)—wanted to have Takao for his own, but she played hard-to-get, and hesitated to name a price. The would-be patron refused to be turned away, however, for in those days there was nothing money could not buy—not even a *dayū*, the very highest rank of courtesan, who, unlike her inferiors, might not deign to entertain certain customers at her prerogative. Ultimately, Takao asked for her weight in gold, fully expecting to turn the suitor away, when he called her bluff and accepted the terms. The transaction turned into a major event: a huge balance beam was set up in public, and the courtesan, laden down with every trinket and piece of finery in her possession, tipped the scale at upwards of 20,000 *ryō*.

Yoshitoshi's painting is a comic masterpiece. The poses and expressions of the onlookers register disbelief as Takao demurely stifles a grin in the sleeve of her voluminous robes. The painting style is entirely in the Ukiyo-e manner in lines, fine detailing, and planes of color, with a minimum of shading.

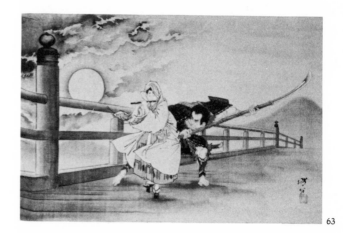

63

63. *Yoshitsune and Benkei Fight on Gojō Bridge* (*Yoshitsune Benkei Gojōhashi no Zu*)
No date

Hanging scroll: ink and light colors on silk
Signature: Yoshitoshi
Seal: Taiso

In what is undoubtedly one of the best-loved legends of the Japanese, the young Minamoto no Yoshitsune meets up with the mighty warrior-priest Musashibō Benkei on the Gojō Bridge over the Kamo River in Kyoto. Yoshitsune, still known at the time by his childhood name Ushiwaka, was fair of face and delicate of build, but had been thoroughly trained in the martial arts by *tengu* goblins of Mt. Kurama, northeast of the capital (see pl. 31). Ambling across the bridge in the moonlight, shawl pulled up over his head and playing the flute, the diminutive figure appears almost feminine—save for the sword at his side. It was the sword that caught Benkei's eye, for this giant of a man would engage in fights just to despoil his opponents of their weapons. His collection was already up to 999 blades, and so by now he was both cocksure of his own strength and overly anxious to round that number off to an even 1,000. Benkei was unaware, however, of Yoshitsune's seemingly supernatural agility. The nimble youth quickly outmaneuvered and exhausted his older foe, leaping and bounding across the bridge. It was Benkei's first defeat, and he was dumbfound—shown up by a mere child! Yet anyone that masterful surely deserved his allegiance, and thereafter Benkei faithfully served Yoshitsune as a retainer.

Yoshitoshi's Gojō Bridge spreads out in dramatic low-angle perspective before the Eastern Hills (Higashiyama) of Kyoto. Benkei wields a *naginata* halberd against the flute-playing Yoshitsune, who remains heedlessly calm. Yoshitsune's *hakama* leggings bear a curious pattern of Shinto *torii* gates and *kadomatsu* sacred pines. Aside from this painting, Yoshitoshi depicted the famous fight scene at least four more times: once as a print triptych (1887; fig. 104), once in *Personalities of Recent Times* (1887; fig. 63), once again in the *One Hundred Moons* series (1888; pl. 27), and once more as an *ema* votive plaque for Naritasan Shishōji temple in Chiba.

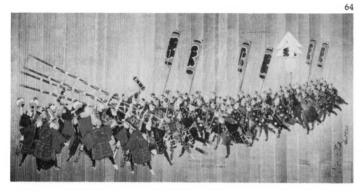

64

64. Ma Brigade Firemen (*Ma-gumi Shōbōtai*)
1879
Ema votive plaque: ink, Chinese white, mineral pigments, and gold foil on wood panel
Signature: *ōju* Yoshitoshi *kore o egaku*
Seal: Taiso

Firemen have the honor of being perhaps the only group of people generally regarded as heroes in nearly every culture throughout the world. Even so, the Japanese "firemen's festivals" must be unique. During these events, the firemen paraded down the streets before an adulating public and then competed one brigade against another in shows of skill and athletic prowess—climbing and balancing like acrobats on tall bamboo ladders. Although technically members of the lower classes, firemen clearly earned this high regard in the premodern city of Edo in combating the constant outbreaks of fire. Up until the Tokyo Earthquake of 1923, the fire hazards arising from the extreme proximity of wooden buildings and the use of open flames for heating and cooking meant firemen had to keep in continual training. Each fireman had his assigned task, and it was the role of the *matoi*, or standard bearer, to direct and coordinate the efforts of his brigade. The fireman's costume was distinctive: indigo-dyed *sashiko* quilted cotton cowls and *haori* jackets bearing the brigade insignia were worn over tight *momohiki* leggings. The quilting was wetted down in cooling water before entering the fire area, and thus the costume embodied a beauty born of necessity. During a festival—such as the one pictured here—the cowl would be replaced by a simple *hachimaki* headband, while some firemen might wear more colorful *happi* coats typical of festive occasions in general.

The idea of *ema* votive plaques originated in the early Shinto practice of presenting shrines with a horse or other valuable offering. Those who could not afford a real horse would offer a picture of a horse—*ema* meaning "picture horse." These would generally be painted in mineral pigments and ink on wood, and hung beneath the eaves of shrines for the local community to see. Later, a broader interpretation of *ema* came to include all manner of prayer-images (including fertility symbols and emblems of wealth), not just horses. Yoshitoshi's painting of the *Ma* Brigade firemen for Hikawa Shrine in the Akasaka district of central Tokyo was thus undoubtedly done at the behest of the fire brigade itself, to accompany some contribution to the shrine and to serve as a reminder of the brigade's readiness to come to the aid of the community. Yoshitoshi obviously enjoyed depicting firemen's costumes, having worked them into compositions many times over the course of his career: an 1885 triptych, *A Celebration of Gallantry* (*Isami no Kotobuki*), shows actors in firemen's garb; another *ema*, the *Hundredth Firemen's Brigade* (*Hyakkumi Shōbōtai*; 1877), is thought to have been similar to this image, but ironically was destroyed by fire; in the *One Hundred Aspects of the Moon* series, the image *The Moon Through Smoke* (*Enchū no Tsuki*, 1886; fig. 72, no. 3) shows the *I* Brigade busily combating a raging fire; and finally the vertical diptych *Yaoya Oshichi Burns Her Own House* (1888; pl. 41) depicts a troop of firemen coming to the rescue. In this painting, the flecks of gold in the background are meant to suggest falling sparks—an interesting textural experiment.

65. The Great Curtain (*Mammaku-e*), or *Sakuma Morimasa Foiled by Hashiba Hideyoshi* (*Sakuma Morimasa Hashiba Hideyoshi o Nerau*)
Ca. 1865
Long processional backdrop curtain: ink, Chinese white, and mineral pigments on linen
Signature: Ikkaisai Yoshitoshi; plus personal calligraphic cipher (*kaō*)

Sakuma Morimasa (1554–83) was an impetuous general under Shibata Katsuie (1530–83), who was lord of Echizen (present-day Fukui Prefecture) and rival of Hashiba Toyotomi Hideyoshi (1536–98) in the power struggles that followed the assassination of the autocrat Oda Nobunaga (1534–82). In 1583, at the decisive battle of Shizugatake in

Ōmi (Shiga Prefecture), Morimasa defeated Nakagawa Ki-yohide (1542–83), former partisan of Nobunaga. Katsuie then ordered Morimasa to withdraw before Hideyoshi's advancing armies, but Morimasa imprudently made a stand and was utterly annihilated by Hideyoshi's superior forces. Popular legend has it that Morimasa, seeking to make a name for himself, thought to subdue Hideyoshi personally, but when the two came within eye-contact range, the intensity of Hideyoshi's gaze overwhelmed Morimasa, making him an easy target.

Yoshitoshi's painting depicts the moment when Hideyoshi stares down Morimasa, causing him to nearly fall off his horse. Painted as a backdrop to line the street for a proces-sion during a Shinto festival at Yanagichō, Kōfu, in Kai province (Yamanashi Prefecture), this work evidences a knowledge of Kanō-school style in the handling of line. The curtain is almost ten yards long, but the twenty-six-year-old Yoshitoshi spared no effort in detailing the entire expanse. It is reported that he worked night and day to complete the tableau, exerting himself far beyond the expectations of the Kōfu populace, and thus became something of a local hero. The ink washes of the background evoke a suitably misty atmosphere for the hills of Shizugatake, renowned for its dense banks of fog. Once again, Yoshitoshi emerges as a perfectionist and a painter of genius, thoroughly acquainted with his subject matter.

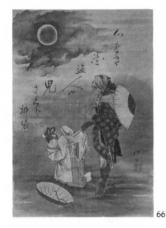
66

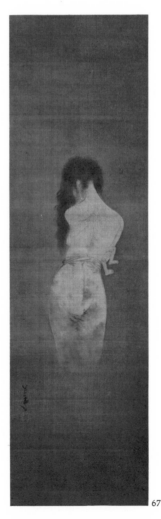
67

66. Umewaka and Shinobu no Tōta (Umewakamaru Shi-nobu no Tōta)
No date
Hanging scroll: ink and light colors on silk
Signature: Yoshitoshi
Seal: Yoshitoshi

This subject, also depicted in *Umewaka and the Child Seller* (pl. 52), is here given a decidedly different treatment. Truer to traditional portrayals of the story, the child Umewaka in his fineries actually looks frightened, while the seedy-looking Tōta delights in his victim's anguish. The figures are done in a style typical of Ukiyo-e painting—that is, they are sharply outlined and exactingly detailed with touches of color—while the background has merely been suggested with a loose ink-wash. The clouds around the moon have been painted with the *tarashi-komi* technique, whereby ink is allowed to drip into a moistened area to spread as it will. The verse by the unidentified haiku poet Ryūtai reads:

Kokoro naki	How heartless
hana-nusubito ya	The thief of youth's flower:
chigo zakura	This infant cherry blossom!

67. An Apparition (Yūrei no Zu)
No date
Hanging scroll: ink and light colors on silk

Signature: Yoshitoshi
Seal: Yoshitoshi

An unidentified subject from an unidentified tale, this painting is nonetheless as haunting as its ghostly theme. Literally and figuratively without any background details, the very faintness of the image only adds to its appeal, at once sensual and ethereal. Here we see what is perhaps the quintessential Japanese ghost: female, of course, and her back turned in that rarefied strain of emotions cold and hot, pathetic and spiteful, which is so characteristic of the wronged woman's scorn. Indeed, in the Japanese belief, a ghost typically shows her visible form only to those who have in some way contributed to her undoing. Thus, placed in the culpable position of the viewer, we must ask ourselves: who is this remorseful spirit? How came the blood stains on her undergarments? What happened to the baby she nurses, held away from our bewildered eyes? We may never known the answers but the disquieting vision lingers unforgettably in the mind.

BIOGRAPHICAL CHRONOLOGY

1839

Born the seventh day of the third month (lunar calendar), second son of Yoshioka Hyōbu II (Owariya Kinzaburō). Birthplace may have been the Yoshioka clan home in the Ōkubu district of Minami Toshima, Musashi province, outside the city of Edo (present-day Tokyo), but more likely was at the Owariya-family business household in the Minami Ōsakachō neighborhood of the Shimbashi district in Edo. After his father's death, however, officially entered in the family register of his second cousin, Kyōya (Yoshioka) Orizaburō, a pharmacist in the Maruyachō neighborhood of Shimbashi. At the time, still known by his childhood name: "Yonejirō, [adopted] second son of Yoshioka [Kyōya] Orizaburō, who rents a storefront in the block of 5 Maruyachō."

1850

Autumn. Begins apprenticeship under Ukiyo-e master Utagawa Kuniyoshi. Some accounts place the date one year earlier. Receives the artist name Yoshitoshi sometime thereafter.

1853

First illustrations for textbook *Illustrated Primer for Language Students* (*Ehon Jitsugokyō Dōjikyō Yoshi*), signed "Yoshioka Yoshitoshi." First *nishiki-e* full-color woodblock print *In 1185 the Heike Clan Sank to Their Doom in the Sea* (*Bunji Gannen Heike no Ichimon Horobi Kaichū ni Ochiiru Zu*), signed "Ikkaisai Yoshitoshi."

1859

Signs name two ways, "Gyokuōsai" and "Ikkaisai," on print triptych *Momotarō Scatters Beans at the Setsubun Festival* (*Momotarō Setsubun Mamemaki*).

1861

Teacher Kuniyoshi dies. At funeral, elder apprentice Yoshiiku kicks Yoshitoshi. Working mostly in illustrations and prints of warriors and actors.

1864

Residing at 2 Okechō in the Kyōbashi district of Edo. His one-year-old daughter dies. Takes leave of Okechō residence and journeys into mountains west of Edo toward the city of Kōfu in Kai province, accompanied by his apprentice Toshikage. Is well received and asked to produce a number of paintings for a Shinto festival at Yanagichō, Kōfu. Runs out of money, but obtains funds to return home from a local priest. Back in Edo, suffers eye ailment serious enough to threaten loss of one eye. Vows not to die an ignominious death in Edo and heads back to Kōfu to recuperate at the priest's temple.

1865

Ranked tenth most popular Ukiyo-e artist in the *Edo Almanac* (*Edo Saiseiki*). Moves to nearby Nakabashi neighborhood. Starts using the artist signature "Tsukioka Yoshitoshi" on prints of the series *One Hundred Ghost Stories of Japan and China* (*Wakan Hyaku Monogatari*) and *Famous Battle Lineups* (*Eimei Kumiuchi Zoroi*), thus identifying himself with the artist lineage of a possible distant relative, the painter Tsukioka Sessai.

1866

Collaborates with Yoshiiku on production of print series *Twenty-eight Infamous Murders with Accompanying Verses* (*Eimei Nijūhasshūku*), which continues into the following year. Still working largely in prints and illustrations of warriors and historical themes. Around this time, draws life-studies of wife and now live-in apprentice Toshikage modeling in various costumes.

1867

Three illustrations in *Colorful Images of Famous Episodes in the Water Margin Saga* (*Shūzō Suiko Meimeiden*) based on woodcut-reproduced figure drawings by painter Kikuchi Yōsai (1788–1878) in his *Sages of Earlier Times and Ancient Historical Events* (*Zenken Kojitsu*).

1868

Antishogunate fighting comes to a head. Yoshitoshi and Toshikage set out to eyewitness the aftermath of the Battle of Ueno. Certain figure studies drawn from bodies found strewn over the battlefield are incorporated into the print series *One Hundred Selections of Warriors in Battle* (*Kaidai Hyaku Sensō*), produced from mid-year into the following year. Yoshitoshi is ranked fourth most popular Ukiyo-e artist in the *Edo Almanac* after Sadahide, Yoshitora, and Yoshiiku. Reputedly marries Okoto, daughter of *kiyomoto* traditional ballad master (hence prior separation from first wife?).

1869

Moves to 1 Hiyoshichō in the heart of the newly renamed city of Tokyo. Yoshimune, former fellow apprentice under Kuniyoshi, rooms upstairs for two-month period.

1870

Discovers fourteen-year-old Toshinobu, then a novice paper lantern decorator; offers him apprenticeship and board.

1871

Painter Kobayashi Eitaku (1843–90) visits Yoshitoshi to study print design. In return, Eitaku tutors Yoshitoshi and Toshikage in painting. Yoshitoshi travels with Eitaku on a

sketching trip, possibly to the Ōiso shoreside, or back to Kōfu, as suggested by a painted screen of Yoshitoshi's dated this year, now found in Kōfu. Yoshitoshi and Eitaku apparently have a falling out, and Yoshitoshi returns to Tokyo alone. Produces a series of genre prints, *Raving Beauties at Tokyo Restaurants* (*Tōkyō Ryōri Sukoburu Beppin*); one of the beauties featured therein, the waitress Okiku of the Suzukiya teahouse, reputed to be Yoshitoshi's mistress.

1872

Obtains exclusive rights to paint for *camera obscura* show in the Ginza district of Tokyo. Suffers severe nervous debilitation from year-end into the following year. Utterly poverty stricken, rents meager quarters at 14 Minami Kinrokuchō. Starts print series *A Yoshitoshi Miscellany of Figures from Literature* (*Ikkai Zuihitsu*), cut short at thirteen or more images the following year. Apprentices at this time include Toshikage, Toshichika, Toshinao, Toshimitsu, Toshimaro, Toshiharu, Toshinobu, and Toshitsune.

1873

Wife Okoto, distraught at their extreme poverty, returns to her parental home in nearby Chiba, selling herself into prostitution. Production of prints and illustrated books grinds to a halt. At the end of the year, however, warrior prints such as *Honors for the Sekigahara Forces* (*Sekigahara Gunshō no Zu*) appear with the signature Taiso ("Great Rebirth"), signaling his recovery. In summer, creates posthumous portrait of Kuniyoshi for his thirteenth memorial services held in June at the Nakamurarō teahouse. On the commemorative marker later erected at Mimeguri Shrine, Yoshitoshi listed ninth in the roster of Kuniyoshi's disciples. Yoshitoshi's own apprentices now number ten.

1874

Six-panel historical print *Ii Naosuke Attacked by Surprise Outside the Sakaradamon Gate* (*Sakuradamongai ni oite Ii Tairō Shūgeki*) proves a major success. Paints *ema* wooden votive plaque *Hundredth Fireman's Brigade* (*Hyakkumi Shōbōtai*) for Sōjiji temple in the Nishi Arai district of northern Tokyo (work later destroyed in fire).

1875

Kept on retainer by the *Postal News* (*Yūbin Hōchi Shimbun*) to produce full-color *nishiki-e* prints in opposition to Yoshiiku on the *Tokyo Daily News* (*Tōkyō Nichinichi Shimbun*). Moves to Komparu Yokochō.

1876

Actor Onoe Kikugorō V performs in Shintomiza theater production based directly on Yoshitoshi's triptych *Edo Color Print of Kawanakajima Island* (*Kawanakajima Azuma no Nishiki-e*); Yoshitoshi paints blood stains on Kikugorō's theatrical armor. Moves back to 14 Minami Kinrokuchō.

1877

Apprentice Toshimitsu, the proprietress of the Kameya geisha establishment, and the owner of the Miyakoya teahouse all look after the extremely impoverished Yoshitoshi. In Kunichika's print *Lineup of Unparalleled Leaders in Tokyo Arts* (*Tōkyō Musō Tōichō Zoroi*), the calligraphic backdrop roster of artist names lists Taiso Yoshitoshi under the category of warrior prints (*musha-e*): "Vigorous brushwork sets him apart from the ordinary." Receives visit from painter Matsumoto Fūko (1840–1923). At the behest of the Ministry of the Imperial Household, executes two or three genre paintings on silk for a large picture album. Eyewitness

prints of the Satsuma Rebellion achieve considerable notoriety. Becomes more financially soluble (receiving six *sen* per triptych design). Moves to 5 Maruyachō; cohabits with local geisha, Oraku. From December, begins genre print series *A Collection of Desires* (*Mitate Tai Zukushi*).

1878

In *Special Feasts of the Imperial Capital on Parade* (*Kōto Kaiseki Beppin Kurabe*), once again depicts Okiku of Suzukiya, this time together with her younger colleague Otake, also reputed to have relations with Yoshitoshi. Does illustration for first issue of the newspaper *Kanayomi Shimbun* in March. *A Collection of Desires* published (receives two-and-one-half *sen* per single image). Depicts emperor's ladies-in-waiting in controversial print series *Beauties of the Seven Nights* (*Mitate Shichi Yōsei*). Paints central figure on a draw-curtain presented to performer Kodanji at the inauguration of the Shintomiza theater. Fellow Ukiyo-e artist Kobayashi Kiyochika (1847–1915) expresses unqualified admiration for Yoshitoshi's *A Mirror of Famous Generals of Japan* (*Dainippon Meishō Kan*); one of Kiyochika's prints, *From the Lesser Known Annals of Japanese History* (*Nippon Gaishi no Uchi*), inscribed "copied from Taiso Yoshitoshi" in characters larger than the artist's own signature, indicating Yoshitoshi's relative standing among artists of the time.

1879

Relationship with Oraku ends. Returns to rented quarters in Minami Kinrokuchō. In financial straits again. For the production of a Western theater piece staged in September at the Shintomiza on the occasion of the arrival of eight actors from England and America plus a musician from France, Yoshitoshi, Torii Kiyomitsu (1832–92), and Kawanabe Kyōsai (1830–89) paint picture-lanterns instead of the usual billboard placards. In December, does illustration work for the *Kabuki News* (*Kabuki Shimbun*). Five-year publication of *A Mirror of Famous Generals* continues; Yoshitoshi possibly studies oil-painting techniques to further the project. Paints *ema* wooden votive plaque *Ma Brigade Firemen* (*Magumi Shōbōtai*) for Hikawa Shrine in the Akasaka district. At year-end, moves to 35 Miyanagachō in the Nezu district of north-central Tokyo.

1880

Begins relationship with neighbor's niece, Sakamaki Tai, who he later marries. Illustrates popular writer Takeda Kōrai's novelization of the Mokuami play *Prophesy at the Crossroads at Ten O'clock One Frosty Night* (*Shimoyo no Kane Jūji no Tsujiura*) staged the previous year at the Shintomiza theater. Fifteen-year-old Mizuno Toshikata, eventually to become Yoshitoshi's favored and most talented disciple, begins his apprenticeship.

1881

In remembrance of the thirty-third memorial of actor Onoe Kikugorō's death, paints two panels depicting the *Three Sages of Shu* (*Shoku no Sanketsu*) as inspired by the Jōruri play *Peach and Cherry Blossoms, Autumn Colors* (*Momozakura Momiji no Irodori*). Theater owner later donates one panel to Atago Shrine in Shiba, the other to Tōshō-gū Shrine in Ueno (whereabouts of Ueno panel now unknown). Attends banquet held at Sannōji temple in Ueno in honor of apprentice Toshiyuki's accession to the title of Yoshimune II; fellow former-apprentices of Kuniyoshi, Matsumoto Yoshinobu and Yoshiiku, also in attendance.

1882

Yoshimune II and Yoshitoshi recruited as illustrators for the *Illustrated Liberal News* (*E-iri Jiyū Shimbun*); salaried at an unprecedentedly high one-hundred yen a month. Previously executed monochrome images and drawings published in one forty-six-plate volume *Collected Pictures of Yoshitoshi* (*Yoshitoshi Gashū*). Invited to participate in the first government-sponsored exhibition of Japanese painting; enters three paintings, *Fujiwara Yasumasa and Hakamadare Yasusuke* (*Yasumasa Yasusuke Zu*), *The Wind and Thunder Gods* (*Fū-jin Raijin Zu*), and another unrecorded title (all three since disappeared).

1883

Spring. Publishes print version of the *Yasumasa* painting of the previous year: *Fujiwara Yasumasa Playing His Flute beneath the Moon* (*Fujiwara Yasumasa Gekka Rōteki Zu*). Proves one of Yoshitoshi all-time classics. Actor Ichikawa Danjūrō IX stages a dance performance at the Shintomiza theater based on this print. In June, helps create life-size figures for a float of the same subject for the Hie Shrine Festival in Akasaka; also paints festival *happi*-coats for participants and rides on the prow of the float himself. Becomes thereby an object of public ridicule in the *Illustrated Liberal News*. At the request of the Omotemachi neighborhood of Akasaka, paints the small panel *Festival Float with Orangutans* (*Shōjō Dashi no Zu*; now coll. Hikawa Shrine, Akasaka). Also paints *The Hag of the Lone House of Adachigahara* (*Hitotsuya Rōba no Zu*) around this time; painting kept in poor state of repair at Myōon'in subtemple on the grounds of Dempōin temple in Asakusa, then transferred to Daigyōin, another subtemple, and finally disappears. Print series *The Four Seasons at Their Height* (*Zensei Shiki*) published in November; the "winter" print *Courtesans of the Daishōrō Establishment in Nezu* (*Nezu Hanayashiki Daishōrō*) features a portrait of the renowned courtesan "The Phantom" (*maboroshi dayū*) with whom Yoshitoshi had formed a liason two or three years earlier. One story has it that the Phantom agreed to let Yoshitoshi perform "some unspecified act" on a part of her body, then sent a request for the unheard-of sum of one hundred yen (an entire month's salary from the *Illustrated Liberal News*) the next morning.

1884

Does illustrations for initial publication of the political newspaper *Lamp of Liberty*. *Illustrated Liberal* tries to keep him on their staff, but Yoshitoshi is set on resigning in favor of the former newspaper. *Illustrated Liberal* blasts Yoshitoshi for several days running. Illustrates for the newspaper *Yomiuri Shimbun*. Marries Tai in December.

1885

Ranked number-one Ukiyo-e artist in *Tokyo Vogues in Detail* (*Tōkyō Ryūkō Saikenki*), and listed among the top five print designers in *Survey of Master Artists of Imperial Japan* (*Kōkoku Shoga Meika Ichiran*), alongside Kunichika, Hiroshige III, Ogata Gekkō (1859–1920), and Kiyochika. Works on the diptych series *Newly Selected Edo Color Prints* (*Shinsen Azuma Nishiki-e*) through the following year, but counter to Yoshitoshi's expectations the print of the well-known *Story of Otomi and Yosaburō* (*Otomi Yosaburō*) sells poorly. Begins production of the monumental series *One Hundred Aspects of the Moon* (*Tsuki no Hyakushi*), a full hundred images when completed in 1891. Becomes interested in vertical diptych compositions; of the sixteen Yoshitoshi produces in the mid-1880s, half are from this year, including

the suppressed titles *The Hag of Adachigahara* (*Adachigahara Hitotsuya no Zu*) and *Genji in the Provinces* (*Inaka Genji*). Paints wooden votive plaque of the protective deity Fudō (*Fudō Myōō Zu*) for the Naritasan Fudōson temple of nearby Chiba. Moves to 2 Sugachō in Asakusa. Toshimasa now head apprentice.

1886

Publication of *One Hundred Aspects of the Moon* begins; receives a reported ten yen per design. Painter Kanō Hōgai (1828–88) praises the image *The Story of Okoma of Shirakiya* (*Shirakiya Okoma no Hanashi*) of the *Newly Selected Edo Color Prints* series. In October, enters services of the newspaper *Yamato Shimbun*, and over the course of two years creates twenty full-color portraits in the series *Personalities of Recent Times* (*Kinsei Jimbutsu Shi*). Also illustrates transcriptions of the comic *rakugo* entertainer Sanyū-tei Enchō's (1839–1900) stories for the newspaper. Leaning toward naming disciple Toshikata as his successor. Paints Mt. Fuji in ink on white silk for Onoe Kikugorō V's costume in the Chitoseza theater's production of *Gallants in the Imperial Place at Plum Blossom Springtide* (*Ume no Haru Tateshi no Goshozome*) in February; also designs gold-thread dragon embroidery for the costume.

1887

Informed by a geomancer that his current lodgings are inauspiciously located, he builds a new house at 2-1 Hamachō in the Nihombashi district of downtown Tokyo; moves his belongings in before completion, only to be robbed of all his personal effects, artwork, and some two thousand yen during the night after he had stayed up late designing Kikugorō V's costume and then fallen fast asleep. The shock of the burglary apparently triggers a relapse into illness. While bedridden, begins work on his last major series, *Selected New Forms of Thirty-six Ghosts* (*Shingata Sanjūrokkaisen*), aided by apprentices Toshikata and Toshihide.

1888

Paints blood stains on Ichikawa Danjūrō IX's armor for the November production of *Minamoto no Yoshitsune amidst the Thousand Cherry Trees* (*Yoshitsune Sembon Zakura*). Also portrays Danjūrō in the *Personalities of Recent Times* series, which the actor much admires. Completes twentieth and final portrait of *Personalities of Recent Times* series; adds full-color print cover, and has the set bound in book form. Attends Japan Art Association's exhibition of paintings by Kobori Tomone (1864–1931) and other Tokyo artists; inspired to change his own painting style. Pupil Matsui Eikichi sets up shop at 59 Senzokumura in Asakusa Park, and sells paintings by Yoshitoshi on silk. Paints background curtain for celebrated dancer Oyō's performance at the Nakamurarō teahouse in Ryōgoku on the Sumida River. Studies *kiyomoto* traditional ballads and Umewaka-school Noh recital. Genre print series *Thirty-two Aspects of Women* (*Fūzoku Sanjūnisō*) published. Listed among the top six print artists of the day in *Complete Survey of Tokyo Masters* (*Tōkyō Meika Shihō Ichiran*) along with Kyōsai, Hiroshige III, Kiyochika, Chikanobu, and Kunimasa.

1889

As one of twelve artists invited by Tōyōdō Gallery to submit works for an exhibition, paints a folding screen, *Red Cliff Landscape* (*Sekiheki no Sansui Zu*), in Shijō-school style. In summer, painter Kaburagi Kiyokata (1878–1973), then twelve years old, visits studio. Toshimasa terminates apprenticeship.

1890

Produces late-period actor prints: three-triptych series *Actors with Snow, Moon, and Flowers* (*Yakusha Setsugekka*) and portrait of Onoe Kikugorō V.

1891

Eyesight worsens, and health generally deteriorates. Illness attributed to various causes: excessive drinking leading to brain disorder; overwork and career-related stress causing cerebral hyperemia, or "brain conjestion" (*nōjūketsu*); shock from the robbery three years before becoming a paranoic obsession; or still again, undue responsibility of serving as a loan-guarantor placing too great a strain on his system. Contracts beriberi from malnutrition. In May, paints billboard placard for Shintomiza theater production of *Sōgen of Iwakura in a Blizzard of Cherry Blossoms* (*Hanafubuki Iwakura Sōgen*), aided by Toshihide.

1892

While ill, reputedly paints folding fans with designs of wild ink-washes and blood spatters. According to an obituary notice placed in the *Yamato Shimbun* on June 10, as Yoshitoshi's condition worsens he is taken to Sugamo Hospital for treatment, then transferred to a clinic in Komatsugawa, and finally declared uncurable and released on May 21. Re-moved to temporary quarters at 3 Fujishiromachi in the Honjo district, where he dies the morning of June 9, although his official residence at the time is still listed as 2-1 Hamachō. The *Yamato Shimbun* obituary goes on to say that Yoshitoshi had been making recuperative progress with house-call treatment, but contracted some iatrogenic ailment, which was misdiagnosed as cerebral hyperemia. Cremated the afternoon of June 9 in the northern Tokyo suburb of Kameido; services held on June 11 at Senpukuji temple in the Higashi Ōkubo section of western Tokyo, attended by many acquaintances and associates. The last three prints of the *Thirty-six Ghosts* series, *Fox Fires of the "Twenty-four Examples of Filial Piety"* (*Nijūshikō Kitsunebi no Zu*), *The Poet Sōgi* (*Sōgi*), and *Kobayakawa Takakage Debates the Tengu of Mt. Hiko* (*Kobayakawa Takakage Hikosan no Tengu Mondō no Zu*), published posthumously on June 18. Another notice in the *Yamato Shimbun* of June 21 informs the public that Toshikage has produced a memorial portrait print of Yoshitoshi published by the deceased master's friend and frequent publisher Akiyama Takeemon.

1898

Memorial stone to Yoshitoshi erected at Hyakkaen park in Mukōjima on the east bank of the Sumida River.

BIBLIOGRAPHY

Halford, Aubrey S., and Giovanna M. Halford. *The Kabuki Handbook: A Guide to Understanding and Appreciation*. Tokyo: Tuttle, 1956.

Hisamatsu, Sen'ichi, ed. *Biographical Dictionary of Japanese Literature*. Tokyo and New York: Kodansha International, 1976.

Iwao, Seiichi, ed. *Biographical Dictionary of Japanese History*. Tokyo and New York: Kodansha International, 1978.

Joly, Henri L. *Legends in Japanese Art*. Tokyo: Tuttle, 1976.

Keyes, Roger S., and George Kuwayama. *The Bizarre Imagery of Yoshitoshi: The Herbert R. Cole Collection*. Los Angeles: Los Angeles County Museum of Art, 1980.

Kobayashi, Tadashi. *Ukiyo-e*. Translated by Mark A. Har-bison. Great Japanese Art series. Tokyo and New York: Kodansha International, 1982.

Lane, Richard. *Images from the Floating World: The Japanese Print*. New York: G. P. Putnam's Sons, 1978.

Leiter, Samuel L. *Kabuki Encyclopedia*. Westport, Conn.: Greenwood Press, 1979.

Narazaki, Muneshige. *The Japanese Print: Its Evolution and Essence*. Adapted by Charles H. Mitchell. Tokyo and New York: Kodansha International, 1966.

Stevenson, John. *Yoshitoshi's Thirty-six Ghosts*. New York, Hong Kong, and Tokyo: Weatherhill/Blue Tiger, 1983.

Tazawa, Yutaka, ed. *Biographical Dictionary of Japanese Art*. Tokyo and New York: Kodansha International, 1981.

INDEX

156

定価7,900円
in Japan